Mummified

Manchester University Press

Mummified

The stories behind Egyptian mummies
in museums

Angela Stienne

Manchester University Press

The right of Angela Stienne to be identified as the author of this
work has been asserted by her in accordance with the Copyright,
Designs and Patents Act 1988.

Published by Manchester University Press
Oxford Road, Manchester M13 9PL
www.manchesteruniversitypress.co.uk

British Library Cataloguing-in-Publication Data
A catalogue record for this book is available from the British Library

ISBN 978 1 5261 6189 5 hardback

First published 2022

The publisher has no responsibility for the persistence or accuracy of
URLs for any external or third-party internet websites referred to in this
book, and does not guarantee that any content on such websites is, or will
remain, accurate or appropriate.

Typeset by Newgen Publishing UK
Printed in Great Britain by Bell & Bain Ltd, Glasgow

In loving memory of
my beloved grandparents
Yvette Stienne et Michel Stienne
&
my dear friend
Helen Pike

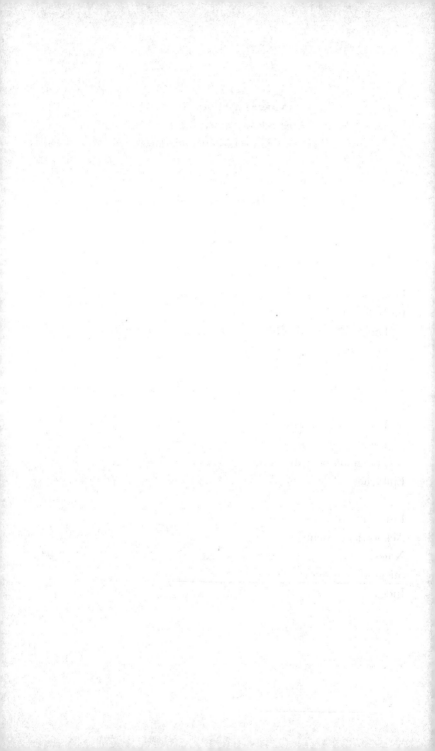

Contents

Foreword

I am delighted to say that the book you're holding in your hands is somewhat unusual: it concerns the reception of ancient Egypt in the modern world.

It is a publication blissfully unconcerned with ancient battles, court intrigues or exquisitely crafted funerary paraphernalia; there are no theories regarding the construction techniques of vast pyramid complexes, their alignment against astronomical points or the ways in which Egypt stood as the dazzling jewel of the Mediterranean for more than 3,000 years. It is, however, a book that presents an equally fascinating tale of how individuals scoured the necropoleis of Egypt for the mummified corpses of Egypt's ancient dead, in order to transport them by land and sea, across thousands of miles, to museums and private collections in the West. It relates the manner in which the steady commodification of Egypt's mummies, predating even the Napoleonic campaign of 1798, determined western attitudes towards these remains throughout the nineteenth and much of the twentieth century, as the mummies of the long deceased were utilised in the causes of scholarship; art; and, indeed, public entertainment. Primarily, *Mummified* is concerned with the ways in which we have connected, and continue to

connect, with mummified human remains in both the some-
what rarefied surroundings of museums and, historically, in
rather different settings. It is a book that shares tales about the
ongoing engagement of the living with the ancient dead and
allows us to consider the nature of that relationship.

As an Egyptologist, primarily concerned with mortuary
archaeology, my own engagement with the ancient dead is con-
siderable; however, I also find myself writing and lecturing a
great deal on the reception of ancient Egypt both within aca-
demia and in modern culture, often, though not exclusively,
in relation to the mummy as a cultural icon. The aspect that
is most apparent from my research is how heavily influenced
by contemporary convictions, concerns and circumstances
Egyptianising cultural works are, and the same is apparent
within the displays of museums and galleries. Whether in the
1920s or the 2020s, the ancient past is *always*, inevitably, overlaid
with the realities of the present.

Reception, as applied to the study of the ancient world, is
a somewhat fluid term. The reception of ancient Greece and
Rome has been a well-established branch of classical scholar-
ship for some decades now, substantially based upon the work
in the late 1960s of German literary theorist Hans Robert Jauss
(1921–1997).

By understanding the ways in which the culture, art, religion,
philosophy and literature of the ancient Greek and Roman
worlds have been comprehended by scholars and, subsequently,
presented to the wider world, from the Renaissance onwards,
our appreciation of the discipline in its current state is clarified.
In order to move forward as a subject, it must retain a well-
defined view of the past. There is, today, a greater acceptance
of the fact that *all* historical enquiry is influenced by the cultural

mores of the periods when that research was undertaken and disscminated. By way of example, it is clear that substantial differences would have existed between a stage production of Sophocles's *Oedipus Rex* mounted at London's Royal Opera House in 1912[1] and the National Theatre's production of 2008,[2] and not merely in terms of technology or stagecraft. Our appreciation of the creative choices – literary, artistic and academic – informed by the predominant culture and politics of the period substantially alters our experience of the ancient text.

Egyptology has been relatively slow to respond to the ideas of reception theory – unlike classics, it is a comparatively young branch of the humanities – but it is increasingly engaging with this theoretical field. Over the last two decades, a small number of significant books and articles have considered the ways in which our understanding of ancient Egyptian culture has been influenced not only by the prevailing attitudes of preceding generations of scholars, but also by the choices made by artists, writers and, ultimately, filmmakers and game designers in their portrayals of the ancient past. *This* is one of those significant books.

Mummified is the first book to focus solely upon the reception of the mummy within the context of museum collections – Egyptological, general and private – specifically in the UK and France, both of which are cultural contexts of which the author has vast experience. Through consideration of the reception of these preserved human remains over the last 200 years, this book addresses the ever-changing motivation and psychology of excavators, scholars and the public at large. The question of mummy unrolling is particularly pertinent here: when it became apparent that there was increasing press and public resistance to this formerly popular practice, it

came, very swiftly, to an end. The final notable public mummy unrolling was conducted at Manchester University by the estimable Margaret Murray on 6 May 1908. The mummy in question, Khnumn Nakht, hailed from the twelfth dynasty and had been excavated at Rifeh. Photographs show the event to have been very well attended, though articles published in the succeeding days, including a heartfelt but rather clumsy poem, revealed a marked distaste for the whole project. Murray was incensed and somewhat hurt by the experience, as her publication on Khnumn Nakht's tomb, two years later, reveals.[3] She had been involved for the best of reasons, in a spirit of purely academic enquiry, and this volte-face by the media was a salutary lesson.

In the course of her wide-ranging exploration, the author also addresses the biographies of the mummies' afterlives: not, however, the spiritual rebirths these individuals might have imagined for themselves but, rather, their corporeal afterlife of discovery, seizure and movement across the globe to cultures and circumstances they could never have imagined in life.

In choosing to concentrate upon mummified human remains, the author tackles the peculiarly privileged role that mummies play in our modern understanding of the culture of ancient Egypt, and the ways in which they capture the minds of scholars and the public alike. They inhabit a problematic, often awkward, liminal area between being the physical remains of living individuals, whose culture and history we study through material artefacts, while at the same time being themselves artefacts of forensic, artistic and archaeological study.

However, as *Mummified* shows, this is not an entirely new phenomenon. Mummies have been consumed, often literally, for centuries in a variety of ways, which strike us now as peculiar

and, frequently, distinctly ghoulish. The public unrolling events and private parties that took place throughout Europe and the United States from the mid-nineteenth century are a perfect case in point. I can personally attest to the fascination exerted by such events, as I have, since 2016, led several lavish recreations of mummy unrollings at major institutions in the UK and beyond. In advance publicity, it has always been made clear that no actual mummified remains will be employed and that the purpose is merely to give modern audiences a flavour of the mummy unrollings undertaken by the likes of Thomas Joseph Pettigrew, of whom you will read more later. However, in the storeyed, glass-fronted atrium of the Ashmolean Museum, approximately 1,000 people watched with rapt, albeit slightly horrified, expressions as I spent an hour unrolling my 'mummy', discussing the funerary practices of the ancient Egyptians and what I was uncovering beneath the endless lengths of prepared and carefully stained strips of cloth, discovering an amulet here and a wrapping inscribed with hieroglyphs there. Of course, it was an entirely theatrical entertainment, but the fascination exerted by such spectacles was still palpably present. Smaller numbers, such as the 300 seated spectators at the Ny Glyptotek, Copenhagen, enabled me, after divesting myself of the *fin de siècle* trappings, to field pertinent questions from the audience and to ask them what so fascinated them about Egyptian mummies and what they had gained from witnessing such an unrolling, however fictitious.

I'm pleased to say that our genial author, Angela, has been able to attend these staged unrollings on more than one occasion, and I would like to think that she has been able to bring elements of this lost – but far from lamented – phenomenon of yesteryear to the present work.

Foreword

As we have seen, mummies can represent considerably more than mere relics of purely academic interest; they have infested the imagination, in addition to the intellect, over the last 200 years. Egyptian mummies have become immediately identifiable icons of literature and film, recognised by children from the youngest ages, often before they have ever set foot within a museum or gallery. They are known through cartoons, toys, stationery and even sugary snacks. In the twenty-first century, the mummy – and fantasies thereof – has become part of our modern cultural landscape. In addition to horror films, there are boundless television documentaries filled with the latest 'theories' and new evidence direct from the field. The incredible parade of the New Kingdom royal mummies through the streets of Cairo in April 2021, from their galleries within the Egyptian Museum to their new display in the National Museum of Egyptian Civilization, in twenty-two specially designed golden hearses, live-streamed online throughout the world, provides ample proof of their public appeal, even when there are no mummies to be seen – merely Egyptianising modern vehicles marked with the cartouche and anglicised name of each royal personage. Indeed, the gleaming presence of these unseen mummies was sufficient to elicit tremendous national and international engagement. This lavish and visually striking event, funded by the Egyptian Government, allowed modern Egyptian voices to be heard as they expressed pride in their history and culture. It was an effective means of enabling the people of Egypt to engage with their ancient dead on a grand scale, without placing the mummies at any risk.

Mummified is far more than just a history of the accession and study of Egypt's dead. It is also the author's very personal and, at points, touching reminiscence of the many mummies she has

encountered. I have a feeling that all Egyptologists recall their first encounter with a displayed mummy in a museum. My own was with the mummy of a tiny, unnamed but elegantly wrapped Ptolemaic lady on display in the Kelvingrove Art Gallery and Museum in Glasgow. Displayed in a wooden case dating from the early twentieth century, with three glass viewing panels, the mummy lay in the trough of her wooden coffin with an intricately decorated lid mounted above, enabling visitors to see her sweetly painted cartonnage funerary mask beneath a net of shining blue faience beads. I subsequently visited both museum and mummy many, many times during my formative years. The mummy and the magnificent pink granite sarcophagus, displayed at the entrance to the Egyptian Gallery, which once held the remains of Pabasa, Chief Steward of the God's Wife of Amun, Nitocris I, are firmly etched into my memory. Unconnected, save for their proximity in Kelvingrove's collection, they became to this small boy, at least, somewhat indivisible. As this book points out, in the minds of the public there is a degree of interchangeability between the terms 'mummy', 'coffin' and 'sarcophagus'.

Today, the little Ptolemaic mummy has been transferred to another museum just a few miles away, while the sarcophagus of Pabasa retains a central place in the collection. I have continued to revisit and to study both; the connection remains.

Angela's discussion of the mummies in this work is never mawkish, but she is at pains to remind us that these museum exhibits were once as quick and as vibrant as her readers. Our attitudes towards mummies have changed considerably in the past, and will continue to change as we move forward.

I am particularly delighted to have been invited to provide this brief foreword to Angela's first book. We've known each

other for more than a decade, first meeting while she was volunteering at the Petrie Museum of Egyptian Archaeology at University College London, where I was delivering events, usually with a substantial reception component. We've lectured together on a number of occasions, most notably when Angela organised a memorable study day at Leicester Museum & Art Gallery for the Egypt Exploration Society. I have always been impressed by her tremendous enthusiasm and absolute dedication to our discipline. In recent years, since completing her PhD, she has contributed to numerous panels and discussions regarding the display of human remains in museums. She is the ideal person to act as our guide through this incredible history of human interaction with the ancient dead.

<div align="right">

John J. Johnston
West Dulwich

</div>

Prologue

A curator at the Musée du Louvre is cleaning the case where an ancient Egyptian man is resting. There is something stuck at the bottom of the case. Someone has attached a little piece of paper. On it is scribbled 'reiveille toi!!!' [sic] *– wake up!*

The handwriting and the mistake on the note indicate that it was most likely written by a child visiting the Egyptian galleries, who left a message for this mummified man. Clearly he had been lying far too still for this child. Wake up, they urged. Whoever wrote the note, it seems that they looked at the mummy and thought of him as alive, or as having been alive. Perhaps they instinctively recognised the mummy as the body of a human being – or, perhaps more likely, they had seen one too many films where a mummy in a museum case comes to life.

I know the man who was the recipient of this note very well. His name is Pacheri, although some have called him by other names.[1] The Musée du Louvre has been his home since 1827, and for the past two decades, he has been my silent companion.

I have been visiting him since I was a teenager, when I wandered the rooms of the Louvre, dreaming of becoming an Egyptologist, trying painstakingly to read the ancient Egyptian script and to absorb the knowledge on display.

At the same time, I do not know him at all. He lived in ancient Egypt about 2,000 years before I was born, during Ptolemaic rule, and he has been lying, inert and silent, in this museum for the past two centuries. I can learn as much as I want to about the history of his time and the complicated circumstances that brought him to Paris, but I will never know him, not really. I stand in front of his glass prison, and I wonder about his life in Egypt, why he is here in Paris, and why so many people come to the Louvre and do the same thing as me: stare at him on display. In the same way that he has been with me through my personal journey, Pacheri is going to follow us on the journey that is this book. Because, like many displaced bodies in European museums, he has a story to tell.

*

I have been interested in stories about Egyptian mummies for many years. I grew up in the suburbs of Paris, and when, at thirteen, I decided I wanted to become an Egyptologist, my attention naturally turned to the closest collection of Egyptian material culture. The Louvre contained two floors of ancient Egyptian artefacts and one very impressive body: Pacheri. For years, I read all I could find about ancient Egypt; spent innumerable hours in the museum bookstore and various Parisian libraries; took hieroglyph classes on school breaks; and even interned at the museum when I was just fifteen, to get a better grasp of this gigantic institution. At nineteen, I finally got my dream job: I became a summer gallery attendant at the Louvre.

I would arrive at the museum at 8 a.m. and be in the galleries half an hour later, before they opened to the public. I wanted to take in the feeling of walking in the vastness of this museum, without anyone else around. Every morning, I would find out where I had been allocated: a new room every single day. I not-so-secretly wished to be allocated to the Egyptian galleries, to wander in the rooms I was still discovering and to learn all I could from the other gallery attendants, especially the senior ones, who were a living memory of the museum. It was during my second summer as a gallery attendant that I asked another member of staff, someone who was particularly knowledgeable about the history of the Egyptian galleries, about the lack of mummies at the Louvre. Why did the museum have so few?[2]

That is when they told me about the missing mummies.

It is a story that is so eccentric, unbelievable, and yet true to some extent, that I have dedicated a lengthy section of Chapter 3 to it. To uncover the truth about those mummies, I went on a quest for a missing document, wandering the museum looking for clues, even visiting the Church of Saint-Germain l'Auxerrois, which faces the Louvre, and asking a bemused clergyman if he had Egyptian mummies in his crypt! It took a few years to locate the document – and the missing mummies. This curious tale is what launched my own interest in researching the stories of mummies, but it is not the only reason. As I worked in these galleries for a few summers, I witnessed visitors from around the world engaging with the mummy of Pacheri, and the diversity of their interactions really startled me. Some would turn away from the body, while some were mesmerised and would stay for lengthy periods. Some seemed bewildered, and then there were

always the visitors who knocked on the case and told the mummy to 'wake up'. My enthusiasm only grew, and I knew that I wanted to explore why we engage with Egyptian mummies, and why we engage with them in different ways. To do that, I packed up and moved to England, with little English, to take courses in Egyptology and Museum Studies. I thought I was leaving France for a year, but stayed in England for a decade, dedicated to understanding the stories of our interactions with Egyptian mummies. I returned to the Louvre on many occasions, doing my doctoral thesis on the history of its collection of Egyptian human remains, and this time studying the British Museum too. I have made these museums my professional home, and much of my life has been tied to these complex institutions and the ancient bodies that we call Egyptian mummies.

One day, as I was walking in Paris, on my way to the natural history museum, a sign on the side of a monumental fountain caught my eye. The street name was rue Georges Cuvier, and above it someone had tagged the word 'racist'. I already knew about the disturbing race studies of ancient Egyptian and other African bodies that had taken place in the nearby museum, instigated by this man. I thought, someone else knows this story too.[3] But how many people walk past rue Georges Cuvier, or the Denon Wing at the Louvre, or even Galerie Vivienne in Paris, and make a connection with Egyptian mummies?[4] The landscape of Egyptian body-collecting in Paris, which I had learned about through years of research, captivated me – but I knew it was a relatively obscure history. On another occasion, as I was walking in Leicester in England, I passed the statue of Thomas Cook by the train station, and the copper heritage sign inserted into the pavement in the cultural area of this city, and asked myself: how

many know the connection between Cook, Egyptian mummies and the local museum?[5] Before long, I was seeing Egyptian mummies everywhere. Mummy stories are all around us, and yet the presence of Egyptian mummies in European history is so long and so much a part of the cultural furniture that we have stopped asking ourselves questions about them.

I wrote this book because I wanted to keep asking questions, and because I wanted you to join me on this journey, exploring stories related to Egyptian mummies in the European landscape.

<p style="text-align:center">*</p>

Perhaps you have seen Egyptian mummies in museums too. You may have felt curiosity, fear, concern or nothing at all. You may have returned to see them, being drawn by these human bodies on display. You may feel torn by the viewing of the dead and the ways these remains are displayed, or you may feel deeply emotional about the connections to death and the afterlife that the bodies facilitate. Perhaps, as for me when I was young, the viewing of an Egyptian mummy stopped you in your tracks: you were meeting an ancient Egyptian, someone who lived and breathed in ancient times. You were making a connection with the past. You may have thought during your museum visits about the big questions that the viewing of these mummified bodies raises – questions that museum professionals often call ethics – or perhaps you didn't: you just walked past them, and maybe had a curious look. It is very possible that you are not much of a museum visitor at all, and your interactions with Egyptian mummies have occurred through books, documentaries or movies. Either way, your initial emotional responses are valid. They are conditioned, in part, by your own feelings about life and death, but also by

what you know about Egyptian mummies, whether you view them as a visitor or as a professional working in fields related to archaeology, museums or even forensics.

Your emotions are also conditioned by your experience of the museum. Museums can be places of enjoyment and learning for some, while for others they are places of trauma – physical manifestations of a history of violence. If your history, the history of your community and that of your ancestors, is linked to violence, trauma, colonisation and displacement, then you will know why the museum as an institution can be a difficult place to navigate and even to access. But if, as for me, the museum has been for you first and foremost a place of enjoyment and curious wandering, it is entirely possible that what you know about museums and Egyptian mummies is not the whole truth – and that is because museums have been complicit in telling only some stories about themselves and the objects they contain. This book and its many stories will bring to light some aspects of the great unlearning of the museum – and of Egyptology as a discipline[6] – that is necessary if we are fully to grasp the implications of our interactions with Egyptian mummies, but I cannot tell you how to feel about these bodies displayed in glass cases. There is no right or wrong way to visit a museum, but there are ways to have more informed museum visits.

The Egyptian mummy has been the subject of many books, and yet few have invited you – the visitor, the researcher, the curator or simply the inquisitive reader – to become an active museum visitor, and an agent of change. Very few have questioned why the Egyptian mummy is in museums around the world today. In this book, I share stories that attempt to counter the usual mummy narratives: they are stories of things that go

wrong, stories of displacement, stories of practices that are a little odd, stories of studies that are outright racist, but also stories about individuals who were fascinated with mummies, stories about technology and its potential, and stories about where we go from here and what we can do next. In choosing which stories to tell, I have tried to cover a diversity of topics to help you think about this vast subject.[7] The stories take place in France and England, because that is where I have pursued my research but also where I have led workshops and engaged with the public. But it is not an entirely personal choice. France and England were also the two main countries to battle for the political, cultural and intellectual control of ancient and modern Egypt, and both countries have left these histories unchallenged for some time. I am going to invite you to question the bodies and artefacts that are inhabiting museums, and the narratives attached to them, wherever you are.

This book was written during two worldwide paradigm shifts that have put the body, the dying and the 'other' at the forefront of conversations. The first was an international call for decolonisation and restitution that, though it already existed, was heightened by the Black Lives Matter movement, as well as the publication of important books about museums that reached global markets and put the behind-the-scenes museum conversations in the spotlight.[8] The second was a global pandemic that forced people to think about, witness and experience death – a pandemic that is still ongoing as I write. The viewing of Egyptian mummies in European museums is very much embedded in these changing conversations about experiences and traumas that are linked to the living, the dying and the rituals of death.

# Mummified

Mummy Stories

The museum shop is a very popular place. Rows of books, reproductions and souvenirs. On a shelf, little colourful sarcophagi that look like pencil cases attract the eyes of visitors. Inside, a white chocolate mummy.

One of those little sarcophagi and its chocolate mummy, sold at the British Museum in London, sparked the submission of a story to *Mummy Stories*. *Mummy Stories* is the online platform I have been running since 2017, collecting tales of individual encounters with human remains.[9] The story came from Rafaela Ferraz, who recalled her interaction with an Egyptian mummy that has been displaced to, and is displayed in, Portugal:

> I know that to stand before Pakharu today, in a museum in western Europe, is to participate in – and benefit from – a history that does not recognize him, this Egyptian man from another place and time, as a person. It's the same history that's made it possible for me to tell the quirky, subversive, but not exactly macabre tale of my white chocolate mummy; the same history that's made it possible for Europeans before me to grind up actual mummies and call it medicine.

We will return to this curious mention of mummies as medicine in the next chapter, but for now, Rafaela continues:

> Maybe it's not enough, as a visitor, to know of this history, to accumulate these factoids as evidence of wrongdoing. Maybe action should follow. But I'm not there yet. I still own that sarcophagus pencil case, even though my days as a budding Egyptologist are long gone. And I still value this relationship, fragile as it may be – this opportunity to connect, fantastically, with people whose lives began and ended long ago, so many lifetimes before mine.[10]

score native>8>

This is one of many stories, short and longer, that I have col-
lected over the years, but I like this one particularly because it is
about learning and being vulnerable; it is about being open to
change, even if it is uncomfortable or takes time. This is a story
that tells us how a museum visitor can participate in a complex
conversation – a conversation not just about the unappetising
and rather grotesque merchandising decisions made by people
who stock gift shops, but also about the ethics of human remains
in museums, and how they should be celebrated, advertised and
thought about. A conversation about being human.

The story of Rafaela, and my own stories, which I recount in
the pages of this book, exist because we have both had access to
Egyptian mummies in European collections – access to bodies
that have been taken from their home country. Being able to
view and interact with Egyptian mummies and artefacts in
European museums in the way that I have done throughout my
career remains a privilege, and one that came at great cost to
the mummies' home country and its people. And, unfairly, my
privilege to view these ancient Egyptian bodies and artefacts is
one that is often denied, or complicated, for modern Egyptians.

This paradox is brought to light by Egyptian scholar Heba
Abd el Gawad and Alexandria-based cartoonist Mohammed
Nasser in their project *Egypt's Dispersed Heritage*.[11] It is a project
that uses comics to engage with complex contemporary issues
surrounding the displacement and dispersal of Egyptian arte-
facts around the world. The first comic opens with Abd el Gawad
saying to Nasser, 'Did you know that British-led excavations
have discovered thousands of artefacts in Egypt and exported
some of them to 27 countries?' Hearing this, Nasser gets sud-
denly excited and starts wrapping himself up in fabric. Abd
el Gawad asks him what he is up to, to which he responds, 'Tell

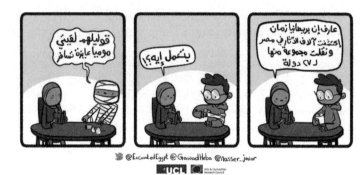

1 Nasser mummifying himself to be able to travel; part of the *Egypt's Dispersed Heritage* project, by Mohammed Nasser and Heba Abd el Gawad. The comic is read from right to left.

them you discovered a mummy who wants to travel.' Today, it is easier for an Egyptian mummy to travel the world than it is for many modern Egyptians; and as such, it is easier for me to view thousands of displaced objects in the Louvre and the British Museum than it is for the people whose culture they belong to. But that is not all: today, the voices of Egyptians are still missing in past stories of discovery, and are being suppressed in conversations, from museums and from the archive, too.[12]

While writing this book, I talked with Egyptian Egyptologist and community engagement specialist Dr Fatma Keshk, the founder of *The Place and the People*, about her own engagement with Egyptian mummies. Dr Keshk's work is to create engaging narratives of stories from ancient Egypt to share with wider audiences in Egypt.[13] She recalled:

> As an Egyptian kid who grew up in Cairo and started to visit the Egyptian Museum at an early age, I always had true mixed

reactions towards the mummies of the pharaohs, especially the group of royal mummies that until early 2021 was displayed in the mummy room at EMC [Egyptian Museum, Cairo]. While on one hand, we grow up feeling proud of our ancient history, I always doubted whether I should be contemplating the mummified bodies of our ancient ancestors, even if they were pharaohs. At this early age, I hadn't realised yet the possible ethical issues involved in the study and display of Egyptian mummies; they were, however, some of my least favourite museum objects of ancient Egypt.

I asked her how her views have changed now that she is an active professional in the field of Egyptian cultural heritage and cultural outreach. She said:

Building on my own struggles with the funerary life of ancient Egyptians, engaging in such a narrative is one of the most complex missions of my work. Yet, I choose the objective side, which means I choose to explain to the public in Egypt why the ancient Egyptians chose to have their bodies mummified and how this choice is closely linked to the conceptions and beliefs of their ancestors. Building on this, I choose not to judge any of the previous or current practices that might have dealt 'unethically' with the study and display of ancient Egyptian mummies, and I choose to focus on making the audience aware of the ancient and modern history of mummies and leave it to their own beliefs and thoughts to evaluate the different current practices.[14]

A deep awareness of the complicated past and a commitment to make our own judgements and to decide for ourselves how our learning and emotional experiences can shape, build and transform our own attitudes and behaviours when it comes to Egyptian mummies.

A journey of learning and unlearning.

Introduction

The mummy

'With oils, and wrappings from the hands of Tayet … a mummy-case of gold, a mask of lapis lazuli …' Those were the promises made in the Tale of Sinuhe to an Egyptian man living abroad. A proper way to be mummified.[1]

Before we embark on our journey through these chapters and do some learning and some unlearning, we need to ask one seemingly simple, but actually very complex, question.

What, exactly, *is* a mummy?

An Egyptian mummy is the preserved body of an ancient person.[2]
It is a body (sometimes wrapped up, and sometimes not).
It is the dead body of a human.
It is a corpse.

And yet, for centuries, a mummy has also been a painted wooden coffin, a medicinal cure, a medical specimen, a racial construct and an object to be displayed. This dual identity, as both body and object, has had a huge impact on how we think about Egyptian mummies. Over the years, I have run numerous

workshops and given talks to a range of audiences, from the general public to academics and museum professionals. These have taken place in various settings, mainly in England, and once in the middle of a pub! One question I am asked without fail is this: is an Egyptian mummy a body (human remains) or an object (artefact)? The general public ask this because they are stunned at the idea that these are real preserved bodies and wonder how they should behave towards human remains in museums, while professionals are concerned with categorisation, codes of ethics and inventories. Every time I hear the question asked, I wonder how we have, over time, moved in a direction where the very humanity of Egyptian mummified bodies is questioned, if not denied. I always pause and ask the audience to think: are you *actually* unsure about this? If you step back and think about it, is it not obvious? But there are so many layers of conditioning that affect how we see a museum object that sometimes we do not recognise what is in front of us.

For the avoidance of all doubt: a body.

Let's turn to the ancient Egyptian mummy for a moment, and the practice of mummification. The preservation of the dead in ancient Egypt took two main forms, with a multitude of small-to-large variations, owing to changes in beliefs, the evolution of practices, and regime changes by both internal and insurgent rulers. These are a reminder that the ancient Egyptian civilisation spanned more than 3,000 years, and, therefore, change was inevitable. In spite of that, the representation of ancient Egypt in the media, as well as in many museums, often blurs a very large geographical and temporal range – think of how many times you have seen Tutankhamun or Cleopatra represented with pyramids, a form of interment long gone by the time these figures ruled Egypt.

The first kind of preservation is what we call natural mummification, and the second is called artificial mummification – even though 'mummification' is a complex and at times problematic term. The natural preservation of the body, which is a feature of the early period of ancient Egyptian civilisation, consisted of conserving the body through natural means. Often this was done by placing the body in a pit in the sand to protect it from the elements.[3] Artificial preservation, which came later, is more involved, and consists of deliberately applying a series of steps to prevent the decomposition of the body. It is this that most characterises the ancient Egyptians, and it is also the practice that has impressed and startled people around the world.

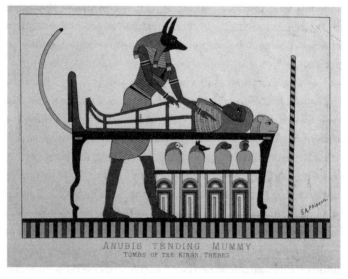

ANUBIS TENDING MUMMY.
TOMBS OF THE KINGS, THEBES

2 'Anubis tending mummy, Tombs of the Kings, Thebes', Wellcome Collection.

We do not know a lot about mummification, which can be surprising considering how much focus is placed on mummified bodies and their afterlife when it comes to ancient Egypt. Our own fascination with mummies has led people to declare that the ancient Egyptians were obsessed with death, a misconception that arises from the fact that more items remain extant from funerary contexts than from daily life. This is partly because everyday objects have survived in smaller numbers as a consequence of settlements being closer to the Nile and more prone to decay over time; but it is also because archaeologists and museum curators have long chosen to collect objects they thought were mysterious and monumental – and that would therefore appeal to funders and visitors – and this did not include linen clothes or everyday pottery.[4] It is also important to stress that, as a result, what we see of ancient Egypt in European museums, and also in most books, is overwhelmingly elite – we're looking at the mortuary beliefs and practices of affluent people. The golden objects discovered in tombs are not representative of ancient Egypt as a whole.[5]

We do know, from surviving texts, that the treatment and transformation of the deceased body as part of the mummification ritual was essential to those ancient Egyptians who could afford it, and this led to increasingly complex steps to transform the deceased bodies of the wealthy: steps that included the removal of organs (usually – but not always – with the heart staying in place), the desiccation of the body, the use of plants and products to stabilise organic tissues, and the wrapping of the body, but also a set of rituals that are not visible to us today, and yet were equally important. These steps evolved over time and naturally became more sophisticated and more adapted to

the changes of the body and its needs.[6] The variations are great. Often, books about ancient Egypt offer a 'recipe' for mummification, but the idea of just one method is not reflective of the changes in preservation techniques. However, it is clear that the ancient Egyptians developed considerable knowledge of the workings of the body through physical study. Their impressive understanding of the natural elements, including salts and plants, contributed towards preservation techniques that, when executed properly, allowed the body to survive until the present.[7]

While there were great variations in the ways used to preserve the body, the overall aim was to prevent its decay. Helpfully, spell 154 of the *Book of the Dead* gives us an idea of what to avoid: 'Hail to you, my father Osiris! You shall possess your body; you shall not become corrupt, you shall not have worms, you shall not be distended, you shall not stink, you shall not become putrid.'[8] While the body (the *sah*) was important, we know from texts that other entities were equally crucial to reaching the afterlife.[9] These included the heart, the name and the shadow, as well as spiritual elements such as the *ka*, the *akh* and the *ba*. The survival of the body was essential for those aspects to be reunited.[10] It can be difficult to grasp what these relate to today, and some have made the mistake of applying a modern conception of the world to ancient belief systems. This is particularly problematic in the case of western scholars, whose attempts to understand the connections the ancient Egyptians had with the natural and metaphysical world are not unlike settlers misinterpreting native and aboriginal practices: concepts are twisted to fit a western narrative. We will see in Chapter 8, for example, how the concept of the 'naming of the name' has been reused recently to explain dubious scientific studies in museums and universities.

Our understanding of the boundary of what a mummy is has also been in question for some time. Is a mummy still a mummy when it has been unwrapped? What about when the heart has not been removed? Are the wrappings, once removed from the body, still part of a mummy, or are they just linen?[11] Of course, to this we must add the increasing awareness that the word 'mummy' is not the most appropriate word to refer to these bodies – we will learn about its origin in the next chapter. For ease, I have retained the word for this book, as this is how most people know these preserved bodies today. I have also used variations of it, including 'mummified bodies' and 'ancient mummified person'.

Another point: today we understand the word 'mummified' as referring to a state that prevents the body from decaying, but to the ancient Egyptians the dead body was always trans-muting; what we see as a halt was in fact movement and change. Perhaps it is the museum that has truly mummified these bodies, preventing them from continuing their journey into the afterlife. And possibly, it is our idea about what a mummy is, where it belongs and why it is visible to us today that needs to be *un*-mummified.

Already, not everything is as it seems.

The Egyptian mummy as many understand it today is there-fore a construct. We are increasingly aware that a mummy should probably not really be called a mummy, and that we do not fully understand how the ancient Egyptians felt about the whole con-cept of mummification and the afterlife. What we do know is that bodies were preserved and transformed, and that it mattered for individuals that they were – and this is relevant because, for centuries, mummies were removed from Egypt and brought to Europe, where their fate was not preservation but destruction.

*

Mummified

The viewing of Egyptian mummies in European museums has become so normalised that it is easy to overlook how strange it is that Europeans collected these remains – and how strange it is that we continue to visit them today. Egyptian mummies are bodies, but they are bodies that have been commodified over time and claimed as museum objects. They are the bodies of people, nevertheless. These people were at the heart of a civilisation deemed so developed that some countries fought for control of its narrative, collecting along the way the (mummified) bodies of humans whom they attempted to use for their own ends: apothecary, medical, historical, anthropological and

3 Thomas Rowlandson, *A Scholar and/or Physician Carrying a Cane Peering at an Egyptian Mummy through a Pair of Eyeglasses*. Gouache drawing.

colonial. Why have Europeans been fascinated with Egyptian mummies for so long, and why do they continue to study and display these human remains? What leads people to study the dead bodies of another people?

At the core of this long-standing interest in Egyptian mummies is a very human concern – death. And also, a very human interest in who these people were – life. The history of Egyptian mummies in European museums is full of fascinating stories: from the first medical dissection in London, to a curator's obsession with collecting a mummy; from some strange apparatus at the British Museum that allowed a mummy to rotate, to the curious practice of public unrollings. But the history of Egyptian mummies in museums also sheds light on some of the worst traits of human nature – the desire to conquer, to classify, to accommodate and to erase others – which led curators and scientists on a mission to prove that Egyptian mummies were in fact white people. The tangled history of western colonial relationships with Egyptian mummies and the implications of this history today are at the core of our interactions with mummies in museums, and yet few know of this complex and dark chapter in history, which still influences how we think about and encounter these bodies.

Europe's history with ancient Egypt can be traced back all the way to the Greeks and the Romans. Herodotus, the Greek philosopher, was himself very curious about the practices of ancient mummification and wrote at length about it.[12] But the European history of collection is better traced back to the Middle Ages, when Egyptian mummies were dug from graves and ground into a medicinal powder, the *mumia*.[13] The mummy was therefore at first a medical specimen to be collected. It then became a curiosity, displayed in the cabinets of the wealthy for

domestic and selected viewing. It is the eighteenth and nine-
teenth centuries that mark a shift in the European interest in
Egyptian mummies. At this time, a strong desire emerged to
make ancient Egypt part of a cultural and political agenda,
especially in France and in Britain, in the context of imperial
expansion. Even today, the Egyptian mummy is still very much
a topic of conversation in society, with public debates and con-
troversies arising periodically in the press, focusing on questions
of race, DNA and provenance. These conversations often miss
the complex history of these mummified bodies in European
culture.

This is a book of those stories.

Chapter 1

The mummy as medicine, the mummy in medicine

On an ordinary road in West London, individuals from around the world are sharing a room. Their home is white, clinical. Africans, South Americans, Papua New Guineans, French, British in a single room. It is very quiet. This is a museum warehouse.

It is 2019, and the address is 23 Blythe Road, West Kensington. Originally built as the headquarters of the Post Office Savings Bank, this impressive building, known as Blythe House, is the store and archive of the Victoria & Albert Museum, the British Museum and the Science Museum. In the portion of the building allocated to the Science Museum, in a small, characterless room, over a thousand bodies are living their afterlife together. A single room for the remains of people from all around the world. Two mummified bodies from ancient Egypt; heads from Africa; the artificially preserved tattooed skins of soldiers from France;[1] mummified bodies from South America; tsantsas from Ecuador; body parts in jars from Britain; and many, many more.

In one room, the extent of humanity represented. A snapshot of a collecting mania.

I visited this storeroom in spring 2019, before the collections were moved out of London.[2] I was a Medicine Galleries Research Fellow at the Science Museum, conducting research on the historical links of the museum with ancient Egyptian human remains and devising programmes for public engagement. Access to this room is restricted; I had the privilege to be allowed in. As I entered, with gloves on, I sat on the floor for a moment and looked around. The room was narrow, lined with industrial cabinets, a row of cupboards on each side, one in the middle, a small table in the centre, some more shelves on each side. All the cabinets and shelves were covered with white paper, so that one could stand in this room, unaware of the thousands of lives inhabiting this space. But I had read the 213-page list of the human remains in the care of the museum,[3] and I knew: this was a museum graveyard, the result of the obsessive collecting of one man, and also of the collecting craze of a type of institution, *the museum*. I wondered, sitting on the floor to take a moment to breathe in this suddenly suffocating space, how is it possible that so many bodies have been removed from their countries and taken to this little room in the British capital? What was the rationale behind putting so many bodies in a single room – entire bodies and body parts, sometimes as small as a lock of hair, but often as violent and shocking as heads on a shelf? Why was I looking at an Egyptian mummy inside the storage space of a national science museum? And who was behind this impulse to collect the human remains of foreign people?

One man: Henry Solomon Wellcome.[4]

To understand why two mummified ancient Egyptian bodies and numerous Sudanese skulls and skeletons made their way onto the shelves of this storeroom in London, we need to

look back in time and travel to London in the early 1900s. We must look to two areas of the city: first Westminster and then Bloomsbury.

American-born businessman and philanthropist Henry Solomon Wellcome has had an impact on medical history in many ways, first as a pharmacist, then as the owner of one of the world's largest pharmaceutical companies – Burroughs Wellcome & Co. – and also as one of the most extravagant collectors that medical history has seen. It is nearly impossible to envision the sheer number of artefacts and foreign bodies that Wellcome collected. To put it in context, Tony Gould, in *Cures and Curiosities*, noted that 'by the 1920s he was spending more yearly on acquisitions than the British Museum, and by the early 1930s he had five times as many artefacts as the Louvre'.[5] At his death, Wellcome's collection is estimated to have comprised several million objects of all kinds, housed in various warehouses in London.

A small part of the enormous collection was on display at the Wellcome Historical Medical Museum in London, set up by Wellcome and open between 1913 and 1932. This museum was not just a collection of medical objects, but also included anthropology, archaeology, art and other domains that reflected both Wellcome's personal interest and travels, and the European obsession with collecting 'exotic' things. The Wellcome Historical Medical Museum archival photographs show that he collected numerous human remains, including many heads that he put on display,[6] and that he was keen on categorising medicine and other practices, with galleries of 'primitive' medicine highlighting his European bias. The catalogue of the museum, printed in two editions, for the opening and then the later reopening of the museum, notes:

The importance of museums as an integral part of teaching is now fully recognised, and, by intelligent classification and system-atic grouping of objects, it is our aim and purpose to make the Wellcome Historical Medical Museum of distinct educational value to research workers, students and others interested in the subject with which it deals.[7]

This was not just a display of objects; it was an educational tool to illustrate the different uses of medicine through time, and to highlight the superiority of some people over others. As you will see as the chapters progress, museums have never been neutral spaces, and when it comes to the display of other people – whether it is their material culture or their bodies – the French and the British have consistently sought to prove their superiority over other customs and practices, using education, science and the museum as vehicles to promote those ideas.

So what ancient Egyptian objects did the museum choose to display, to delight and educate the visitors of the early twen-tieth century? We have some clues in the original museum catalogue.[8] Egypt and Sudan were present throughout the exhibition. The guide notes that 'a series of objects from the excavations made by Mr. Henry S. Wellcome in a prehistoric station at Gebel Moya, Anglo-Egyptian Sudan, is shown in Cases 20–23.'[9] Wellcome travelled to Egypt and Sudan on many occasions and supervised excavations between 1911 and 1914 at the prehistoric cemetery at Gebel Moya, from which he col-lected skulls and human remains.[10] Egyptian artefacts were pre-sent in various rooms: amulets, sculptures of deities associated with healing, medical papyri, stone mortars supposedly used for medical purposes and so on. The guide makes constant refer-ences to Egyptian material culture, and we know that Wellcome

took an early interest in the ancient Egyptians. Lacking the educational background on this topic, he sought connections with well-known archaeologists at the time, including Sir William Matthew Flinders Petrie, by addressing them directly in letters:

> I am very deeply interested in the origin and development of the sciences in ancient Egypt, especially in connection with Astrology, Alchemy, Medicine and Surgery, and should esteem it a great favour if you would kindly inform me of any sculptures, carvings, paintings, or papyri having reference to these subjects which there may be in the Museums or in other collections within your knowledge. I shall also be grateful to you if you can let me have any information about the early physicians of Egypt, and if you can tell me of any portraits of them. I will, of course, bear any expenses incurred in procuring the above mentioned information.[11]

To support his research interest, Wellcome, who was incredibly wealthy, used objects as currency; and at times, these objects were human skulls.[12] On the death of Wellcome in 1936, the Wellcome Trust was created – to this day, it is one of the world's largest private biomedical charities.[13] The work then began to dismantle this enormous collection, with individuals working for decades to find the objects suitable homes. Archives attest to advertisements being placed in newspapers and bulletins to ask for takers for the many artefacts,[14] and these were dispersed amongst museums across Britain, including Bolton Museum, the Ashmolean Museum in Oxford, the Fitzwilliam Museum in Cambridge and the Petrie Museum in London.[15] Not everything was given away, however, and in 2007, the Wellcome Collection opened in Bloomsbury, with several thousand objects in its care.[16] While some items were donated to other museums

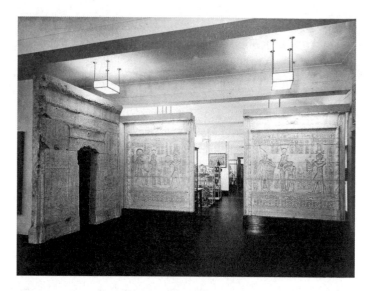

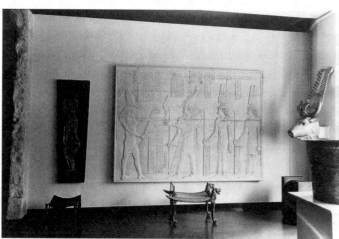

4 & 5 Casts of Egyptian reliefs at the Wellcome Historical Medical Museum.

6 The illustration on the first guide to the museum was reproduced on the visitors' book of 1913.[17]

when the collections were dispersed, the Science Museum in London is today home to many of Wellcome's objects, on long-term loan – including over a thousand human remains.[18] In particular, Henry Wellcome's archaeological excavations in Egypt and Sudan, especially in Gebel Moya, are the reason for the collection of Sudanese skulls in the Science Museum.[19]

In London, in 2019, there were therefore Egyptian mummified bodies and Sudanese skulls in a science museum, on long-term loan from a medical museum – the bodies of real humans from long ago, displaced, stored and then shared between two British institutions. Their location at the Science Museum, which has the largest medical collection on display in the world, is not, in fact, that incongruous.[20] Egyptian mummies, today expected in archaeological and ethnographical museums in

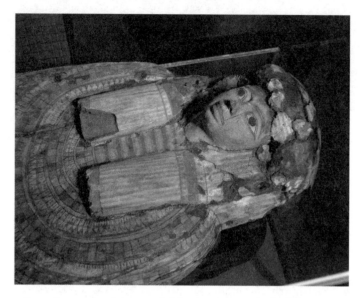

7 Sarcophagus containing an adult human mummy in the Science Museum, London.

Europe, were first and foremost part of medical collections. But their medical history does not begin as objects on display in medical museums; Egyptian mummies started their European history *as* medicine.

We are embarking on a journey to explore instances of Egyptian mummies being used in the natural and medical sciences. From the *mumia* of the Middle Ages and Renaissance, to a medical dissection in Britain, from a chemist interested in Egyptian mummies, to a mineralogist forced to unwrap a mummy by an insistent Egyptologist, to the laboratories of today where mummies are still poked around for more data, the Egyptian mummy has caught the attention of pharmacists, chemists, mineralogists, surgeons and other medical practitioners for most of its European life. This is where our journey

uncovering the European history of Egyptian mummies begins, and it sets the scene for many other interactions, up to today.

Consuming Egyptian mummies

In Medieval Europe, Egyptian mummies were in demand. If you were sick – and wealthy – the apothecary might suggest you ingest mumia, a powder made from ground ancient bodies. In Europe, mummies were medicine before they ever became museum curiosities.

In the twelfth century, a medical practitioner who lived in Cairo, Abd al-Latif al-Baghdadi, wrote an account about a substance extracted from the stomach and brain of cadavers that Europeans bought for half an Egyptian dirham. He recalled, 'One of the merchants selling this drug showed me a bag that was filled with it; I saw in it the chest and stomach of a corpse that was full of this mummy.'[21] Before the Egyptian mummy was *a* mummy, it was first *full of* mummy, or *mumia*. The early history of Egyptian mummies in Europe is thus a surprising one: it is a story about Europeans eating the ground-up corpses of foreign bodies; of dead bodies being commercialised and used as currency; and it is also a story about how we use the word 'mummy' to denote the embalmed bodies of the ancient Egyptians, unaware of this word's unsettling origin.

But what brought people to think that Egyptian mummies could cure them?

In 1530, a coloured illustration in the *Livre des simples médecines*, a very important medical publication by Matthaeus Platearius, showed a skeletal-looking person in a box inside a cabinet of curiosities, which included some large red coral and some shells, including one the size of a human being.[22] The skeleton was in

fact an ancient Egyptian mummy. A curious place for a mummy indeed. The publication, which was widely circulated and reprinted, noted that a mummy is found in pits of dead bodies, and that the best variety is the black and smelly one. Platearius added that the 'white' mummy, on the contrary, has no value. What exactly was Platearius talking about when he mentioned a black and a white mummy? He was thinking of something different than the White mummy we will discuss in Chapters 6 and 7 – Platearius was not thinking about ethnic origin at all, but about the embalming products used in the mummification and whether they had turned the mummy black.

When mummified bodies were first exhumed by local Egyptians and European travellers in the Middle Ages, the black colour of some mummies was assumed to be bitumen from the Red Sea. *Mumiya*, or *mummia*, is a term of Persian origin, which is also found in Arabic and refers to bitumen, and therefore these bodies were called *mumia*.[23] This is where the word 'mummy' comes from. Bitumen was considered to have various healing properties, and therefore mummies were turned into a powder for medicinal use. The word 'mummy' was not attributed to the full body at first, but to this blackened substance that attracted the greed of European kings. The French King Francis I is thought to have used it to cure diseases. It was not the most popular cure in Europe, but the use of *mumia* was common enough to develop into a market, and fake mummies made from the corpses of recently deceased people were created to supply the demand.

Not everyone agreed on the actual benefits of the *mumia*. The famed French surgeon Ambroise Paré, horrified by such a practice, dedicated an entire chapter of his *Discours* to Egyptian mummies, titled 'Le discours de la mumie' ('The

Discourse of the Mummy'). He warned against the risks of ingesting powders derived from bodies that have been decaying for centuries: 'From this work one can see that the ancients were curious to embalm their bodies, but not with the intention that they served as food or drink to the living, the way they have been used until now; never did they think of such a vanity and abomination.'[24] Pierre Pomet, in his *Histoire générale des drogues* of 1694, dedicated a section to Egyptian mummies, highlighting his reservations as to the actual medicinal properties of mummies, and yet he noted that one must choose a mummy that is 'beautiful, shiny, very dark, without bone nor dust, with a good smell, the smell of burning, not of pitch'![25] Similarly, French chemist Nicolas Lémery listed all the virtues

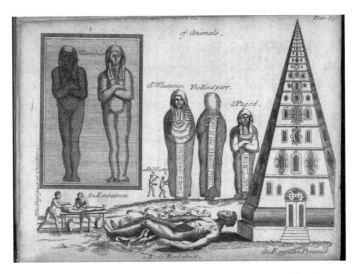

8 'Plate showing different types of mummies and the mummification process', in Pierre Pomet, *A Compleat History of Druggs Divided into Three Classes, Vegetable, Animal and Mineral* (London: printed for R. Bonwick, 1712).

31

attributed to mummies in his *Traité universel des drogues simples*.[26] For centuries, therefore, Europeans were curing their headaches by drinking a powdered substance taken from the decomposing bodies of ancient Egyptians, thinking the bitumen in the embalming resins would cure their ailments. But was there really any bitumen on Egyptian mummies? Recent studies have found that for the first 2,000 years of mummification in Egypt, bitumen was in fact not used in the mummification process and only became prevalent from around 750 BC up to the Roman period.[27] This means that quite a lot of Egyptian mummies used for their medicinal properties probably contained no bitumen at all, and individuals were simply ingesting powdered corpses.

If the thought of an Egyptian mummy used as a medicinal cure has left you perplexed, for quite some time it was the very idea of what an Egyptian mummy was that confused Europeans. In 1690, the entry for 'mummy' (*mommie*) in the *Dictionnaire universel* by Antoine Furetière remarked that a mummy is 'an ancient, embalmed body brought from Egypt, shown in cabinets of curiosities', but that it was also used as a medicinal cure for several ailments in the form of ground mummy powder.[28] In fact, Furetière turned out to be so unsure as to what a mummy really was that he added several definitions: a body from Libya; a liquid from embalmed bodies; a drug composed of bitumen; and, also, the corpse of a recently diseased person disguised as a genuine ancient Egyptian body. The dichotomy between the Egyptian mummy as an object of collection and an organic body – one that could at times be used for medicine – was already prevalent, and while the mummy is no longer used as medicine, this contradiction between body and object is still something we encounter today.

One element that people became increasingly aware of was that the Egyptian mummy was a body and, notably, an incredibly well-preserved body. How was it possible that such an ancient organic body had survived that way, and what could the natural and medical world learn from this skilled preservation? Before anyone realised that ancient Egyptian material culture could serve political and intellectual agendas in museums, mummies were more commonly destroyed than preserved. From surgeons to chemists and mineralogists, Egyptian mummies have been in the hands of men who have caused the destruction of countless numbers of these human bodies. Paradoxically, the way to understand preservation was to halt it, and this is how Egyptian mummies became entangled in a typically medical practice: dissection, in its many guises.

The mummy and the theatre

'I caused another mummy to be opened.' With these words, Maillet, the French General Consul in Cairo, reported a practice that became all too common for Europeans: the dissection, in private or with an audience, of mummies.

The man who 'caused' the mummy to be opened was amateur naturalist Benoît de Maillet, who was French General Consul in Cairo between 1692 and 1708. Maillet's interest in the natural sciences was extensive, and he was particularly interested in geology and the formation of the earth, which he studied while visiting Egypt and the Mediterranean. Between 1692 and 1720, Maillet worked on a publication, *Telliamed*, which appeared posthumously in 1748.[29] While in Egypt, Maillet also wrote *Description de l'Égypte* – a title later employed for the publication of the results of Napoleon's expedition of 1798–1801. Maillet

first wrote to Phélypeaux de Pontchartrain about the discovery of a mummy on 17 September 1693, and five years later, in 1698, he told him of another mummy that he had opened in front of an audience in Cairo:

> This mummy had its right hand placed upon its stomach, and under this hand were found the strings of a musical instrument, perfectly well preserved. From this I should conclude that this was the body of a person who used to play on this instrument, or at least of one who had a great taste for music. I am persuaded that if every mummy were examined with the like care, we should find some sign or other by which the character of the party would be known.[30]

Maillet revealed his understanding of the Egyptian mummy as the corpse of a human being, whose character could be uncovered by a careful examination through a process of removal of wrappings and, at times, full dissection of the body.[31]

In 1692, the year Maillet went to Egypt, a document on Egyptian mummies entitled *Lettre d'un académicien* was published by the French heraldry specialist Claude-François Menestrier.[32] It recounted a man's conversation about an Egyptian mummy. The individual had, according to Menestrier, four questions. What is a mummy? Where do mummies come from? How did mummies remain intact for so long without being corrupted? And, finally, what is the meaning of the depictions and symbols on the shrouds of the mummies? The questions highlighted in this letter represent the fundamental interrogations raised by interaction with Egyptian mummies at the time. Of these, the incorruptibility of the mummy was the primary factor that made the mummy so peculiar to Europeans. The desire to

uncover the science behind the mummification process inevitably led to the destruction of many of them.

Maillet and Menestrier's inspections of mummies in the late seventeenth century indicate that the public opening of ancient Egyptian corpses was already practised before the more familiar public unrolling sessions of the nineteenth century (which we will explore in Chapter 5). They are anchored in anatomical practices in both France and Britain. While dissections are today private and professional affairs in these countries, attending the opening of a body was for a long time quite standard. In fact, dissections of human bodies were a necessary means of advancing medical knowledge, and often it was the dead bodies of criminals that were used for these explorations. Bernard de Mandeville, an Anglo-Dutch physician and philosopher, wrote in 1725 on the practice of criminal dissections that:

> We ought to encourage the improvement of physick [*sic*] and surgery, wherever it is in our power. The knowledge of anatomy is inseparable from the studies of either; and it is almost impossible for a man to understand the inside of our bodies, without having seen several of them skilfully dissected.[33]

The anatomy theatre emerged in continental Europe between the late fifteenth and early sixteenth century, when the Humanists became fascinated by the reinterpretation and study of the human body, its functioning and its relation to the world. The anatomy theatre was not just a space of investigation into the human body via the act of dissection, but also a place of public conversation and contemplation of the body. The body intrigued both the medical practitioner aiming to improve his practice and members of the public, who felt a mix of wonder

and repulsion. In 1540, Andreas Vesalius, who contributed considerable advances to the study of anatomy, conducted a series of demonstrations in Bologna that give insights into the format of these events. In particular, Vesalius created a format for the public anatomy lecture, divided into two separate parts: first, in one place, the lecture, based on existing publications on anatomy and, at a separate time and location, the opening up of human remains (a format we will see replicated in Chapter 5). At that time, Leiden and Padua were the forerunners of the anatomy theatre, offering access to the public, who had previously been prohibited from viewing medical dissections.

Meanwhile, in England, there was limited access to anatomy dissections for both the public and anatomists themselves. Dissections were conducted at Oxford and Cambridge between the early and mid-sixteenth century, but they were not numerous and were rarely open to the public. The implementation of the Murder Act of 1752 created a shift, forcing the Company of Surgeons to conduct dissections of the corpses of convicted criminals in public.[34] In the late eighteenth and early nineteenth century, issues surrounding the acquisition of corpses transformed the public's relationship with anatomical dissections. Two men, William and John Hunter, elevated the status of anatomical dissections in the eighteenth century, and John Hunter carried out the first recorded medical dissection of an Egyptian mummy in Britain, at John Hadley's house in 1763 (see Chapter 4).[35]

Through the practice of anatomical dissections, corpses (whether recently deceased or ancient) could offer clues to the mysteries of the body itself: its functioning and, more importantly perhaps, its deficiencies, through the study of diseases.

The advances of medicine and the recognition of the necessity of medical dissections in improving knowledge of the human body soon clashed with issues of supply. In the 1820s, demands were therefore made for better legislation to provide a supply line of cadavers. The issue was partly resolved in England through the Anatomy Act of 1832, which regulated the supply for medical research and the teaching of anatomy. A major change brought about by the Anatomy Act was in the acquisition of recently deceased bodies. While the Murder Act, in place since 1752, had limited access for medical schools and practitioners to the bodies of executed prisoners, the Anatomy Act of 1832 provided access to the bodies of those who had died in hospitals and workhouses and whose bodies had not been claimed by relatives. The openings and dissections of Egyptian mummies throughout the eighteenth and nineteenth centuries are therefore significant in a context of reconsiderations of what the body meant to groups of individuals. But the dissection of Egyptian mummies was not only valuable to understanding what was under the wrapping; at times it was precisely those wrappings that interested scientists.[36]

Salt, rocks and reed

A chemist who wants to understand how salts preserve flesh, a mineralogist who would rather be crossing deserts and a very insistent Egyptologist with a papyrus that can transform his career. They have one thing in common: dissected mummies.

In 1754, the French chemist Guillaume-François Rouelle undertook an examination of the head and pieces of a mummy at the suggestion of the Comte de Caylus, a wealthy collector who

had Egyptian mummy parts in his private collection.[37] This episode was reported in the press:

> A piece of history on which M. le Comte de Caylus was working led him to consult M. Rouelle: it was the embalming of the ancient Egyptians, a matter of finding what materials were employed, samples of which one can see in the mummies we have left, and how they were used.[38]

Born in Mathieu, a Norman village near Caen, Rouelle was interested in the sciences from an early age: an anecdote refers to his purchase of a cauldron at the age of fourteen to conduct his own experiments.[39] He left his medical studies in Caen to pursue chemistry, later moving to Paris, where he studied pharmacy under Gottlob Spitzley. Established in Paris as an apothecary in 1738, Rouelle lectured on chemistry, giving the lectures in his own laboratory, and attracted the interest of many intellectuals of the time including Denis Diderot, Antoine Lavoisier and Antoine-Auguste Parmentier. Rouelle's rise in Paris was meteoric, such that in 1742 he took over the position of demonstrator of chemistry at the Jardin des Plantes. Two years later, in 1744, the success of his chemistry courses in his laboratory at Place Maubert helped him to become a member of the Académie des Sciences.

His research focus? Salts. He was so passionate about salts that he wrote five large publications about them, called *Mémoires*.[40] The fourth publication, 'On the embalming of the Egyptians', was concerned with the salts used in ancient Egyptian mummification. He was particularly interested in *natron* (natrum), the salt used for purification. His analysis of substances found in mummies also aimed to prove that the ancient Egyptians used bitumen from Judaea and other aromatic gums in the mummification process.[41]

Rouelle's work was not, per se, an opening or a dissection, but actually the study of mummy fragments resulting from the tearing apart of pieces of mummies. This method of examining mummies places them in the context of natural sciences (here, chemistry) which is different from the other interactions with mummies that we will see in other chapters: Rouelle's motivation was related to his scientific interest and reputation, rather than an actual interest in mummies.[42] It is clear that certain research questions were driving forward the investigation of Egyptian mummies in the natural sciences, and that the most important of these questions was their extraordinary preservation.

About seventy years later, still in Paris, the Egyptian mummy was still being studied in the natural sciences, but this time by a mineralogist. It is 1824 and the *Revue encyclopédique* has just announced the opening of two Egyptian mummies, including a very curious one: 'a good mummy with an extraordinary volume and weight'.[43] His name: Padiimenipet.

The opening took place at the house of a famed French mineralogist, Frédéric Cailliaud, who found himself involved in the opening of two Egyptian mummies, at the demand of none other than Jean-François Champollion, future curator of the Egyptian collections at the Musée du Louvre and one of the translators of the hieroglyphs (see Chapter 2).[44] Between 1815 and 1822, Cailliaud travelled to Egypt, Nubia and Ethiopia to collect minerals.[45] Cailliaud was a major actor on the French scientific scene of the first half of the nineteenth century, and took up the position of curator of the Muséum d'Histoire naturelle de Nantes – natural history museums were considered the most esteemed scientific institutions at the time and had more appeal than art museums.

Born in Nantes in 1787, at a young age Cailliaud developed an interest in mineralogy – a term that then concerned the structure and origins of the earth. At twenty-two, he moved to Paris to study at the Muséum national d'Histoire naturelle, which opened in 1793. In 1815, he travelled to both Cairo and Alexandria, where he made the acquaintance of Italian antiquarian and diplomat Bernardino Drovetti. Following a journey to the southern lands of Egypt, Drovetti, impressed by Cailliaud's geological expertise, recommended him to the viceroy of Egypt, Muhammad Ali, who appointed Cailliaud as the government mineralogist. His first mission was to locate emerald mines in the Gebel Zubarah. Cailliaud not only achieved this goal, but also made significant archaeological discoveries: the temple of Redessieh, the ruins of Sekket and the ancient road from Coptos to Berenice. In 1818, he travelled to the Western Desert and became the first western explorer to visit the oasis of Kharga. Over the course of his stay in Egypt, on multiple occasions Cailliaud visited the temples of Thebes, the centre of the Franco-British cultural competition, represented by agents Giovanni Battista Belzoni and Henry Salt (these names will reappear in the following chapters).[46]

In 1819, Cailliaud embarked on his second expedition to Egypt to complete the survey work of the *Commission*, which had been interrupted in 1801: in particular the mapping of the Nile Valley in the southern regions and the exploration of the Nubian temples. The Académie des Inscriptions et Belles-Lettres also required that Cailliaud bring back antiquities from the Theban region. From March 1820, he travelled up the Nile towards Nubia, and during the journey he stopped in Saqqara, El-Kab, Edfu and Thebes to take objects. Amongst the objects collected in Egypt, Cailliaud recalled in *Voyage à Méroé* that

'With the help of some Arabs from Gournah, whom I occu-
pied doing digs, I opened various tombs, and found there some
very interesting pieces … I acquired a series of good mummies,
with their cases covered in hieroglyphic figures and paintings
in a good state of preservation.'⁴⁷ The antiquities brought back
by Cailliaud were temporarily displayed at 11 rue de Sèvres in
Paris in the 'Cabinet Cailliaud', prior to their acquisition by
the government. Unlike the objects from his first expedition,
this second collection was not acquired immediately by the
government, and Cailliaud complained that the situation had
been mishandled.⁴⁸ The 'Cabinet Cailliaud' was the site of the
opening of mummies on 30 November 1823, reported in the
Revue encyclopédique:

> Opening of two mummies from Mr Cailliaud. Amongst other
> precious objects brought back by Mr Cailliaud from his last
> journey to Egypt, and which compose his rich Egyptian cab-
> inet, the curious and the antiquarians had distinguished a good
> mummy with an extraordinary volume and weight.⁴⁹

This male mummy, a man named Padiimenipet who had
died in the nineteenth year of Trajan's reign, was acquired
in Qurna in 1820 from the Italian dealer Antonio Lebolo.⁵⁰
It was a somewhat unusual mummy: its weight of about
110 kg and the large size of the head and feet attracted atten-
tion. The mummy was described by Cailliaud in his *Voyage à
Méroé*. Champollion went to see the mummy after it arrived
in Paris, as recorded in his *Lettre à M. Letronne* of March 1824.⁵¹
Champollion was more interested in the hieroglyphs cover-
ing the mummy – and especially in some issues relating to the
naming of the mummy – than the body itself. Cailliaud noted
that Champollion was satisfied during his visit that he was able

to confirm the validity of the hieroglyphic system he had published a few years earlier.[52]

Champollion-Figeac, the brother of Jean-François Champollion, reported in the *Revue encyclopédique* that after hesitating for a while, Cailliaud had finally agreed to satisfy the curiosity of a number of individuals by opening the mummy. The audience included Dominique-Jean Larrey, a military surgeon, member of the Académie Royale de Médecine and the Académie des Sciences. Larrey took part in the French campaign in Egypt and wrote extensively on Egyptian surgical practices.[53] The opening started with the removal of the outer wrappings that formed an envelope around the body, and in between which was placed a papyrus bearing the names of Cleopatra and Ptemenon. Cailliaud continued removing the fabrics of different qualities, and in total unrolled 380 m of wrappings during the three-hour-long operation. It took a further four days to unwrap the body completely, involving the use of a hammer, as a bituminous substance had stuck the fabric onto the dried flesh. The mummy had the peculiarity of having the eyes and mouth covered with a golden plaque, a custom that Cailliaud noted was foreign to Egyptian practices. Other details, such as the closed mouth and the golden wreath, led Cailliaud to suggest that it was the mummy of a Greek individual. The papyrus deciphered by Champollion confirmed that it was a young man who had died on 2 June in 116 CE. A series of drawings by Cailliaud in his *Voyage à Méroé* illustrate the various aspects of the mummy and the coffin, including a drawing done before the unwrapping, and one of the face of the mummy unwrapped. The second mummy opened by Cailliaud – which received less attention – presented an entirely

different embalming technique without any noticeable use of bitumen, salt or any other resinous substance.

The Egyptian mummy, today seen in museums around the world, has therefore had a completely separate afterlife in Europe: one where it has been dissected, studied and even eaten, as a medicinal cure and a medical specimen. But this medical afterlife is far from over…

A twilight hospital visit

The Royal Brompton hospital is receiving an unlikely patient for a CT scan. Unlike patients who come to this London hospital to find out how to stay alive, this patient is already dead. She was brought here to help the living.

The Egyptian mummy seems always to have been part of the medical world, and at times it even inhabits the very hospitals used by the living. This was the case for the mummy of Tamut, who, in the early 2010s, visited the Royal Brompton Hospital in Chelsea, London, to be examined in the latest dual-energy CT scanner. Tamut was an ancient Egyptian singer who lived in 900 BCE and suffered from severe calcified plaque in her arteries. Daniel Antoine, curator of bioarcheology at the British Museum, noted that 'In her case it is a large deposit and, if a fragment had detached and moved away into the heart, she would have had a heart attack and if in the brain, she would have had a stroke. It is remarkable to be able to see plaque in such clarity.'[54] Tamut was one of eight Egyptian mummies put on display at the British Museum in 2014 for an exhibition called *Ancient Lives, New Discoveries*.[55] The exhibition, to which we will return to in Chapter 8, was a prime example of the

intersection between medical sciences, Egyptology and human remains: it highlighted the immense potential of new technologies, in particular medical imagery, in uncovering more data about ancient Egyptian human remains. The British Museum is far from being the only institution taking its mummies on nighttime or dawn trips to the hospital. A news article on the Manchester Museum website reports that 'Ancient Egyptian mummies travel to Manchester for health check-ups'.[56] The two mummies in question were taken from Derby Museum to the Royal Manchester Children's Hospital, where they were photographed, CT-scanned and X-rayed. It was only their second move in 140 years, as they had left once before for another medical check-up, an earlier X-ray. The news article insists that 'the mummies were imaged in the evenings when the hospital clinics finished, to minimise inconvenience to patients. They were then repackaged into their specially produced crates and couriered back to the museum.'[57]

Just as the trade long ago in *mumia* was an attempt to use ancient Egyptian bodies to support the health of modern people, and embalming techniques were studied in the hope of learning how to apply them elsewhere, so the contemporary study of Egyptian mummies via medical imagery is of interest to today's medical world. While dentistry has evolved considerably (one of the mummies in the British Museum exhibition had suffered extensive tooth damage), the world is still grappling with diseases that have their origin in the ancient world and are still partly unresolved; amongst them is cancer. In 2011, an international team scanned a male Ptolemaic mummy from the Museu Nacional de Arqueologia in Lisbon that had several lesions located mainly on the spine, pelvis and proximal extremities. They used a multi-detector computerized tomography

(MDCT) scan, which produces extremely detailed images, and this indicated a diagnosis of osteoblastic metastatic disease, a form of bone damage most common in cancers. The team recounted that 'these radiologic findings in a wrapped mummy, to the best of our knowledge, have never previously been documented, and could be one of the oldest evidence of this disease, as well as being the cause of death'.[58] In 2016, it was a team in London that reported the earliest evidence of metastatic cancer (one that has spread to the whole body) to date, by studying the remains of a young man from ancient Nubia.[59] The published paper states that 'the study further draws its strength from modern analytical techniques applied to differential diagnoses and the fact that it is firmly rooted within a well-documented archaeological and historical context, thus providing new insights into the history and antiquity of the disease as well as its underlying causes and progression.'[60] These pieces of research, coupled with other studies in DNA and tissue sampling that take place in institutions such as the Francis Crick Institute in London,[61] have the potential to reveal much about the ancient Egyptians, but they also further our understanding of illnesses that continue to perplex the medical world. The ethical cost of this research is something we will explore further in Chapter 8. Let's now explore a context you are perhaps more familiar with: the collecting and display of Egyptian mummies in European museums.

Chapter 2

The displayed mummy, the displaced body

A brother and a sister are living together in the East Midlands of England.
They live on the first floor of a recently renovated building. At one point, they
even had a pool. But this is not their dream home. This is a museum.

On a warm June morning, the Leicester Museum & Art
Gallery was hosting an event it had successfully been running
for many years: a celebration of Refugee Week. The museum
has been a pillar of community gathering and support, hav-
ing recently been awarded the Museum of Sanctuary Award.[1]
Turning an institution like this into a safe space for refugees
and asylum seekers is no small task: historically, a museum
is an exclusionary space. As with the collection of Henry
Wellcome, displays of world arts and world cultures were not
created to celebrate differences, but rather to demonstrate
them. And yet, every year this museum's programming of
inclusive events climaxes in a day of gatherings and celebra-
tions in the museum rooms; the courtyard; and the pedestrian
walkway, New Walk.[2] Attached to the iron gates, a sign reads
'Refugees welcome'.

The displayed mummy, the displaced body

There is a strong link between this welcome of refugees, displacement and the museum. Displacement is the act of uprooting something or someone, from a family, from a familiar environment, from where this person or thing belongs. The history of extra-European collections in European museums is a history of displacement – it is the story of humans and artefacts that have been removed from their home, and moved to places in Europe and elsewhere in the world that are so very unfamiliar to them.

In June 2019, I walked past Victoria Park, down New Walk and made my way inside what was then called New Walk Museum. I was about to spend my birthday in an unusual way – leading workshops at a museum. For the second year in a row, I had been invited to take over a room to engage the public and communities with questions related to Refugee Week. In 2018, I co-curated with refugees and asylum seekers an award-winning relabelling of items in the World Arts Gallery, leading the successful production of twenty-five new labels that were on display at the museum for nearly seven months.[3] It was a celebration of individual stories of displacement and a model of what a contemporary museum can do when it not only engages its community but works together with it. When I was invited to return in 2019, I could choose the room I wanted to take over this time, and I knew what story I wanted to tell: that of four people forced to live their afterlives in a museum, their story anchored with the history of the city they inhabit.[4] On a day when we were exploring the *hows* and *whys* of people migrating or seeking refuge in Leicester, I wanted to talk about those who had been forcibly removed from their country and moved to provincial England to be put on public display for the enjoyment of museum visitors.

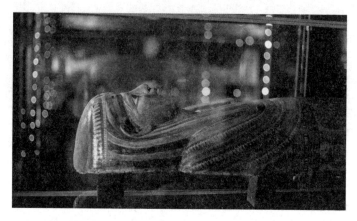

9 A coffin on display at Leicester Museum & Art Gallery. Photo courtesy of Lucas Mathis.

This is the story of the Leicester Museum & Art Gallery ancient Egyptian galleries.

Two of the bodies that inhabit the newly refurbished Egyptian rooms are brother and sister. Their names are Bes-en-Mut and Ta-Bes. They lived in ancient Egypt in the Late Period, around 700–600 BCE, and were buried in a city we now call Akhmim. Bes-en-Mut is a male, who died at the age of around fifty. He was a priest at the Great Temple of Min at Akhmim. His sister, Ta-Bes, is thought to have been around twenty years old when she died. Both their bodies were unearthed in 1884 during excavations by a French archaeologist named Gaston Maspero. Why did two Egyptian bodies excavated by a Frenchman in Egypt end up in the city of Leicester in the East Midlands of England? The story involves a local travel agency and an emerging local museum.

We are in the 1840s in Leicestershire, where a travel revolution is taking place. A man named Thomas Cook, initially a cabinet-maker and then a lifelong missionary, has started taking people

in Leicester and Market Harborough on 'tours'. To begin with, these tours are short rail excursions, but soon enough they extend to bigger trips, for example to see the London and then the Paris Exhibitions. In 1865, Thomas Cook acquired premises in London to create offices and a travel-themed shop, and in 1872 he partnered with his own son, John Mason Cook, to create the company Thomas Cook & Son.[5] The company pioneered package holidays around the world – including to Egypt. Their main travel agency was in Leicester, where you can still see their building.

At around the same time, in the 1850s, the Leicester Literary and Philosophical Society handed over its collection of objects to the then mayor of Leicester, William Biggs, 'in trust for the public, I hope for ever'.[6] The donation was substantial: 10,000 objects. The museum, then called the Town Museum, was housed on New Walk in Leicester, where you can find it today. The purpose of the museum was, behind its cultural and scientific façade, very much political, as with most museums. The mayor accepted the gift, stating that 'it has been shown that … the pages of history, the regions of science, the world of art, the songs of the poets, the lessons of sages, are common property of scholars, of Christians, and of gentlemen'.[7] A grand statement, there, on 'common' property or heritage that wants to be inclusive, and yet is immediately the property of a few – not unlike today's discourses on 'shared heritage'. In 1840, the Literary and Philosophical Society published a catalogue of one of its exhibitions that included a range of objects, from Indian dresses to fossils, birds and insects … and an Egyptian mummy.[8] While it is unclear what happened to this Egyptian mummy, it is evident that the Society had substantial and diverse collections when it donated its objects to the future museum. The museum's collection then grew over the years, sometimes without much

rationale, which led a curator to say that 'the great curse of the collection, so to speak, is sketchy versatility'.[9] It was around 1880, just before the creation of an extension to the museum, that the mummified brother and sister, Bes-en-Mut and Ta-Bes, were taken from Egypt together with their coffins and brought back to England by John Mason Cook. Cook had used his profession as a means to acquire and remove Egyptian bodies. The mummies and coffins were subsequently given to the Leicester Museum, and thus two Egyptian mummified bodies became part of the cultural landscape of an English city and its local museum.

Today, there are four Egyptian human mummies in the collection of the Leicester Museum & Art Gallery. In addition to Ta-Bes and Bes-en-Mut, there is also Pe-Iuy, who lived in Egypt around 700–500 BCE, and whose body and coffin were bought by the museum in 1859 for £45 (it is the first mummy to have been taken to the museum). The fourth mummy, Pa-Nesit-Tawy, was originally buried near Thebes, where he lived around 600 BCE.[10] His name is known from the hieroglyphs on the top half of the coffin. The mummy had been gifted to the Prince of Wales when he visited Egypt in 1869. The Prince then gave the mummy to the Hon. Oliver Montagu, who passed it on to the Huntington Literature and Scientific Society. Dr Garrod of the Society presented the mummy to Leicester Museum in 1928.

Once these mummies had been brought to the Leicester Museum, their journey did not end, and their display changed over time. They have been displayed on virtually every floor of the museum. In the 1930s, an extension to the museum offered a new home for the Egyptian antiquities. They were exhibited in the basement in a curious setting: a large room, lit from the street above, with a mosaic-covered floor that featured a fish

pond (with living fish) at its centre, surrounded by small trees in pots. This was a nod to ancient Egyptian representations of gardens, and an attempt to replicate the kind of home those ancient Egyptians had possibly dreamt of. But this is Leicester, in a green and humid land the ancient Egyptians never imagined; and this is not a dream home, this is a museum. In a historical photograph, the coffins, and possibly the mummies, are seen on display at the back of the room in individual cases. Later, they were displayed in a tomb reconstruction, a type of display that was very popular at the end of the last century. The room, on the ground floor of the museum this time, was dark and atmospheric – so dark that it was hard to read the labels – and the mummies were displayed in separate settings that were a reconstruction of how they might have been found in tombs. In 2018, the museum underwent a complete transformation, and the new Egyptian galleries were moved to the first floor and given much more expansive, brighter spaces.[11] The Egyptian mummies are now in a separate place from displays of material culture associated with life. A sign warns individuals that they are about to see human remains, giving them the choice to view the rest of the collection only if they prefer. The bodies are now in separate cases, with Ta-Bes and Bes-en-Mut placed next to each other.

If you visit Leicester today, you will inevitably see signs of Thomas Cook and his son John Mason Cook in the landscape of the city. As you exit the train station, you will walk past Thomas Cook's statue, which marks his relation to railway travel enterprises; as you walk in the Cultural Quarter, you will see his name engraved on the pavement. On Granby Street you will walk past the Temperance Hall built by Thomas Cook, and in the city centre you can still see the Thomas Cook & Son building with its terracotta panels charting the history of the Cook business.[12]

10 A frame in Leicester Museum & Art Gallery, mentioning John M. Cook. Photo courtesy of Lucas Mathis.

From the mummy pits to the cabinet of curiosities to the Musée du Louvre, the presence of Egyptian mummies in France and England is the result of intentional, calculated enterprises to take these bodies out of their resting places and bring them back to Europe. Whatever the language used in museums and in the media, Egyptian mummies did not 'arrive' or 'come' to museums, they were displaced and then displayed.

The curious mummy

In 1717, a woman named Lady Mary Wortley Montagu shared her anxiety about an Egyptian mummy in a letter. While she was worried the mummy in her possession would be taken prisoner, she had planned for a different jail: a private cabinet.

While in Turkey with her husband – the British ambassador Edward Wortley Montagu – Lady Mary Wortley Montagu

entertained an extensive correspondence. During her stay in Constantinople, she collected artefacts and hoped to acquire an Egyptian mummy:

> I have bespoken a mummy, which I hope will come safe to my hands, notwithstanding the misfortune that befell a very fine one designed for the King of Sweden. He gave a great price for it, and the Turks took it into their heads that he must have some considerable project depending upon it. They fancied it the body of, God knows who; and that the state of their empire mystically depended on the conservation of it. Some old prophecies were remembered upon this occasion, and the mummy was committed prisoner to the Seven Towers, where it has remained under close confinement ever since: I dare not try my interest in so considerable a point as the release of it; but I hope mine will pass without examination.[13]

She had desired a specific mummy, but was unsure about the fate of it, since the King of Sweden, Charles XII, had suffered the above disappointment in acquiring his own mummy. The Fortress of the Seven Towers, the 'Yedikule Hisarı', was a treasury and archive of the Ottoman Empire, as well as a prison. This curious moment evoked in Lady Mary's correspondence suggests that Egyptian mummies were considered a prized possession to be sought after, collected and even taken 'prisoner'. Whether she ever secured possession of the mummy is unclear, as is the fate of the one Charles XII tried to collect. However, it is evident that, by the eighteenth century, Egyptian mummies were coveted by individual amateurs, collectors and royals alike for a different type of prison: the cabinet of curiosity.[14]

What was a cabinet of curiosity? It was a private collection of objects that were assembled to categorise the physical world, to tell stories about the past but also to showcase power and

position. A cabinet of curiosity – often displayed in actual ornate wooden cabinets – was a marker of wealth and power in society. And in many cabinets, there were Egyptian mummified bodies. But where does this strange idea of displaying a mummified corpse in one's living room come from? It was in the mid-sixteenth century that Egyptian mummies became objects of collection, a few centuries after they had been exhumed and used as a source of medicine. The craze for mummies and mummy parts as souvenirs and objects to be displayed in private collections is revealing about attitudes to Egyptian bodies in France, Britain and also Italy at the time.

It was in late Renaissance Europe that the fascination with ancient Egypt peaked, with the ancient civilisation considered as the key to some lost knowledge, embedded in esoteric symbols.[15] In the seventeenth century, for example, Athanasius Kircher epitomised this vision of ancient Egypt in his works, compiling an anthology of Egyptian writings and claiming to have deciphered the ancient Egyptian script.[16] In *Oedipus Aegyptiacus*, Kircher presented an engraving of the inside of a mummy pit, a group burial, which was accompanied by a map.[17] The mummy pits were composed of numerous corpses buried in a single pit, and the sight of so many mummies both disconcerted and intrigued.[18] In 1718, Christian Hertzog published his *Essay de Mumio-Graphie*, in which he made a direct reference to the practice of going to mummy pits to collect Egyptian mummies: 'Only Europeans were capable of such an enterprise, who whether it be for profit, the balms themselves, or in the hope of finding some rarities, adventured into these underground locations, to find amongst the dead that which made the living live in luxury.'[19]

A century later, Charles Irby remarked:

> It is impossible to conceive a more singular and astonishing sight than this. Imagine a cave of considerable magnitude filled with heaps of dead bodies in all directions, and in the most whimsical attitudes; some with extended arms, others holding out a right hand, and apparently in the attitude of addressing you; some prostrate, others with their heels sticking up in the air; at every step you thrust your foot through a body or crush a head.[20]

Not only did the mummy pits provide an almost endless supply of Egyptian mummies for trade, collection and consumption; they also provided an unparalleled environment for the development of imaginative theories and assumptions regarding the mysterious funerary practices of the ancient Egyptians. It is revealing that expeditions were conducted with the sole purpose of collecting the human remains of ancient Egypt, an organised extractive method that persisted for centuries. These mummies, when they were not destroyed on site for the making of the *mumia*, were sent to Europe to feature in private collections. The Egyptian mummy, the corpse of an ancient human being, became a marker of sophisticated society.

In 1629, François-Auguste de Thou sent a letter from Sakkara to a prominent French collector, Nicolas-Claude Fabri de Peiresc.[21] He noted: 'I was the other day at the mummies & went down to a cave, where I saw 5 or 6 corpses as entire as if they had just been buried.'[22] The mummies were removed and taken to France, where Peiresc and a visitor partially unwrapped one of the mummies. The event is recorded as follows:

> He was charmed by the new curiosities he found at his house – among other things, the two mummies – and to hear him

discussing this method of embalming … after removing with dif-
ficulty the various wrappings from the head, which were the same
as those of the rest of the body, nothing was found.[23]

Soon enough, Egyptian bodies became an essential feature of
every respectable cabinet. Several acquaintances of Peiresc had
their own collections of mummies. In the cabinet of Boniface
de Borilly in Aix, there were 'four crocodiles, one very large,
and three smaller. Diverse bodies petrified and embalmed. One
foot and a leg of a mummy.'[24]

In the absence of a centralised museum space in Paris to host
Egyptian collections – unlike Britain, France had its first national
collection quite late, with the Louvre opening its Egyptian
galleries in 1827 (see Chapter 3) – Egyptian material culture, and
especially Egyptian mummies, were to be found in these private
collections. Aristocrat Joseph Bonnier de la Mosson had a sub-
stantial collection in his Hotel de Lude in Paris; a catalogue of
the objects it contained was produced when the collection went
up for sale in 1744. The introduction provides an overview of its
extent, though it is written to attract purchasers:

> There has yet to be found in France, as of today, a cabinet that
> has earned the attention of the public, besides the one exhibited
> here. The variety of objects that form its collection, the number
> of objects, the difficulty in gathering so many rarities, required
> an amateur as ardent, and as rich, as the late M. Bonnier de la
> Mosson, in order to attain to the execution of such a vast project,
> regardless of the place that it required, to organise the ensemble
> with order & with advantage.[25]

A characteristic of this collection was its scientific focus: there
were not, in Bonnier de la Mosson's cabinet, any antiquities,

and yet the head of an Egyptian mummy was included in the collection. In the *Catalogue raisonné d'une collection considérable de diverses curiosités* by Edmé-François Gersaint, the numerous objects were ordered by category, following the division established by Bonnier de la Mosson. The section 'Cabinet d'anatomie' reads:

> This cabinet contains three glass cabinets, in which are kept human skeletons of various ages; several other animal skeletons of diverse species; some myologies & angiologies; some good pieces of anatomy in coloured wax; and some portraits in wax made from nature.[26]

The 'troisième armoire', the third glass cabinet, mentions 'the head of a mummy' among a list of human remains including skeletons and dried human skins. The anatomy cabinet was smaller than the others, and also less visible. Possibly, its contents, a selection of anatomical specimens with some rare and uncharacteristic conditions, made it an oddity in the context of the rest of the collection, and it may have attracted a more particular set of visitors. Following the premature death of Bonnier de la Mosson, the house was sold, and some of the contents of the cabinets were bought by Comte de Buffon for the Jardin du Roi (which would become the natural history museum of Paris). He acquired not only some of the rare specimens in jars, but also the furniture that accompanied the collection. The general content and organisation of Bonnier de la Mosson's cabinet can be reconstructed via drawings made by Jean-Baptiste Courtonne in 1740; however, these drawings did not include the anatomy collection, and the fate of the mummy head is unknown.

Another important collector in the mid-eighteenth century was the Comte de Caylus, who amassed collections of

antiquities and published on the ancient Egyptians. At a young age Caylus had befriended the artist Antoine Watteau, and was himself an artist, creating the illustrations for his own publications. Between 1752 and 1767, Caylus published *Recueil d'antiquités égyptiennes, étrusques, grecques et romaines*, a seven-volume publication.[27] The first part of the work was dedicated to the ancient Egyptians. Despite providing a long list of artefacts collected in Egypt, this publication makes no mention of human remains. And yet, he certainly collected some! Caylus acquired an *hôtel particulier* in 1736 to house his antiquity collection, located at 109 rue Saint-Dominique in Paris. Charles Le Beau, a member of the Académie Royale des Inscriptions et Belles-Lettres, wrote about this place that 'the entrance of his house announced Ancient Egypt: one was received there by a beautiful Egyptian statue five feet five inches in size.'[28] The statue had been bought by Caylus from a descendant of Benoît de Maillet, and it was on the frontispiece of the first volume of his *Recueil d'antiquités*. Despite their absence from the publication, Caylus owned mummy parts in his collection, which he had examined by French chemist Guillaume-François Rouelle in 1754 (remember the man who studied salts in Chapter 1 – this is how he got the mummy parts). Egyptian mummies held sufficient significance in collections to be mentioned and therefore traceable. Phélypeaux de Pontchartrain, who had commissioned Maillet to bring back artefacts from Egypt – including a full mummy, which you will remember Maillet opening for the public in Egypt – had his own collection containing an Egyptian mummy. The mummy was later transferred to the Cabinet des Petits-Frères, located at the Place des Victoires, and was incorrectly thought to be that of Cleopatra.[29] The cabinet was dismantled during the French

Revolution, and the mummy was buried in the garden – a story to remember for the next chapter…

Mummies were also part of royal collections, although they are not well documented. The description of Louis XV's cabinet made by Buffon and Daubenton in 1750 notes 'the inner finger of the right hand of a mummy with a part of a left foot'.[30] This account contrasts with the inventory of Louis XIV's library in 1684, which stated that the cabinet contained no fewer than 'seventeen mummies from Egypt',[31] making it the largest collection in Paris in the late seventeenth century. The fate of the seventeen mummies, of which only a finger and a foot remain, was not recorded. It is possible that they suffered from poor conservation and completely deteriorated.

It becomes evident that Egyptian mummies have been part of the landscape of France for quite some time. Virtually any area of Paris can be mapped out with individuals who had cabinets containing Egyptian human remains, and these remains were transferred, passed along, buried or abandoned, a constant movement of bodies exchanged as merchandise. This was precious merchandise indeed, but not for its human value – it was its cultural, intellectual and political value as a marker of power that counted. A similar study can be made for England, showing an overwhelming presence of ancient Egyptian corpses being displaced and displayed. And yet, if the cabinet of curiosity was the temporary home of many Egyptian bodies, showcasing collectors' networks, it is the national museum that transformed the ways in which Egyptian mummies became, and remain, established as symbols of power and displacement. No event marks this transformation more clearly than Napoleon's invasion of Egypt (1789–1801) and the two enterprises that followed: the

publication of the *Description de l'Égypte* and the installation of Egyptian collections at the Musée du Louvre.

Displacement and power

On a ceiling at the Musée du Louvre, a man is portrayed attending the unearthing of an Egyptian mummy. Commissioned in 1828, this painting was not celebrating ancient Egypt, but the successes of the man in question: Napoleon Bonaparte.

This ceiling is one of four that covered the four Egyptian rooms attributed to the new department of Egyptian antiquities, which opened in 1827. The painting in question is by Léon Cogniet and represents Napoleon Bonaparte, surrounded by Savants and artists, attending the excavation of an Egyptian mummy in a sarcophagus.[32] An adjacent ceiling represents, this time, ancient and modern Egypt, with French allegorical figures shown lighting a torch: France is lighting up the way.[33] Objects from the Louvre's collections are also represented on these ceilings. At the Louvre, in the late 1820s, just as much as today, the ceilings were powerful displays of power, and the most representative episode of power and displacement in France's history with Egypt is none other than Napoleon's military expedition to Egypt.

On 12 April 1798, the five members of the Directoire, the French government at the time, signed a decree ordering the formation of an *Armée d'Orient*, with the twenty-eight-year-old General Bonaparte in command.[34] The objective was first and foremost political: the French wanted to halt the expansion of Britain's empire, and to manage this enterprise successfully it needed to prevent British access to the sea. However, instead of

11 Léon Cogniet, *L'expédition d'Égypte sous les ordres de Bonaparte*, 1835.

a direct naval confrontation, intervention in Egypt was seen as meeting the same strategic goal of preventing British access to India. The exceptional character of the expedition to Egypt led by Napoleon lies in its being a joint cultural and military enterprise. Indeed, in addition to the army, Bonaparte had planned for 151 additional men to join, who were selected for their intellectual and scientific abilities and were to be engaged in collecting data on both ancient and modern Egypt. Together they formed the Commission des Sciences et des Arts.

It has often been suggested that the cultural enterprise was a separate mission that just happened to embark on the same boats to Egypt – this assumes wrongly that cultural missions to foreign countries, especially to non-western countries, are apolitical. And yet, is there anything more political than cultural and intellectual missionary enterprises in occupied countries? Is there anything

more political than the collecting and extracting of objects and bodies for western museums? It was not Napoleon's first attempt to combine looting, scientific mission and invasion.

Among the men enrolled in this Commission were individuals who would become central to the development of French museums and of French Egyptology. Geoffroy Saint-Hilaire, for example, was a naturalist who attended the Collège de France and classes at the Jardin des Plantes. In 1793, upon his return from Egypt, Saint-Hilaire was appointed to the chair of zoology as one of twelve professors at the Muséum national d'Histoire naturelle. He entered into correspondence with French naturalist Georges Cuvier in 1794, and together they wrote five *Mémoires* on natural history. It was Saint-Hilaire who provided Cuvier with Egyptian mummies for his personal research (we will explore their work on Egyptian remains in Chapter 6). Another individual involved in this mission, Joseph Fourier, was later appointed secretary of the Institut d'Égypte and governor of Lower Egypt.[35] After the French capitulation to British and Ottoman forces in September 1801, Fourier returned to France to occupy the post of professor at the École Polytechnique, before being appointed prefect of the département of Grenoble by Napoleon. Fourier was also the editor of the *Description de l'Égypte*, and as a result of his contributions to Egyptian archaeology he was elected to the Académie Française and the Académie de Médecine in 1826. Numerous other individuals went on to take prominent positions in France after their return from Egypt, showcasing a strong link between the expedition, positions of power in French government, and the creation of institutions and publications that supported French domination over Egypt. In addition to these few men, the expedition also included forty-five engineers; a dozen mechanists; and balloonists; a dozen

doctors and pharmacists; and thirty geometers, astronomers, chemists, zoologists, botanists and mineralogists.

The 'Savants', as they were called, operated under unusual circumstances: they had to work alongside an army that had come to carry out a military invasion and to battle against the British. They departed Toulon on 19 May 1798 and stopped in Malta in June, reaching Alexandria in July 1798. In that month alone, the French army had two of its most important battles. At the so-called 'Battle of the Pyramids', which was in fact located ten miles from the pyramids, at Embabba, and occurred just three weeks after the arrival of the French troops in Alexandria, the French victory established Napoleon's dominance over the Mamluks. However, ten days after this victory, the entire French fleet was destroyed by the British under Admiral Horatio Nelson. With the sinking of the French flagship, the *Orient*, the expedition lost its scientific instruments, surveying equipment and supplies. However, the French were on a long campaign: after the naval defeat, they remained on land and the Savants remained in Egypt. The botanists set up their experiments in the garden of Passim Bey's palace, and Saint-Hilaire established chemistry laboratories and collected mineral, botanical and zoological specimens.

However, following France's complete defeat in 1800, the British offered an ultimatum: the Savants and the French army could return home unarmed in exchange for the entirety of the material culture they had collected. Offended by the offer, Saint-Hilaire proposed destroying the collections rather than handing them over to the British, an act he compared (with a remarkable lack of self-awareness) to 'burning a library of Alexandria'. At no point was the idea of leaving these objects to the Egyptians considered. In the end, part of the collection

was retained by the French, though the largest proportion was seized by the British troops, including the Rosetta Stone, now at the British Museum.

Individuals engaged in the Commission des Sciences et des Arts were tasked with acquiring an extensive knowledge of ancient and contemporary Egypt. The idea that modern Egyptians lacked this knowledge was pervasive, and it contributed to the belief that the results of this extensive study, namely the *Description de l'Égypte*, would 'reveal' ancient and modern Egypt to the world, but also to the Egyptians themselves.[36] The investigations were disseminated through various publications, as personal accounts, scholarly research in a number of fields and more substantial publications aimed at a wider audience. Among the personal accounts was a series of recollections by Colonel Chalbrand, published in 1855 after his death. There is little information on Colonel Chalbrand other than his military rank during the campaign, but his memoirs show that he was interested in the collection of artefacts and the customs and art of the countries where he was stationed. Among the objects he brought back from Egypt was a collection of Egyptian mummies. The account reads:

> He had brought back from all the places he had visited objects of curiosity from which he had formed a museum. It was mainly Egypt that had provided the richest and most complete part of his collection; he had allotted an entire room of his house to it. One could see there statues, some mummies in perfect condition [...] Most of these objects originated from the excavations in the tombs of Thebes.[37]

Other accounts by members of the expedition show the availability of the mummy as a souvenir of the campaign. This

illustrates the intensive ongoing excavations of Egyptian sites at this time. Dominique Vivant Denon, whom we will meet in Chapter 4, attested to the regularity of these excavations. In his publication *Voyage dans la basse et la haute Égypte*, he indicated the existence of a market for Egyptian mummies both for the *mumia* found inside them and for the treasures they might contain. He noted:

> In Cairo they sell the resin found in their wombs and the skulls of these mummies, and nothing can prevent them from taking these out; then the fear of giving away one that might contain some treasures (they never found any in similar excavations) makes them systematically break the wooden casing and tear apart those made of painted canvas covering the bodies in rich embalming.[38]

The work of the Savants resulted in a monumental project: the *Description de l'Égypte*, edited by Edmé-François Jomard. In February 1802, the Imperial Press began the publication of the cultural and scientific research under-taken in Egypt. The volumes included 837 copper-engravings and more than 3,000 illustrations, organised into three main themes: 'Antiquités', 'État moderne' and 'Histoire naturelle'. The *Description* recorded the many antiquities and sites uncov-ered, living Egyptian culture, and the local flora and fauna, thus creating a unique ethnographic and geographic compendium. Both animal and human mummies were included. Four human mummies were featured in the plates, in the section 'Thèbes hypogées'. The publication was an ambitious plan to transform France's unsuccessful military campaign in Egypt into a cultural enterprise, and even today the political dimension of Napoleon's endeavours continues to be described as nothing more than a cultural excursion meant to open Egypt to the world.

12 Frontispiece of the *Description de l'Égypte*, Vol. I (1809).

13 Display of the bust of Akhenaten at the Musée du Louvre, with view of the ornate ceiling.

As you walk in the Musée du Louvre today, you might visit the Egyptian galleries, spread over three floors, two of which are dedicated to pharaonic Egypt. In the room of Akhenaten, if you look up, you will see the ancient Egyptian pharaoh – his bust – facing the symbols of power and dominion on the walls of the museum. If you walk down the corridor, you will find the God Amun with Tutankhamun facing a painting of Louis XIV, in a room richly adorned with French symbols. The Egyptian material culture, and the body of Pacheri, are today surrounded by the gilded signs of power that proliferate throughout the

rooms, from the ceilings down the walls, encrusted in the heavily ornamented doors, engraved in every element of the wall decorations. Power and displacement. The Musée du Louvre still displays most of its collections in rooms that are a constant, vivid reminder that the presence of these objects is an act of control – the history of Egyptology is not just one of curiosity and interest in the ancient Egyptians; it is a history of State-directed displacement of objects and bodies.

The language of displacement is something museums still have to reckon with when addressing the provenance of their objects. In museums around the world, especially those in the West with extra-European or native material culture, the language is one of objects 'arriving' in museums. In France it is still one of legal partage – a system put in place to divide up ownership of excavated artefacts in the early twentieth century[39] – a conversation that is so pervasive that it is part of powerful individuals' media conversations even today.[40] The bodies on display in Leicester and at the Musée du Louvre are displaced bodies. They have their place in conversations about displacement, like those we had at Leicester Museum & Art Gallery; they have their place in conversations on restitution and anticolonialism too. Let us now explore more stories of the display of Egyptian mummies, from the British Museum to the Musée du Louvre, to see how these displaced bodies have been presented and what it says about their value in museums, then and now.

Chapter 3

Mummies buried in a garden, and other incidents

'To turn round a dead … or a living mummy … touch and twirl the proper Spring'. In the eighteenth century, detailed instructions were given to help you make a mummy inside the British Museum come to life.

It was a Tuesday morning in London. The month was June, although I had earlier been woken by the downpour against my hotel window. I was a short walk from St Pancras railway station, and I had planned to walk down Euston Road, stroll past the building I had first lived in when I moved to London, take a left on Tottenham Court Road and another left at the end of the road to make my way to the British Museum. But the rain was so heavy, the wind so strong, that I hailed a cab, and on the journey there I thought that this unaccommodating weather made for an atmospheric backdrop for the morning I had planned. By the time I reached the iron gates of the British Museum, I was drenched, and yet I managed a faint smile when my photograph was taken to get my visitor pass ready. It was 9 a.m. and the doors were to open to the public an hour later. I had one short hour ahead of me to examine a coffin – and not just any coffin.

A coffin with mysterious holes in it.

What took me to the British Museum on that morning was the unpublished script of a theatre play set inside the building. It was written in 1767 and is kept in the British Library, which I had visited the day before. It makes reference to a mummy, the so-called Lethieullier's mummy, named after the collector who brought it back from Egypt, Col. William Lethieullier. The mention of the mummy in the manuscript is fairly short and inconsequential for the plot of the play, and yet this brief description is striking: 'Nothing easier. Do you observe that small spring-handle there? It is the easiest thing in the world, believe me, to turn round a dead – ay, or a living mummy, if you can but find out, and touch and twirl the proper Spring.'[1] The author had, it seemed, offered instructions on how to make a mummy come to life: you simply operate a mechanism to make it move on its own. What an uncanny sight that would have been! Of course, this is simply a work of fiction – or is it? Just six years later, an entry in a document in the British Museum, Volume II of *The Surveyors and Workmen's Estimates*, mentions an operation 'to refix the Machinery for turning one of the mummies'.[2] Was there, really, a rotating mummy inside the British Museum?

With the team at the museum, we took the coffin of the Lethieullier mummy, the first coffin to enter the British Museum (today EA6695, 'wooden coffin of Irtyru'), out of its display case in the so-called Enlightenment gallery. You may have walked past it, in this dark, atmospheric wooden gallery – and quite possibly missed it, owing to the lack of any contextual information for visitors. And yet this coffin, displayed standing up in the dark, surrounded by mummy heads with even less explanation, has a story to tell.

As we took the coffin out (only the upper lid was on display), it became clear that something was not right at its top and bottom: it was riddled with holes. The arrangement of the holes – one large hole surrounded by smaller ones – and the square imprints on the coffin confirmed it: there was indeed a device attached to rotate this coffin.

This coffin and its mummy are fairly well documented. William Lethieullier gifted them to the British Museum in his will, in which he stated: 'I give to the Public Museum at Montagu House my Egyptian Mummy, with everything thereunto appertaining, with the rest of my Egyptian antiquities.'[3] The mummy was illustrated, first by George Vertue in 1724, and then in an engraving by the antiquarian Alexander Gordon in 1737.[4] Gordon wrote on the circumstances of the discovery of the mummy that:

> This singular Monument of *Egyptian* Antiquity, was found by some *Arabs*, in one of the ancient *Cryptae*, or Catacombs of the Dead, in the Field of SAKARA, about three Leagues from *Cairo*, in the Year 1721, while its present possessor Captain *William Lethieullier*, was in *Egypt*, to whose Assiduity in promoting Matters of Antiquity and Curiosity, the Learned World owes this noble Remain, and who afterwards at *Alexandria* ship'd it on Board the *Dove Galley* for *England*, where it arrived in the Year 1722.[5]

The mummy was listed in the British Museum's collection in 1756 as 'the skull of a mummy', and 'two feet and a hand, seemingly of a mummy.'[6] Guides to London and the museum, as well as visitor accounts, allow for some understanding of the arrangement of the early rooms. In *London and Its Environs Described*, Robert and James Dodsley wrote a description of the

content of each room, and here we find our mummy. They noted that:

> Having giving [*sic*] in at the porter's lodge … your name, addition, and place of abode, you have notice given what day and hour to attend, and a ticket given you. By shewing this you are admitted, and entering the hall … you ascend a magnificent stair-case, nobly painted by La Fosse. The subject of the ceiling, Phaeton requesting Apollo to permit him to drive his chariot for a day. On the inside walls a landskip [*sic*], by Rousseau: this brings you to the vestibule … the ceiling represents the fall of Phaeton; in this is a mummy and some other antiquities.[7]

In another account, Edmund Powlett takes his reader on a virtual tour of the museum, room by room. Describing the room with the mummy, he notes that:

> The room is set apart from the immediate Reception of Presents, and contains several very curious Articles, given by colonel Lethieullier, his Brothers, and other Benefactors. I shall mention an Egyptian Mummy, which is deposited in a Glass Case, in one Corner of the Room, as its Coffin is in the other.[8]

These accounts tell us that the mummy was initially displayed on the upper floor of the museum in a vestibule lined with cabinets. The room was furnished with a collection of miscellaneous objects, mostly from the Lethieullier family. The mummy itself could be seen in the northern corner of the room in a mahogany case with glass lids and slides, while the coffin was on the opposite side. To us it may seem strange, but the mummy was displayed as if standing up. The display of Egyptian mummies in an upright position was a common practice at the time, and throughout the nineteenth century. Evidence can be

found in both descriptions and visual materials from the period, and the feet of mummies are often damaged as a result.

It is unclear what happened to the mummy itself after that, but our coffin reappears in the 1830s, and it now has a new feature … it rotates, in an uncanny position, as if roasting on a spit. On 10 November 1838, the *Penny Magazine* published an article on a new space at the British Museum, entitled 'New Egyptian Room, British Museum'. The space included new acquisitions (incorporating objects and remains acquired during the French expedition to Egypt), and the article mentions our coffin:

> In the centre of the room are two glass cases, containing in the lower portions the outer cases or coffins of two mummies, which may be seen in other parts of the room. These coffins are covered within and without with paintings and hieroglyphics having reference to the deceased; and, being upon pivots at the ends, are so placed that both the interior and the whole of the exterior may be seen.[9]

The Illustrated London News of 13 February 1847 reported:

> But here, as everywhere, last of all comes death; and the floor of the room is mostly occupied with plate-glass cases of mummies, and various emblems of the painted pageantry to which mortals have fondly clung in all ages of the world. Here are coffins, sepulchral cones, and other ornaments, scarabeo, amulets, &c. The casts illustrate the heroic life of Egypt, just as the contents of the cases illustrate the social life. This room has usually crowds of visitors.

An engraving accompanied the text and presented another view of the Egyptian Room, showing that very little had changed over the course of the previous decade, apart from the addition of an

Egyptian-style frieze. In this engraving, we can see a man peering through the glass case at the 'rotating' coffin, with its apparatus.

On that rainy morning at the British Museum, we were staring quite puzzled at the evidence of a long-forgotten display innovation. It is unclear whether the apparatus allowed for the rotation of the coffin, or if the coffin was just fixed that way, but as with many stories ascribed to mummies, it inspired some creative ideas in the minds of individuals who wanted to imagine mummies coming to life. As the words 'mummy' and 'coffin' were often used interchangeably, it is very likely that, in the eighteenth century, you could see a rotating coffin on display at the British Museum. That is, a coffin without its mummy.

EGYPTIAN ROOM.

14 Engraving of the Egyptian Room at the British Museum in 1847.

But there is more to this story, on themes that are by now familiar: a misplaced human body and a ruined coffin.

In this chapter, I want to introduce you to strange stories of things gone wrong. Mummies that decay, mummies that were refused by museums, mummies that never made it to display and mummies that were subjected to bizarre presentations. These unexpected stories really make us consider a variety of questions. Why have Europeans tried to collect, bring back and display behind cases these human remains and their coffins? At what cost to human life (even in their death) did Europeans bring these bodies back from Egypt? What are the strange and curious stories that have accompanied these bodies and their display in private collections and public museums? From the Louvre in Paris, to the British Museum in London, to a suburban city in France, these are stories of national collections and their political role; of curses, legends and myth; and of tragic endings. They are also, crucially, stories that challenge a simple narrative that has dominated for two centuries: the one that claims Europeans are better placed to preserve the remains of ancient Egypt.

Murder at the Louvre

Five months before the opening of France's first national galleries of ancient Egyptian material culture, a man is digging a hole in the museum's garden. He is hastily covering two bodies with lime.

On 27 July 1827, the governor of the Louvre, the Marquis d'Autichamps, wrote a letter to the Louvre's director, the Comte de Forbin. It was a short letter, with curious contents. The governor cordially informed his correspondent that he did not

see any objection to the digging of a hole in the garden of the Louvre to bury some human remains after tragic events that had occurred at the museum. In this letter, he included some essential advice: lime should be added to prevent 'the exhalations of these distant beauties'.[10] Two bodies had decomposed so badly that they needed to be buried and bleached. It was a matter of urgency, and the cover-up took place in secret, to prevent this unfortunate affair from tarnishing an important upcoming event. But who died on the grounds of the Louvre in 1827? What mysterious murder took place in this landmark of French culture?

At this point in the story, the Louvre is five months short of the opening of the first ever national galleries of Egyptian material culture in France. While the British Museum had Egyptian artefacts from its opening in the 1750s, decades later in the 1820s France still had no national collection of Egyptian objects. The intellectual, cultural and political control of ancient Egypt had become crucial. One man decided it was time to put France on the map by building its own collection – and the man in question is very relevant to our murder mystery: Jean-François Champollion.

Champollion was born in 1790 in Figeac, France, the youngest of seven children. In 1802, he enrolled at the school of Abbé Dussert, where his proficiency with languages first became evident through his study of Latin and Greek, and then Hebrew, Arabic and other languages. His skills came to the attention of Joseph Fourier, the prefect of Grenoble, who had been part of the French campaign in Egypt. The encounter with Fourier forged Champollion's interest in the ancient Egyptian civilisation, while Fourier became an ally and supporter of Champollion's endeavours throughout his life. Champollion is best known today for his role in the deciphering of the hieroglyphs, and in 1824 he published the *Précis du système hiéroglyphique*, a guide to decoding them.[11]

While the deciphering of the hieroglyphs is Champollion's most famous accomplishment, his role in the formation and curating of France's first national galleries of ancient Egyptian material culture is less well known. Still, for Champollion, it was a logical extension of his work. On the last page of his *Précis*, he expressed the need for an Egyptian gallery in Paris:

> A wish that all the friends of science will undoubtedly support: that in the midst of the general tendency of minds for solid studies, a prince, sensible to the glory of letters, may bring together in the capital of his state the most important relics of ancient Egypt, those on which are unrelentingly inscribed religious, civil, and military history, that an enlightened protector of archaeological studies may accumulate in a great collection the means effectively to explore this new historical mine, still almost virgin territory, to add to the annals of mankind the pages that time seemed to have stolen from us. May this new glory, for any institution eminently useful is also eminently glorious, be reserved to our great country.[12]

On 15 May 1826, Charles X signed the decree that marked the creation of a new gallery, which opened in late 1827 – the Musée Charles X. The decree ordered the restructuring of the existing Musée des Antiques, which would thereafter be divided into two sections, the first covering Greek, Roman and Medieval art, the second Egyptian and Oriental art. The decree stated that 'Mr. Champollion Le Jeune is appointed curator of the monuments that form the second division of the Musée des Antiques.'[13]

To mark the opening of the new galleries on 15 December 1827, Champollion published a guide, *Notice descriptive des monumens égyptiens du Musée Charles X*.[14] These 166 pages reveal the original contents of the first Egyptian gallery at the Louvre, listing 5,333 objects, with no illustrations. For the visitor encountering

Egyptian material for the first time, this guide would have been a precious aid to the exploration of the galleries. Because it was meant for visitors, the *Notice* only includes the objects on display, and therefore we know less about how many, and which, artefacts were kept in storage.

Champollion formed an entire national collection in a short time by acquiring objects that were already in European collections, rather than sending agents to collect them in Egypt, which had long been the custom for European museums.[15] The first group of objects came from his friend, Edmé-Antoine Durand, who had Egyptian artefacts in his private collection. The 2,150 Egyptian objects acquired from this collection on 2 March 1825 formed the nucleus of the future gallery holdings. Champollion was concerned that Durand was coveting the so-called 'second collection' of British agent and collector Henry Salt, which Champollion had his eye on too. In a letter, Champollion noted 'some good mummies' in what he had seen of Salt's collection. Champollion won out, acquiring the second Salt collection and adding 4,014 objects to the royal collection. In 1827, before the opening to the public, Champollion continued to add artefacts to the museum through acquisitions from private collections: the Brideau collection, the Denon collection (we'll look at this one in Chapter 4) and the entirety of the second Drovetti collection. Through these acquisitions, Champollion aimed to create 'un véritable musée d'objets égyptiens' (a true museum of Egyptian artefacts), which would present a variety of objects, displayed in an educational manner. Upon his return to Paris from Italy, Champollion had just under a year to arrange the new museum, with the inauguration originally planned for 4 November 1827.

Four rooms on the first floor of the Cour Carrée's south wing were assigned to the Egyptian section and separated from the Greek and Roman rooms by the Colonnade Room. The cohabitation did not go too well – at the time, classical art was considered far superior, and the curator of the classical galleries was not pleased that half his space had been usurped for the unusual art of the ancient Egyptians.[16] Fontaine wrote in his *Journal* about the two different sections, and noted:

> The gallery of King Charles X composed of two divisions occupies the entire wing by the river in the northern part of the great Court. The sitting room with columns, above the window, separates the two divisions, whose leaders, not unlike the rulers of this world, do not live in the most perfect and the best possible agreement. Each seeks to increase their own display, finding the space given to them too cramped. One would conquer the other and even dispossess him completely if he could.[17]

In the *Notice* written by Champollion in 1827, two rooms (the first and third) are designated as funerary rooms with artefacts related to embalming:

> We have assembled in these two rooms all the objects related to the embalming of human bodies. This practice, which was both religious and sanitary, was halted only after the establishment of Christianity in Egypt: embalming was more or less in demand, depending on the period or the importance of the individual. This art declined under Roman and Greek domination; the mummies made with the greatest care and study all belong to the pharaonic period and kings of the Egyptian race.[18]

*

Now we have set the scene, let's return to our murder mystery. To do so, we need to pay close attention to the Egyptian mummies in the *Notice*. Three Egyptian human mummies were in the initial collection when it opened in 1827: 'N.1 momie ou corps embaumé' (mummy or embalmed body), which corresponds to a male mummy; 'N.2 momie de femme' (female mummy); and 'N.3 momie d'homme' (male mummy). The description of the first mummy is rather lengthy, and Champollion names him Siophis in his guide to the collection.

Mummies were mentioned in a few visitor accounts, and two of these accounts are especially useful. Nestor L'Hote, who had himself travelled to Egypt and produced thorough documents and drawings, visited the new Egyptian galleries.[19] He wrote that 'in the two funerary rooms are the human mummies, the coffins of the mummies, funerary images, boxes and statues of wood, stelae of funerary manuscripts, etc.'[20]

Another visitor was Alexandre Lenoir, who wrote in *Examen des nouvelles salles du Louvre*:

> We owe to the generosity of Charles X a museum of antiquities that France was lacking. This new attraction draws the crowd in; the scholar, the studious man, the amateur, as well as visitors who are simply curious, all come here to pay tribute to the King, protector of the fine arts … See gallery Charles X, N.1 mummy of an individual named Siophis and N.2 that of a woman.[21]

Lenoir's account was published in early 1828, just a few months after the opening of the galleries in December 1827. At the time of his visit, either there were only two mummies left on display or he simply ignored the third one. The mummy referred to as Siophis (today named Pacheri) survived well at the museum (and, as we saw in the Prologue, is still on display today), but the

fate of the two other mummies is unclear – they do not appear in later museum accounts.

But two other small mummies are missing entirely from both visitors' accounts and the *Notice* written by Champollion. They are missing for a simple reason. At the time of the opening of the Egyptian galleries, they were lying only a few metres away from the Cour Carrée, where the new galleries were located. But they were out of sight entirely: they had been buried in the garden of the Louvre, facing the Church of Saint-Germain L'Auxerrois. Their journey to the afterlife, already altered by the opening of their tomb and their removal from their home country, concluded beneath the green grass of a French castle. While Frenchmen were celebrating the new-found splendour of Egyptian material culture inside a museum, they were also standing in close proximity to two Egyptian bodies that they had essentially caused to die a second time. A celebration of an ancient country's art and knowledge, and the desecration of its ancient people, all in the span of a couple of months.

These ancient remains were in the care of a museum dedicated to their celebration and display – a museum where such bodies were considered new and exotic things, but where staff were not familiar enough with what it takes to look after a mummy, in a climate very different from the one where their afterlives had been expected to play out. They were kept in such a way as to cause them to putrefy and decay, which would not have had happened had they been allowed to rest in peace in Egypt in the first place. These human remains were then quietly disposed of without ceremony or even a marker for their unexpected resting place.

These were not the first ancient Egyptian bodies to have been desecrated on European land. Champollion had discussed

similar cases of mummies that putrefied in a letter to Roger Gaspard de Cholex of June 1824, in which he advised on the conservation of mummies at the Royal Museum in Turin, Italy. He noted:

> There is indeed a type of mummy prepared either by injection, or with a liquid balm, which only survives a few months in the European climate, much more humid than in the catacombs where these bodies rested for so many centuries. The mummies of this kind quickly begin to decompose and release a fetid odour, which spreads to all nearby objects.[22]

Across Europe, individuals grappled with the same issue of decomposing mummies. Geologist and antiquarian John Woodward had commented on a mummy he had encountered in a private collection in England, stating 'I myself saw here a mummy, brought formerly out of Egypt that, after it had been for some time in our more humid air, began to corrupt and grow mouldy, emitted a foetid and cadaverous scent, and in conclusion putrefied and fell to pieces.'[23] The mummies at the Musée Charles X that had developed signs of decomposition were thus buried in the garden of the Louvre, next to Perrault's Colonnade, which is located at the easternmost façade of the Palais du Louvre. In 1830, at the same location, the bodies of those who died during the barricade of the Trois Glorieuses were also buried. Ten years later, the remains buried in the garden were transferred to the Colonne de Juillet at the Bastille. The mummies are thought to have been mixed with the contemporary remains and transferred as well, although this idea is speculative and may merely be an urban legend.

15 Augustin Régis, 'The Egyptian funerary room in the Musée Charles X', 1863.

16 'The Egyptian sarcophagus room at the Louvre', 1875–1899.

The sudden death of Champollion in 1832 created a period of instability for the museum. In 1855, just under three decades after the opening of the galleries, Egyptian mummies that had been taken from their tombs and brought back from Egypt all the way to Paris were already relegated to storage rooms. The updated guide notes that 'the unwrapped mummies and several good mummy cases have been consigned, because of lack of space, to a study room, to the second floor of the Louvre.'[24] The display of mummies remained largely unchanged until 1932.[25] While it has more Egyptian mummies on display today, in more than one department, the Louvre remains, in many ways, a museum with little consideration for Egyptian human remains, a museum of unwanted mummies.[26]

The unwanted mummies

In 1743, a mummy was brought to Cambridge University Library, where it did not receive a warm welcome. It was deemed 'a most unnecessary present for a University'. There is no longer any trace of this unwanted mummy.[27]

These various incidents of Egyptian mummies decaying and being buried or relegated to a bottom shelf are not isolated. From the very early days of Europeans collecting Egyptian mummies, whether for private collections or public museums, mummies have suffered all sorts of incidents. At the hands of collectors who had very little idea of what to do with fragile human remains, or institutions that quite simply did not care much about mummies, the remains of ancient Egypt have experienced quite a few misfortunes. Between the fantasy of owning a body from a foreign land and the reality of preserving an organic corpse, there is a stark reality: often bodies were

taken out of tombs on an impulse, and once they were back in Europe, no one knew what to do with them. Add to this a pinch of curses and imagination, and the issue of cramped museum stores, and you will find, from the fifteenth century up to today, collections and museums refusing, relegating and neglecting the human remains they collected.

As early as 1629, François-Auguste de Thou wrote in a letter to the French collector Peiresc that he had been offered a very fine mummy and wanted to bring it back to France, except for an irritating inconvenience: superstitious French sailors refused to take mummies aboard, because of anxiety about transporting dead bodies. They feared that mummies risked triggering 'extraordinary storms and sinking the ship'.[28] Not so long after, a man who had claimed these superstitions were quite ludicrous was forced to throw overboard the mummified head he was carrying with him on a sea voyage, having been accused of instigating a storm.[29] In 1816, the painter J. M. W. Turner visited Egypt and was gifted a mummy by the British Consul; worried that he would not be able to bring it back, he decided to keep the mummy in a box that looked nothing like a coffin. A decade later, a man equally worried he would not be able to bring back his mummy decided to cut its head off, so he would not be accused of bringing a full body on board. But the most curious story about a mummy and a sinking ship has to be the story of the British Museum's so-called 'Unlucky Mummy'.[30]

The Unlucky Mummy is, like our British Museum rotating mummy, a coffin and not a body. It was given to the British Museum by A. F. Wheeler in 1889, and it initially came from a tomb opened by French archaeologist Victor Loret a decade earlier. The mummy had been destroyed in order to extract the jewellery, and only the coffin, which had a female appearance,

was kept by the museum. A series of incidents were attributed to this very coffin. The case was so serious that two occultists were invited to the museum and proceeded to attempt to deliver the tormented mummy's spirit from its coffin, receiving great press coverage. One of the many extravagant, and varied, stories attached to this single coffin is that of a very unwanted mummy.

The story goes that in the late 1890s, four young and wealthy Englishmen visiting Egypt were offered a coffin that contained the remains of a princess. One of them decided to buy it and take it back to his hotel; shortly after, he disappeared in the desert and never returned. The following day, one of the three remaining men was accidentally injured and had to have an arm amputated. The third man, upon his return to England, discovered that he had lost his entire fortune. And the fourth and final man fell ill and lost his job. The coffin was then passed to a Londoner, whose fate was not much better. Three members of his family died in a car accident and his house caught fire, at which point, he decided it was time to donate the mummy to the British Museum. But of course, he passed the curse along with the mummy/coffin, and barely had he arrived at the courtyard of the museum before the mummy was causing chaos. So many people were hurt or died in the following days that the mummy was relegated to the basement of the museum. A mummy abandoned in a storeroom … a story we have heard before!

There are many stories attached to the Unlucky Mummy, but some of the most curious relate to its involvement with the sinking of none other than the most famous ship in the world: the *Titanic*. The connection? According to one story, a passenger had the ill-judged idea of mentioning this mummy over dinner, thus cursing the ship and causing it to sink. In another, the mummy itself was on the *Titanic*, brought aboard by a man

from Southampton. And in yet another, the mummy survived the sinking, and the owner, terrified by what had just happened, refused to keep it and sent it back to its former owner; later she went on to cause another boat to sink!

The various stories of the Unlucky Mummy tell us that it was very much an unwanted mummy – and may have caused quite a lot of chaos on its way. But like the story of our rotating coffin, these stories are also of a mummy taken out of its coffin and subsequently destroyed irreparably, and of European fantasies and anxieties around what mummies could do in revenge for their displacement and mistreatment. It seems as if, on some level, there was an understanding that the mummies, if sentient, would be entitled to some righteous anger.

One man is central to this story of the Unlucky Mummy: Wallis Budge. He was a curator at the British Museum at the time, and published extensively.[31] Budge was a central promoter of a key piece of museum propaganda: the claim that Europeans are better equipped to look after ancient Egyptian artefacts. Keen to defend not only his right, but also his duty, to loot and export Egyptian human remains and artefacts, Budge wrote that 'the main looters of tombs, the great destructors of mummies, are the Egyptians themselves'.[32] He insisted that the ancient Egyptians – the mummies – would no doubt have found the British Museum a much more favourable environment in which to live out their afterlives than Egypt. Budge repeatedly insisted that the ancient Egyptians wanted their names to be remembered, and their environment to be favourable, and to this Englishman, no place was more promising than a national museum in Europe. And yet, these stories of decay, destruction, neglect and bizarre displays tell us a rather different story: what if the European museums were not, in fact, an ancient Egyptian

dream home? Accepting this would have required of him and his contemporaries to concur that the European museum is a problematic, and often rather traumatic, place for both ancient and modern Egyptians. Sadly, he was nowhere near this train of thought, and neither are many Europeans today.

The stories of unwanted and discarded mummies are not confined to the past.

*

In the suburbs of Paris, a waste collector is sorting through objects at the local collection centre. Oddly, one of them is shaped like a coffin. He has worked in a cemetery before, and he knows immediately: this is not just any abandoned object. We are in 2010, and the waste collector brings the small coffin to the town hall of Rueil-Malmaison, in the western suburbs of Paris. Someone had cleared out one of the old houses that make up the landscape of this historic city, and without realising it brought to this place an object linked to the city's Napoleonic history: a wooden coffin.

There is someone inside the coffin: the unwanted mummy of a small child.

After this sordid discovery, the coffin and the mummy were taken for inspection to the Musée du Louvre in Paris. Following a fundraising campaign by the city of Rueil-Malmaison, the mummy was restored at the Centre de Recherche et de Restauration des Musées de France. It was identified as that of a small child of about five years old, named Ta-Iset. The young mummy was put on display at the local history museum of Rueil-Malmaison (Musée d'histoire locale) on 21 May 2016. When I visited the museum on that day, I wondered how a child, mummified at great cost in ancient Egypt, ended up first

in a bin, and then by chance in a small room in a museum in the suburb of Paris.

In the next room, I found a clue to why this might be.

The room next door has on display an astounding 1,600 tin soldiers representing Napoleon Bonaparte's Grande Armée. Their presence in a small museum that now contains an Egyptian mummy is not accidental. Rueil-Malmaison was the home of many of the men who engaged in the Napoleonic invasion of Egypt in 1798–1801. Various hypotheses have been put forward regarding the person who took the mummy of Ta-Iset from Egypt and had it displaced to Rueil-Malmaison. Among the suggestions, Col. Varin-Bey has been considered a prime candidate. He took various positions in Napoleon's army: first a soldier in the Italian campaigns, he was then promoted General of the Army of Egypt and became the director of the cavalry school in Cairo. Upon his return, General Varin-Bey lived at 37 rue de Marly in Rueil-Malmaison. There is no significant proof that he had this specific mummy, but documents attest that he had a collection of artefacts removed from Egypt.

This abandoned child will now spend their afterlife in a suburb of Paris, in a city that is not unfamiliar with the collection and display of Egyptian mummified bodies, as we are about to discover in the next chapter, via a curious story about a mummified ... foot.

Chapter 4

The mummy's foot

'If you look closely, right here, you'll see the toes poking from the wrappings. Can you see them? Just like ours!' I am at a museum attempting to persuade visitors that these mummies are real people, by pointing at mummified feet.

It is the middle of the afternoon, and I am on my third tour of the day. The room is rather quiet. I close my eyes and gather my thoughts, while individuals start to assemble in front of the sign that reads 'Journeys of the mummies'. It is Refugee Week, we are back at the Leicester Museum & Art Gallery, and I am here from the Science Museum in London on a public outreach event, with one aim: making sure that people leave this room thinking about Egyptian mummies a little differently. We have met the Egyptian mummies that inhabit this museum in Chapter 2, and on this occasion one of them has caught my attention: it is the mummy of a man who has his feet poking from the ancient wrappings, leaving the lines under his toes and his finely cut nails visible.

Visitors don't know it yet, but this is not their usual mummy tour. We are not here to talk about ancient Egyptian funerary practices or the art of embalming; neither are we here to talk about treasures or mysteries. Instead, we are here to contemplate these bodies, trapped in glass cases in a museum in the

middle of the East Midlands. We are here to question why they are here, but also why *we* are here.

The third tour begins.

The tour that day asks one big question, 'What makes us human?' A label I composed for the occasion is Blu Tacked to the case above the mummy of Bes-en-Mut. It reads:

> It is easy to think about mummies as objects, because they are wrapped and don't look like real people at first. But if you look closely, you might notice that you can see this mummy's toe poking through the bandages. Often, when you see the feet, it's because mummies were displayed standing, and it damaged the wrappings. Seeing skin and nails reminds us that they were real people like us![1]

There is something undeniable about the parched skin, the fine lines, the dry nails: the materiality of humanity in the flesh. A testament to a body that has survived centuries. I observe. I see people going around the case, crouching to see the foot more closely, pointing out: 'Look, we can see the fingerprints!'

That day in Leicester, the home of the discovery of finger-printing, these visitors were engaging with the curious idea that these wrapped things they were encountering were not just entertaining shapes in bandages but the bodies of real people, with actual fingers and toes… The tour ended with a curious story about Ramses II's passport, and the visitors left the room talking amongst themselves about dead people's fingerprints and a passport issued for a long-dead king.[2]

There is a precedent for this interest in mummies' feet. While Bes-en-Mut's mummified foot was only just poking through the wrappings, museums have been collecting and displaying detached body parts for a while. Mummy heads on cushions, hands displayed against a wall or lying covered in jewellery,

mummy feet in glass bells: the museum is a store of uncanny body parts. They are on display, they are in stores, and sometimes they exist only in writing, long lost in transfer and in disorganised storage facilities. But body parts rarely become body parts on their own: they are the result of the actions of individuals who break apart bodies and keep the fragments that are useful to them, whether for medical, antiquarian, scientific, racist or even aesthetic purposes. Each of these mummified body parts has its own story, and these stories tell us more about modern Europeans than they do about the isolated remains living a degraded second life in museum stores and inside display cases.

The public viewing of the recent dead is not something that is familiar in Europe today. And yet visitors gather in their thousands to see the mummy rooms of the British Museum, and other European museums. In their galleries, museums display full Egyptian mummies, sometimes unwrapped Egyptian mummies, and sometimes separate body parts. At the Louvre in Paris, for example, you can see a gilded mummy head on a cushion, while at the World Museum in Liverpool you can see a hand clearly torn away from its body; both are in recently refurbished galleries.

In this chapter, I want to take you to the Louvre in Paris, with a detour to Egypt's Valley of the Kings, to introduce a singular man. This man kept a mummy head in his office and collected a mummy's foot that inspired work by a famous writer. We will then look to London, where an unusual, dissected mummy foot still resides in a large medical museum, and then we will go back to the Louvre, where two mummy heads are receiving very different treatment. These are stories about feet and heads that have been taken from Egypt as souvenirs and political trophies, and they are a stark reminder of a strange European fascination with the 'other'.

The making of the mummy's foot

The director of the Louvre in Paris is posing in his office, surrounded by his favourite objects. Amongst them is a mummified head under a glass bell. But his most notorious object? A mummified foot that inspired a curious story.

The man in the engraving is standing with his left hand placed on an adjacent table, on which are arranged artefacts. Behind him is a cabinet, containing more objects that are hard to distinguish. On top of the cabinet is a mummified head inside a glass bell, etched with great care, and a sculpture of the Egyptian god Anubis. On the floor, two large objects are positioned so close to the man in question that they tell us clearly that this scene is staged. A large sculpture of Isis and a Greek vase are positioned far too vulnerably for the two highly valuable artefacts they are – they would have been kept somewhere much safer than this. But this is an artificial set-up, aiming only to showcase an important man's art collection. The location of this scene remains uncertain.[3] We do know that in 1813, the man in this picture lived at Quai Voltaire in Paris, and it is likely that this is where he posed for the picture. The items in the image were from his personal collection, rather than the museum he directed: the Musée du Louvre.[4] The artefacts and artworks represented were carefully selected to produce a snapshot of his collecting activities and his career more widely. This is confirmed by the fact that these artefacts were also included in his own publication, *Monuments des arts du dessin*.[5]

The man standing in his office is Dominique Vivant Denon, probably the most neglected and yet the most curious and prolific mummy collector in Europe. If the extravagant life of Denon is often unfamiliar to them, many visitors to Paris will have encountered his name: the Denon Wing of the Musée du Louvre is none other than that of the Mona Lisa and the

Winged Samothrace, the most crowded area of the Louvre at any time of the year. But not many would link the Denon Wing to the man himself, and fewer still to some of the collections stored in the basement of the largest museum in the world. This is the story of a man who desperately wanted to collect an Egyptian mummy, a man who embarked on the French expedition to Egypt as the oldest, and yet one of the most adventurous, members of the scientific team. It is also a story of disembodied heads and feet – why they have fascinated us for so long and what it means to encounter them in museums today.

We are going to start this story in 1798, in the Valley of the Kings in Egypt. Denon is the oldest member of the scientific commission that accompanied Napoleon's military expedition. He is not an archaeologist, or a mineralogist, or a naturalist, like many of the men on the scientific commission. In fact, Denon, who lived an eclectic life, is rather hard to define.[6] But one thing is for sure: this expedition transformed his place in society, and especially in French museums. Denon is a versatile and multitalented person: by this point he has had a successful diplomatic career, working in Sweden and Switzerland, but most notably in Naples, where he was a *chargé d'affaires* for seven years. There, he worked on another skill of his: the drawing and collecting of ancient monuments. In 1787 he was admitted to the Académie Royale de Peinture et de Sculpture. But it was his attendance at the salon of Joséphine de Beauharnais that changed the trajectory of his life the most, allowing him to meet her husband, Napoleon Bonaparte, who invited him to join the French expedition to Egypt.

Following his return, Denon would go on to be appointed the new head of French museums, and head of the Musée Napoléon (the Musée du Louvre), a position he held until 1815. For the museum, and for himself, Denon built up a monumental collection

of artworks and artefacts. He set up restoration workshops in the west wing of the great gallery and developed a large-scale inventory project. After the exile of Napoleon, however, the collections were dismantled. But Denon was not just a political figure at the helm of a cultural institution: he was also a skilful engraver for his own publications, as well as the author of a successful erotic novel and numerous erotic etchings. A very colourful character, indeed!

Let us return to his vast personal collection, which, of course, included Egyptian mummies. How did Denon end up with such a large collection of Egyptian material? As it turns out, going to Egypt had been a goal of his for quite a while, as he recalled in his memoirs: 'All my life I had longed to journey to Egypt, but time, which wears all, had squandered this wish. When the expedition, which would make us leaders of that land, took place, the possibility of completing the venture reignited my desire for it.'[7] The expedition in question would not quite make the French 'the leaders of that land', and it would also fail to get Denon the full mummy he really wanted to bring back from Egypt. But upon his return he did have a substantial collection of Egyptian artefacts, and the sale of his collection after his death included 482 Egyptian objects.[8] In Egypt, Denon not only visited the Delta, where the Commission was located, but also travelled throughout the country and visited Upper Egypt, where he made intricate drawings, took lengthy notes and collected antiquities. His drawings were used in the *Description de l'Égypte*, Napoleon's publication, which appeared between 1809 and 1829, edited by Edmé-François Jomard.

Denon's first encounter with mummies in Egypt was not with human mummies but with animal ones. In Saqqara, a chamber containing over 500 specimens of mummified ibis had been discovered, and Denon opened one of them with naturalist Étienne

Geoffroy Saint-Hilaire. Denon had always wanted to visit Upper Egypt, and he finally reached the Valley of the Kings in 1798, where he found a very peculiar object. A mummy's foot.

He describes his new acquisition as follows: 'It was without a doubt the foot of a young lady, a princess, a charming being, of which shoes had not altered the shape, and of which shape was perfect; it felt like obtaining a favour, and made me a for-bidden lover in the lineage of the pharaohs.'[9] It is remarkable that the viewing of an abandoned, torn-apart human foot did not startle Denon; quite the contrary. He was quite convinced that his mummy – of which he only had a foot – was simply beautiful. But his mummy was also very much incomplete. His quest for an intact mummy was ultimately unsuccessful:

> I was brought mummy fragments: I would promise anything to have some complete and intact ones; but the avarice of the Arabs deprived me of this satisfaction: they sell in Cairo the resin found in the entrails and skulls of these mummies and nothing can pre-vent them from taking these out.[10]

Denon left Egypt without the mummy he coveted but brought back enough artefacts and notes to produce two very suc-cessful publications. *Voyage dans la basse et la haute Égypte* (1802) is a recollection of his journey, and *Monuments des arts du dessin* (published posthumously in 1829) is an art-oriented publication that includes sections on ancient Egypt. Both publications were personal, the first a travel journal and the second an overview of his own private collection. *Voyage dans la basse et la haute Égypte* proved hugely popular and made Egypt appealing to a general French audience. It appeared a few years before the publication of Napoleon's *Description* and very much influenced its develop-ment and reception.

Denon's collection of Egyptian mummies and mummy parts was surprisingly extensive considering his non-specialist background. He had a varied interest in human remains, and his collection included examples of hair and bones. The catalogue of Denon's objects – created at his death for the purpose of selling the entire collection – includes four coffins; six mummies; two mummy heads; two hands; and, naturally, one foot.

But what happened to the foot back in France?

In 1817, Denon is in Paris and receives a visit from novelist Lady Sydney Morgan, who recalls:

> I found in this curious collection several objects which could not be classified: a perfectly preserved human foot, which may once have been part of the charms of amiable Beatrice or beautiful Cleopatra. Two thousand years at least have passed since they rested against the cushion of a couch or walked softly in the orange groves of the Delta. It is this pretty little foot which Mr. Denon described during his journey, and which is without doubt, due to its elegant shape, the foot of a young lady or a princess.[11]

Lady Morgan confirms that the foot was brought back from Egypt and that Denon gave it pride of place in his collection, which was regularly visited by members of high society. Her recollection of this encounter is quite similar to Denon's initial impressions: she imagines it to be the foot of a woman, possibly because of its fine shape, but of not just any woman. A foot so remarkable, that survived centuries to land in the French capital, could only belong to a remarkable woman – she cites the famous names Beatrice and Cleopatra – or at the very least to a princess. Lady Morgan imagines the life of the woman, wandering elegantly in the Delta groves of Egypt.

Her imagination makes the foot *come to life*.

The mummy's foot comes to life

The viewing of the mummy's foot in Denon's collection inspired a French writer to create the story of an ancient woman who visits the French capital. But she's not here to explore the city. No, she's looking for her long-lost foot.

17 The mummy foot in Denon's collection, an illustration made by Denon for his own publication.

An antiquarian enters an antique shop in Paris searching for a novel paperweight. He's not looking for just anything. No, he wants one that is different from any other paperweight normally sold in shops. Amongst an array of objects, he notices a small foot, which he believes to be of marble. Upon closer inspection, he realises that the foot is, in fact, that of a mummy. The antiquarian describes the foot as follows:

> I was surprised at its lightness. It was not a foot of metal, but in sooth a foot of flesh, an embalmed foot, a mummy's foot. On examining it still more closely the very grain of the skin, and the almost imperceptible lines impressed upon it by the texture of the bandages, became perceptible. The toes were slender and delicate, and terminated by perfectly formed nails, pure and transparent as agates. The great toe, slightly separated from the rest, afforded a happy contrast, in the antique style, to the position of the other toes, and lent it an aerial lightness – the grace of a bird's foot.[12]

The foot, the owner of the shop explains, belongs to a princess named Hermonthis. The protagonist decides to acquire this mummified foot, which he deems highly original; in fact, he decides immediately that every honourable man should have such an object in his collection. After an evening out drinking a little too much wine, he returns home and falls asleep. He starts dreaming, and his dream is unusual. While he is still dreaming, the antiquarian is awakened by the sound of the mummy foot wriggling, and soon after by another sound similar to someone hopping on a single foot.

The figure of an elegant woman appears behind the curtains with a peculiar characteristic: the woman is missing a foot. After she explains that she cannot regain her foot because

the antiquarian has acquired it, and tells him how much sorrow this is causing her and her father – none other than the pharaoh – the protagonist graciously returns the foot to its original owner. The woman, grateful, invites the man to meet her father, allowing the antiquarian to travel back in time and to enter a netherworld in which all mummies throughout ancient Egyptian history are gathered. There, the antiquarian, who had already fallen in love with the graceful woman, asks the pharaoh for her hand in marriage. The latter is surprised by such a demand, mostly because of the thousands of years' age difference between the two characters! The antiquarian eventually wakes up from his reverie, back in his contemporary reality. Although the dream ends, the story is kept on hold: while the man is back in his room, waking up from his dream, he notices that his paperweight is missing, and in its place is an Egyptian scarab...

This short story is 'The Mummy's Foot', or 'Le pied de momie', published by Théophile Gautier in 1840. Gautier, one of the most admired writers in France, had visited Denon at his house and seen the delicate mummified foot that Denon had brought back from Egypt. But while Denon speculated about the lives of the mummies he had collected, Gautier took these reveries to the next level and explored much more deeply the question of who might be under the wrappings: in this case, as he chose to believe, a beautiful, graceful woman.

This was far from the last time Gautier would think about Egyptian mummies. Between 11 March and 6 May 1857, he published *Le roman de la momie* in twenty-one instalments in *Le moniteur universel*.[13] The Prologue focuses on a young British aristocrat, Lord Evandale, and a German Egyptologist, Doctor Rumphius, who discover an untouched tomb, aided by a

Greek merchant, Argyropoulos. They believe they have found the unviolated tomb of a pharaoh, but upon opening the sarcophagus they find instead a female mummy of outstanding beauty, named Tahoser. They decide to unwrap the mummy, and when faced with the unwrapped body, Lord Evandale becomes lost in thought: 'Strange sensation, indeed, to be face to face with a glorious human being who had lived when History and her records were vague and misty.'[14]

Gautier, who made encounters with the person behind the wrappings a significant focus of his writing on mummies, attended an event in 1867 that his fellow writers found rather dehumanising: the real-life unrolling of a female mummy.[15] We will explore this event in the next chapter. Fantasies and fictions aside, the unwrapped mummy was a stern reminder that the bodies under the wrappings, perhaps once freely wandering the orange groves of the Delta as Lady Morgan had envisioned, were now the prisoners of the very men in Europe whose imaginations and passions for collecting they had inspired.

The heads in our museums

We are back at Quai Voltaire, and the man who had once posed proudly near a mummified head in a glass bell jar is now leaning on a table, attending to a complex set of tasks: observing, drawing, discussing and dissecting a body.

We are not quite sure what happened to the foot Denon acquired – all we have left is the engraving in his publication. However, we do know what happened to the other mummy parts and a full mummy in his collection. On his return from Egypt, Denon was still missing the one artefact he truly coveted: a full Egyptian mummy. At the death of Joséphine de

Beauharnais and the sale of her collection in 1819, Denon finally achieved his long-held goal. The catalogue of this sale indicates 'two mummies from Egypt each contained in a case of walnut wood five feet and half; the head of a female mummy, three ibis mummies inside clay vases'.[16] From this sale, Denon acquired one of the full mummies together with its case. This mummy had been gifted to Joséphine de Beauharnais by Horace Sebastiani, who had travelled to Egypt on a diplomatic mission in 1802. At the same time, Denon also acquired the mummified head of a woman.[17]

Denon did not merely acquire Egyptian mummies as collectible objects: he chose to unwrap the full mummy at his house, in the presence of a small audience. The minutes ('procès-verbal') of the unrolling were recorded over six pages and included in Denon's *Monuments des arts du dessin*.[18] The report of the unwrapping was uncommonly detailed for the time. However, despite the medical undertone of the report, a biased fascination for the female body is evident in his penchant for seeking out perfection in all its characteristics. For example, he noted that a more thorough examination demonstrated that 'the opening of the mouth was of proportion as elegant as it was gracious', and he repeatedly stressed the 'anatomical perfection' of the mummy. This attitude towards the mummified female body may seem strange and inappropriate today, and yet it was very common in writing at the time. The fetishisation of the female mummy under the male gaze was prevalent in writing, and was not limited to fiction.[19]

Denon did leave us one particularly informative item: the drawing that he made of the sequence of the unwrapping. It is not unlike seeing a virtual unwrapping on a screen today, with each stage revealing more details. Denon recorded six steps and

published them in *Monuments des arts du dessin*. The six stages are: (1) 'a mummy, as it was found taken from the box where it was kept', which corresponds to the pre-unrolling stage; (2) and (3) 'removing the wrappings', which together correspond to the first stage of unwrapping; (4) 'it still retains wrappings, but we can distinguish its shape and the position given by the embalmers'; and finally (5) and (6) 'entirely uncovered', once the mummy is fully unwrapped. And yet, if you pay close attention to this illustration, you will see that the sequence appears to be in the opposite order. Indeed, what you see if you read this image from left to right is a mummy being wrapped, rather than one being unwrapped.

In addition to Denon's drawing – and again this is a unique occurrence for the time – is an engraving that depicts the scene of the unrolling. The engraving, produced by John Cheney, is entitled *La séance de débandelettage d'une momie chez Vivant Denon* (*The Unwrapping of a Mummy at Vivant Denon's House*). The scene is located at Quai Voltaire – this is obvious from the view outside the window of one of the Louvre buildings. Denon is represented in the centre of the room, as the instigator of the opening, aided by two other men. The presence of an audience was confirmed in Denon's report of the unrolling, in which he recalled a moment when the smell of the resin covering the wrappings of the mummy was too strong for the spectators.[20] This is an interesting example of the sense of smell being associated with mummies: something you might reasonably expect, but that we have lost in displays today.

After the unrolling, Denon kept the unwrapped mummy and displayed it for a while standing up in its original wooden box. This was indicated in the catalogue for the sale of his collection after his death: 'a female mummy entirely unwrapped and placed standing in a case with glass lid'.[21] During the sale,

the mummy was purchased by a man called Dominique-Jean Larrey, a surgeon in Napoleon's army who had participated in his expedition to Egypt.[22] Larrey donated the mummy to the Louvre on 6 October 1832, together with the box.

It remains in the Museum's stored collection today.

There were two heads in Denon's private collection. The first we have seen already in the engraving of Denon posing in his office. A close examination of the engraving indicates that it is the male mummy represented in the *Description de l'Égypte*. The origin of the second head in Denon's collection can also be traced. On his return from Egypt, Napoleon Bonaparte gave his wife, Joséphine de Beauharnais, a souvenir like no other,

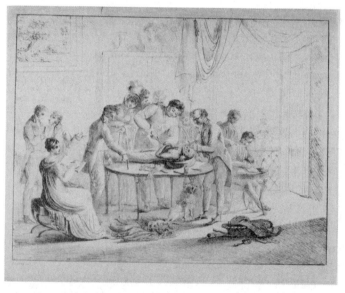

18 Harriet Cheney, 'Unwrapping the Mummy', before 1825. Denon unwraps a mummy at his Paris apartments.

one that she would remember and keep for her entire life. The curious gift was the mummified head of a woman. This head was very striking. It had a thin nose and thick wavy hair that had survived centuries, coloured with henna. It was so striking that it was shown in an illustration in the *Description de l'Égypte*. This mummy's head had been unearthed in Thebes in 1799 during the French expedition to Egypt, and had been displaced and acquired for the collection of Joséphine de Beauharnais in Malmaison. The Egyptian female mummy head was eventually listed in the catalogue of the sale of Denon's collection as no. 246. It was later acquired by Nils Gustaf Palin, who donated it to the Louvre in 1859. It is not on public display.

Denon's legacy lies not just in his extensive collection of mummies – of which we have an astonishingly precise account – but in the diversity of his engagements with mummies. Through his encounters, his collecting activities, his drawings and his physical interventions, Denon challenged the classification of the Egyptian mummy as a body and as an object. He demonstrated that the opening of the mummy was not incompatible with the desire to keep mummies as objects of collection, and that the objectification of the mummy through the process of collecting and unrolling did not prevent one from having a transcendent encounter with the individual behind the wrappings – seeing a beautiful woman in a long-dead foot, for example. And yet, his collecting is not without problems. His obsession with the ownership of human remains and his tendency to pose with severed heads echoes the behaviour of other men of the same century, who posed with trophy heads from other countries.[23] The ownership of heads from other cultures, while not an uncommon habit for powerful men at the time, is never a neutral practice.[24]

19 *Description de l'Égypte*, ed. Edmé-François Jomard, 'Thèbes, Hypogées, Plate 49: profile and face of a male mummy', 1812.

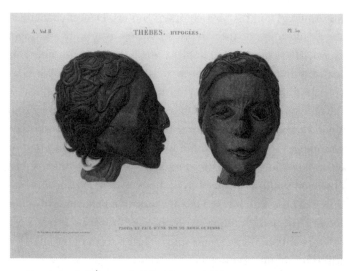

20 *Description de l'Égypte*, ed. Edmé-François Jomard, 'Thèbes, Hypogées, Plate 50: profile and face of a female mummy', 1812.

The mummy's foot

You will have observed that two of Denon's Egyptian mummies were eventually donated to the Musée du Louvre – the female mummy head and the full mummy – while the male head and the foot are no longer accounted for. The full mummy was put on display for a short time, but it was later deemed unfit for public viewing and removed.[25] The head is not on display either, possibly for a similar reason. And yet, if you visit the Roman Egypt galleries of the museum today, you will come across a mummified head on display.[26] It is unprovenanced and dates to the Roman period in Egypt. It bears some resemblance to the head in storage: it has preserved curly hair and is in an impeccable state of preservation, although the one on display has striking gold leaf adornments on the face. Layers of gold have been laid on the face, a practice specific to the Ptolemaic and Roman periods.[27] A face covered entirely in gold is rare, and is thus enticing for public viewing. As a result, today, if you wander the recently renovated rooms of Roman Egypt at the Louvre, you will come across the disembodied head of a Roman person, laid down by a curator on a little cushion, set up for public viewing.

A head without its body.

Museums rarely discuss the heads in their collection; and yet they display them, detached body parts that often have disturbing stories to tell. And while heads from other countries have received a lot of scrutiny, and have often been taken off display, Egyptian mummified heads remain in museums across Europe. There was not much discussion of how these heads became detached from their bodies, why we store them and how we feel able to display them – that is, until one important exhibition asked these very questions.

On 2 October 2017, University College London (UCL) opened the exhibition *What Does It Mean to Be Human? Curating Heads at UCL* in the Octagon Gallery, at the heart of UCL's main campus. Central to this exhibition – and much of the media attention – was the display of the head of Jeremy Bentham and the examination of that of Flinders Petrie, two central figures associated with the university.[28] Bentham died in 1832 and insisted that his body be preserved as an 'auto-icon'.[29] It has been on display at UCL for most of the past 150 years – except for his head, which suffered from poor preservation. But for this exhibition, it was the head that went on public display, without the rest of the body. The exhibition went a step further than the sensational display of Bentham and addressed the problematic questions of the history of collecting human remains, as well as UCL's ties with studies of racial classification and other pseudo-scientific measurements, including eugenics.[30] At the heart of these problematic studies were ancient Egyptian heads. Two were on display, from the collection of the Petrie Museum of Egyptian Archaeology: a mummified gilded head (UC31698) and a skeletal head (UC31176), with links to UCL's history of studies in racial classification. Both heads were acquired or excavated by Flinders Petrie during his time at UCL. These heads are significant because Petrie was heavily involved with eugenics and worked closely with pioneers Francis Galton and Karl Pearson – we will return to these studies in Chapters 6 and 7.

The title of the exhibition, *What Does It Mean to Be Human?*, developed into an important theme throughout: what does it mean to display human remains? This is the same question that we were asking at the beginning of this chapter, in the Leicester Museum & Art Gallery. Throughout the exhibition, curators engaged further with questions of display and ethics by directly

probing public opinion on the display of human remains. Near the mummified head of an Egyptian woman, the label read: 'Egyptian mummies are found in thousands of museums worldwide. Does it matter that ancient Egyptians would be horrified by this?' Aside from exploring how human remains should be displayed, the exhibition asked which stories museums should tell.

What we see in museums is the result of a series of actions: collecting activities, studies, curatorial choices, narrative choices and politics. The head on a cushion on display at the Musée du Louvre is the result of a series of such choices. While the head brought back from Egypt by Napoleon, or the unwrapped mummy from Denon's collection, have been removed from display, this gilded head has been chosen for display, for aesthetic reasons. It has a story, but it is not one that the museum shares.

The onion, the foot and the museum

There is a foot on display at the Hunterian Museum in London, under a cloche. It has a curious element to it: an onion is attached to the sole of the foot. It belonged to the first Egyptian mummy to be medically dissected in England.

The mummy's foot was not just a subject of curiosity for collectors like Denon, or a subject of fantasy for writers like Gautier – it was also of interest to medical practitioners. For this, we have to go back in time a little, but it is a story that is worth exploring: the story of a foot that survived a medical autopsy. We are in 1763, about to witness the first medical dissection of an Egyptian mummy in Britain, or at least the first one of which we have a record. It took place on 16 December 1763

at the house of John Hadley, in the company of important men: Dr Wollaston, Dr Blanshard, Dr Hunter, Dr Petit, the Revd Mr Egerton Leigh and Mr Hunter. Because we know that anatomists William Hunter and John Hunter were there, we can assume that the event was asserted to be for the advancement of medical and anatomical science. William Hunter was already well established as a practitioner in London, and in 1764 he would go on to become physician to Queen Charlotte. His brother John had just returned from the army, and would set up his own anatomy school in London the following year – you will remember them from Chapter 1.

This particular dissection of an Egyptian mummy was very important in considering the Egyptian mummy as an anatomical 'specimen' that could offer clues on the mummification process – a medical focus we have already explored in Chapter 1.[31] But something about its afterlife in London makes it worth exploring further. John Hadley was a professor of chemistry and a Fellow of the Royal Society. The mummy had been lent to him by the Royal Society to 'examine the manner, in which this piece of antiquity has been put together', and to compare the findings with the texts of Herodotus, Diodorus Siculus and Pliny.[32]

This particular mummy had already been described in Nehemiah Grew's *Musaeum regalis societatis* as 'An Egyptian mummy given by the illustrious Prince Henry duke of Norfolk. It is an entire one taken out of the royal pyramids. In length five feet and 1/2.'[33] Grew wrote at length about Egyptian mummies, and his views of what mummies really are were quite eccentric by today's standards. They reflected a contemporary mythology about ancient Egyptian funerary practices. For example, he noted that 'The way of embalming amongst the Egyptians,

was by boiling the Body (in a long Cauldron like a fish kettle) in some kind of liquid Balsam … much after the same manner, as the sugar doth, in the conditioning of pears, quinces, and the like.' Yes, Grew thought mummification was akin to preserving fruit!

Hadley's dissection of the mummy did not produce significant new findings on mummification itself, but it remains an important moment in this history of mummy studies, as the first detailed account of a mummy dissection in England. It is also quite remarkable for the drawing Hadley himself made of the foot. On this drawing, something catches the eye immediately: an onion is attached to the foot! It is unclear if it related to some rituals in ancient times (there are few other examples) or if it grew on the foot through time, but it certainly caught the attention of Hadley and his audience.

In 2016, I was walking for the first time through the rather impressive and intimidating Hunterian Museum at the Royal College of Surgeons in London. It is a museum of preserved human remains, and one that has come under increasing scrutiny over the years for its display of body parts, its representation of disability and illness, and also controversies about consent. It closed for major refurbishment in 2017.[34] I was walking around the main room and heading towards the bookshop when something caught my eye on the left wall. There was something under a glass dome that looked eerily familiar.

A mummy's foot.

But this was not just any foot. It was *the* mummy's foot. I had, by complete chance, encountered the mummy's foot with the onion from the dissection at Hadley's house. As it turns out, the foot was retained by John Hunter, who had participated in the physical act of dissecting the body and had kept it for his

Phalos. Trans. Vol. LIV. TAB.I. p. 9.

1. *The Bulbous root*
2. *The part of the filleting which enclosed the root with the shining skin adhering to it*
3. *The spiral lines of the skin*
4. *The Tendons of the Peroneus Antieus & Posticus*
5. *Some of the Ligaments of the Tarsus*

21 Mummy foot in John Hadley, 'An Account of a Mummy, Inspected at London 1763'.

personal collection. Hunter's collection was acquired by the City of London in 1799, and it was presented to the Company of Surgeons and deposited in what is now the Hunterian Museum. The mummy's foot was on public display until the museum's closure. It was displayed standing, on a wooden mount, with the bulb visible; the label mentioned Hunter briefly, with no further explanation.

The mummy's foot

As I looked at this mummy's foot under its glass dome, displayed in a similar manner to the mummified head in Denon's collection, I wondered how many visitors know how it came to be here, all alone: a foot that is the only remnant from a British medical dissection of a non-British body, so easily taken from its country and displaced to London. Just as Denon did not find a foot by chance (someone must have torn it from its body), this foot is not here by chance.

Heads and feet in museums are not just uncanny objects. They each by necessity have stories of how they came to be detached from their bodies and displayed in a museum – some military, some medical, some perhaps accidental or natural, but all involving a fundamental lack of respect for their status as the remains of human beings. These are stories that most museums are not yet ready to tell.

Chapter 5

Mummies unrolled

The year is 1867, and two brothers are staring, quite puzzled, at the grotesque spectacle taking place in front of their eyes. There is a dead woman standing on a table, shrouded and spinning. Death in a bundle.

It is late May, and the elite of the city are attending the Exposition Universelle de Paris. A peculiar event has been advertised as the central entertainment of the show: the unrolling of an Egyptian mummy. The mastermind of this event is French archaeologist Auguste Mariette, who has been charged with the creation of an Egyptian building for the Exposition.[1] Mariette is the most famous Egyptologist in the country at this time, and the central figure of the expanding French control over ancient and modern Egypt.[2] He took the role of 'directeur des antiquités égyptiennes' (Egyptian antiquities' director) in 1858, at times supervising thirty-seven digs simultaneously, and overseeing all discoveries in the country. Mariette very much instigated the French monopoly on Egyptian antiquities, a mere fifty years after Napoleon's first attempt. The presence of Egypt at the Paris Exhibition is important: with the impending opening of the Suez Canal in 1869 it sends a clear message about

French political ambitions. An Exposition Universelle is, after all, designed to showcase power.

To set the scene, an Egyptian temple, complete with alleys of sphinxes, has been built according to drawings made by Mariette himself. An *okel*, a covered market on the first floor, hosts a collection of human remains, including a staggering 500 skulls of ancient Egyptians and 12 complete mummies. The mummies were unearthed by Mariette at Deir el-Bahari and brought to France especially for the exhibition. Mariette recollected in a letter:

> I managed to save six fine mummies … none of them have been touched, and you will see them as if they had just emerged from their mothers … If it pleases him, His Majesty the Emperor, our noble leader, will be able to attend in person to the unrolling of these interesting subjects of the pharaohs.[3]

On 27 May, Mariette embarked upon the unrolling of one of the full mummies. This took place in front of an audience of some of the most renowned writers of the time, including Alexandre Dumas *fils* (son of the author of *Les trois mousquetaires*); Maxime du Camp; Théophile Gautier (whom we met in the previous chapter); and the Goncourt brothers, Edmond and Jules. The brothers wrote a scathing report of the event, pointing out the strangeness in performing the unrolling of a woman for entertainment:

> We unroll, and unroll again, again and again, and the bundle does not seem to diminish, and there is no feeling of getting closer to the body. The linen seems to revive itself and threatens never to end, under the hands of the assistants who unroll endlessly. For a while, to speed things up and hurry the endless unwrapping, the

mummy is placed on its feet, which make a noise akin to wooden legs, and one can see this standing package turning, spinning, dancing appallingly, in the hurried arms of the assistants: death in a bundle.[4]

Even the author Théophile Gautier, who had imagined the lives of two beautiful Egyptian mummies in his short story 'Le pied de momie' and his novel *Le roman de la momie*, was left disillusioned by the spectacle. He wrote, 'nothing is stranger than [seeing] this rag doll in the form of a corpse struggling stiffly and awkwardly under the hands that are undressing her, in a horrid parody of life'.[5] And yet this parody continued. In June of the same year, another mummy was opened in Paris, this time in the presence of Napoleon III and figures from French society.

In the nineteenth century, one could, therefore, attend the public removal of the wrappings of a long-deceased body for entertainment. Let us put aside, for a brief moment, the intrusive nature of this practice and the disrespecting of an ancient person's desire to keep their body intact, and think about this: individuals were paying to see the stripping of a corpse. Today, unless you work in archaeology, forensics, or in a hospital or mortuary, the chances are that you do not see dead people on a daily basis. And, one would think, you do not generally pay to see corpses paraded on a table. And yet, if you visit museums across Europe or commercial exhibitions like *Body Worlds* in your spare time, you will have seen corpses for entertainment – and in most countries you will have spent money doing so. The public viewing of the dead body is today mediated by the exhibition.

What about people in the past? What was their experience of viewing the dead?

In this chapter, I want to take you to nineteenth-century England, where we will explore a bizarre kind of spectacle: the display and subsequent public unrolling of Egyptian bodies on European soil. We have encountered the people who unwrapped mummies for medical reasons. Now, let's meet two men who were central to turning the practice into shows for general entertainment: Giovanni Battista Belzoni and Thomas Joseph Pettigrew. These unrollings sit within an uncomfortable context. In the nineteenth century, fairs displaying living individuals for their differences were all too common. In the same century, the State-sponsored unrolling of mummies became a political tool.

Exhibiting 'otherness'

In the public gardens of Paris and London; in the theatre halls, cabarets and museums; in the streets and university halls of the European capitals, one could see, on display, 'other' bodies. Mermaids. Monsters. Giants. Mummies.

At the turn of the nineteenth century, the London public could already view dissected corpses on display (corpses that were then called 'preparations').[6] For example, in 1799, the British Government purchased 13,000 preparations from John Hunter's personal collection, which were then given to the Company of Surgeons in London. The Company regularly advertised anatomy lectures and the viewing of human remains in newspapers as well as in guides to London.[7] The dissections, although conducted in private, were made accessible to the public. John Hunter's collection had been displayed in a purpose-built structure in his own anatomy school in Leicester Square since 1785. In 1788, the *General Evening Post* reported: 'One day last week, Mr. John Hunter opened his very curious, extensive and

valuable museum at his house in Leicester-fields, for the inspec-
tion of a considerable number of the literati.'[8] Even though
this was a selected audience, the viewing of the displayed dead
was no longer reserved to medical practitioners. We have seen
in Chapter 1 that the viewing of the medically dissected body
in anatomy theatres has a long history in Europe. But the story
becomes entirely different when the bodies are foreign, and
when the format is entertainment.

In the mid-nineteenth century, a range of ephemeral shows
developed in London. They took different forms: fairs, itinerant
shows, theatre, spectacle, music hall and circus, to name a few.[9]
Although the origin of such performance formats predates the
nineteenth century, it was in the mid-nineteenth century that
the public started to attend these events in larger numbers.
London and Paris were the epicentres of such events, although
the touring nature of some of the performances made them
available more widely. The fascination for novel things made
science exciting and education entertaining, and individuals
made a living producing large shows of contemporary won-
ders and oddities.[10] Bodies were often the central attraction of
these shows. And a particular focus was given to the parade of
bodies that differed from the norm – a norm defined as abled,
white bodies. Julia Pastrana is an example of an individual dis-
played both alive and dead. She was exhibited first as a hairy
woman, sometimes described as 'the ugliest woman in the
world'.[11] Then, after her death, her body was displayed to the
public at 191 Piccadilly, advertised as a 'new and unparalleled
discovery in the art of embalming, whereby the original form
and almost the natural expression of life are retained'.[12] There
was a growing fascination in seeing the dead body preserved
as a simulacrum of life, which had already attracted visitors to

22 Poster announcing the public display of Julia Pastrana.

the viewing of preserved bodies, and later would inspire the Victorian practice of photographing the dead.[13] I invite you to keep this example of Julia Pastrana in mind when reading the next chapter. Egyptian mummies were not included in these itinerant and ephemeral shows, but they appeared in other settings: the museum, public unrollings in theatre halls and the great exhibitions.

By the mid-nineteenth century, Egyptian mummified bodies had been at the British Museum in growing numbers for over fifty years. By the time a mummy unrolling was conducted in London in 1821, there were a dozen mummies at the museum, and most of them were on display. In 1827, when the Musée du Louvre opened its first Egyptian galleries, Jean-François Champollion put the mummy of Siophis (now known as Pacheri) and two other unidentified mummies on display, visible to the public from the day of the opening (see Chapter 3). In addition, the study of ancient Egypt was the topic of heated conversations: for example, there was fierce competition between the British and the French to be crowned the decipherers of hieroglyphs. The ancient Egyptian writing was finally translated in 1822, after centuries of studies, first by Egyptian scholars and then by the French and British. The deciphering greatly increased the possibility of further studies into this ancient civilisation, and Egyptian mummies and material culture became an ever greater part of the European cultural landscape.[14]

Is it also worth observing that mortality was very high in these countries at the time: death was prevalent, especially among children, and epidemics were not uncommon. Seeing dead bodies was therefore much more of an everyday occurrence than it is now. And yet, there is quite a jump from a scholarly or scientific showing of the results of medical dissections of

the recently dead, or the viewing of Egyptian human remains on display in museums, accessible to a selected few, to the fee-paying public viewing the unrolling of a body for entertainment. To understand how this change was orchestrated, we need to turn our attention to a man who was quite accustomed to spectatorship: Giovanni Battista Belzoni.

Crushing mummies, exhibiting bodies

In 1821, a unique, grandiose exhibition opened to the public in London at the Egyptian Hall. In it, one could see an exact replica of the tomb of a pharaoh. The glitzy launch event? A private, by-invitation-only mummy unrolling.

We met Dominique Vivant Denon in Chapter 4, and although Denon and Belzoni could not have looked, or lived, more differently, there is something to be said about both characters. The chances are that you did not know about either, and yet few people can claim to have had such incredibly varied lives or such a talent for the imaginative recollection of their travels. Few people can also claim such a fascination and obsession with Egyptian mummies; both are contenders for the inspiration behind the characters in archaeology movies – but while we wait for the Belzoni movie to become a reality, let me introduce you to one extravagant man worth knowing.

Giovanni Battista Belzoni was born in Padua in Italy, in 1778. He grew to be remarkably tall, measuring 2 m (over 6 ft 6 in), and this played a role in his professional development. While he studied hydraulics, it was his physical appearance that led him to work as a strong man at Sadler's Wells Theatre, where he is said to have lifted an iron frame with up to twelve people on it.[15] This period in his life, which earned him the nickname 'The Strongman', has often been overlooked in his career, and

yet there is no doubt that working in this performance environment affected him greatly. He learnt the art of showmanship and developed a flair for the spectacular and the extravagant. Belzoni knew what an audience wanted, and the media coverage of archaeological excavations and the use of a mummy unrolling as a marketing strategy later in his career were typical of his tactics.

Belzoni was engaged in a number of archaeological enterprises in Egypt. He initially went there to pursue his ambitions in hydraulics, and while that project failed, his strength and attitude did not go unnoticed. He was recommended to the British consul-general in Egypt, Henry Salt. Between 1815 and 1819, Belzoni participated in a number of large-scale archaeological enterprises, including the removal of the upper part of a great statue of Ramses II at Thebes, the opening of the Great Temple of Abu Simbel, the discovery of the tomb of Seti I in the Valley of the Kings, the opening of the pyramid of Khafre at Giza and the transporting of the Philae obelisk.

Belzoni left Egypt in September 1819 and arrived in London in March 1820 to work on his next substantial projects: a book and a public exhibition. He recounted his own encounters with Egyptian mummies in his 1820 publication *Narrative of the Operations and Recent Discoveries within the Pyramids, Temples, Tombs, and Excavations in Egypt and Nubia.*[16] While in Qurna, he had discovered a mummy-pit composed of a maze of tunnels, each filled with numerous mummies:

> The blackness of the wall; the faint light given by the candles or torches for want of air, the different objects that surrounded me, seeming to converse with each other, and the Arabs with the candles or torches in their hands, naked and covered with

dust, themselves resembling living mummies, absolutely formed a scene that cannot be described.

He continued:

> I sought a resting place, found one, and contrived to sit; but when my weight bore on the body of an Egyptian, it crushed [the body] like a band-box. I naturally had recourse to my hands to sustain my weight, but they found no better support; so that I sunk altogether among the broken mummies, with a crash of bones, rags, and wooden cases … every step I took I crushed a mummy in some part or other.[17]

Belzoni knew how to use Egyptian mummies to draw public interest, which fuelled his adventure writing – his publication was so popular that it was rewritten in 1821 and translated into multiple languages – and he used this popular appeal in an exhibition he set up that same year at William Bullock's Egyptian Hall. Before the exhibition, Belzoni held a mummy unrolling aimed primarily at medical practitioners. While the unrolling was for a selected few, it was a calculated move to attract visitors to the show at the Egyptian Hall: first, it gave him and his project scientific credentials, and second, it attracted the curiosity of a larger public wanting to view the mummy.

The *Literary Gazette* reported:

> We congratulate the scientific, the learned, the literary, the lovers of art, and the curious (which enumeration, we take it, embraces a large majority of the public) on the treat prepared for them in the Exhibition by Mr. Belzoni, which opens at the Egyptian Hall, Piccadilly, on Tuesday next. To describe this performance as singular, unique, extraordinary, is but faintly to portray it: to us it appears to be the most interesting and valuable spectacle that ever was conceived and executed.[18]

The exhibition did not need much publicity in itself: the success of Belzoni's *Narrative* and the location of the exhibit in London were enough to generate interest. Designed by Peter Frederick Robinson, the Egyptian Hall – originally named the London Museum – had been commissioned by William Bullock to host his own collection. The building was of Egyptian inspiration, loosely based on Dominique Vivant Denon's drawings of Egyptian temples – especially of Dendera – in his *Voyage dans la basse et la haute Égypte* and inspired by the Egyptian Revival style.[19] The inside of the building was adorned with lotus columns and embellished with imaginative hieroglyphs (the ancient Egyptian script had not yet been deciphered). In 1812, Bullock had held an exhibition of his collection of 'upwards of Fifteen Thousand Natural and Foreign Curiosities, Antiquities and Productions of the Fine Arts', which proved immensely popular.[20]

23 Bullock's Museum (Egyptian Hall or London Museum), Piccadilly, attributed to T. H. Shepherd, 1815.

The Egyptian Hall was the ideal location for Belzoni's ambitious plan and served as an immersive environment. Belzoni had ensured that his exhibition would create awe by having two of the most magnificent rooms from the tomb of Seti I – the Hall of Four Pillars and the Hall of Beauties – recreated, life-size, according to his own drawings, as well as a model of the entire tomb, 15 m in length. The exhibition combined reproductions with real antiquities, sarcophagi and mummies, from among Belzoni's personal acquisitions. Newspapers praised the spectacular show: *The Times* reported that 'every eye, we think, must be gratified by this singular combination and skillfull [*sic*] arrangement of objects so new and in themselves so striking'.[21]

Upstairs were fourteen display cases, including two human mummies. Belzoni's *Description of the Egyptian Tomb* mentions the presence of these two mummies in the section 'Cases of Egyptian Curiosities etc':

> No. 11 A mummy opened in England a short time ago: it is the most perfect of those I unfolded in Egypt, during 6 year's [*sic*] research; the box in which it was contained, is placed above. No. 12 The mummy of an Egyptian priest, remarkable for the singular position and the binding of the arms.[22]

The two mummies were further described in the *Catalogue of Various Articles of Antiquity to be Disposed of at the Egyptian Tomb*, which was created with the intention of selling Belzoni's artefacts at the closing of the exhibition.[23] This catalogue confirms the presence of the two mummies, respectively in cases 11 and 12. The first mummy is described as 'the most perfect mummy known in Europe; it is entire in all its limbs and the hair visible on its head; it was brought to England with great care, and was

unfolded by M. Belzoni before various celebrated physicians ... found in tomb of Memnon ... case well preserved'.[24] The description confirms that this was the mummy unwrapped with such fanfare by Belzoni prior to the exhibition.

Belzoni's exhibition was a huge success, attracting 1,900 visitors on its first day. The format of the exhibition itself was both ambitious and perceptive, capturing the public imagination. The Egyptian Hall was an obvious location for the show, but instead of simply presenting artefacts for display, Belzoni invited visitors to relive the experiences he had described in his *Narrative*. The mummy unrolling, the publication of the book and the building itself all played an essential role in attracting the public. Belzoni created a template for the temporary exhibition: promoted by clever marketing events (the unrolling and

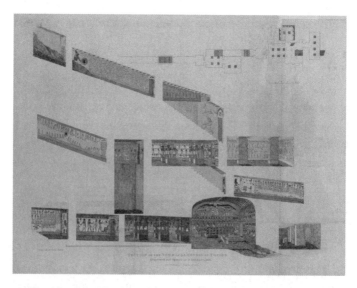

24 'Section of the Tomb of Samethis [Seti I] in Thebes: Discovered and Opened by G. Belzoni, 1818'.

the publication), spectacular in form with large-size and previously unseen objects (a tomb reconstruction and an exceptional number of artefacts), and ephemeral in existence (objects sold at auction at the closing). Belzoni's enterprises were brought to an abrupt end with his death just two years later, in 1823.

The mummy unroller

A respected medical practitioner took the practice of medically dissecting Egyptian mummies in front of an audience to new heights. By the time he had crafted the perfect show, people were waiting in their hundreds to attend a mummy unrolling.

The man in question is Thomas Joseph Pettigrew. Pettigrew was a medical practitioner and followed in the footsteps of his father, a naval surgeon. His medical career has often been overshadowed by his reputation as a 'mummy unroller', but he was undeniably distinguished in the medical field, taking on the position of private surgeon to the Duke of Kent and the Duke of Sussex. Pettigrew was involved in lengthy correspondences with scientists and intellectuals of his time, such as John Coakley Lettsom, Astley Cooper, Michael Faraday and George Cruikshank.[25] His medical network was bolstered by memberships and positions in medical societies, including the Medical Society of London and the Royal Humane Society. After the death of his wife in 1854, Pettigrew devoted his life to archaeology and took up another position, that of vice-president of the British Archaeological Association, although he never travelled to Egypt himself.

In 1821, Pettigrew met Belzoni in London during the exhibition at the Egyptian Hall. Belzoni – whom Pettigrew called

'that most intrepid and enterprising traveller' – had invited Pettigrew to his mummy unrolling. The latter recalled the event:

> My attention had been directed to this curious subject of inquiry from an intimacy with the celebrated traveler Belzoni. With him I had the opportunity of examining three Egyptian mummies, and although the state of their preservations was not of the best description their condition was sufficient to awake my curiosity.[26]

Shortly after, Pettigrew purchased his own mummy. It had been taken to England in 1741 by the physician Charles Perry, who described it in *A View of the Levant*, in the section entitled 'An Essay Towards Explaining the Principal Figures on Our Mummy.'[27] The mummy had, according to Perry, been found in the catacombs of Saqqara and was 'the most curious antiquity of the sort, one only excepted'. Pettigrew purchased it at a sale by auction and unrolled it in 1823 at his Spring Gardens home.

Ten years later, in 1833, Pettigrew bought a mummy at Sotheby's for £23, during the sale of British agent Henry Salt's collection. The mummy had been brought from Thebes, and Pettigrew described it as 'the finest and most interesting specimen' in his publication *A History of Egyptian Mummies*.[28] At the same event, his friend, Thomas Saunders, bought another mummy for the sum of £36 15s. Pettigrew unwrapped both on 6 April 1833 at Charing Cross Hospital, where he was a lecturer in anatomy. The event was reported in the *Gentleman's Magazine, and Historical Chronicle*: 'At the Charing Cross Hospital, on Saturday April 6, two Egyptian mummies were opened and unrolled under the direction of T. J. Pettigrew, Esq. F.R.S. These specimens were purchased at Messrs. Sotheby's sale of Egyptian antiquities.'[29] The *Gentleman's Magazine* gave a lengthy

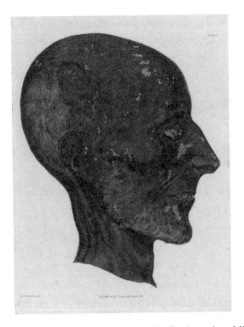

25 Profile view of a mummified male head in Pettigrew's publication.

description of the intervention, which is complemented by Pettigrew's own recollection of the event. Pettigrew's mummy, an older male, did not have any outer wrappings intact, and so Pettigrew was unable to compare it to the work of his predecessors. The resulting body, which was a brownish colour, was illustrated in a striking drawing included in the publication. The other mummy, which belonged to Saunders, was in much poorer condition.

The study of the first mummy did not end with this unrolling. Further examinations were performed, as a way to continue the study of the mummy but also as a means of retaining some

interest from the members in attendance. The *Literary Gazette* reported:

> Mr Pettigrew stated, that he should subject the flesh and intestines to a series of experiments and examinations, without exactly stating their nature, and that he would feel obliged to any of the scientific persons present for any hints or information in the progress of his undertakings. We shall look forward with anxiety to the result.[30]

This was not very different from other unrollings carried out in medical circles: Pettigrew was interested in the nature of mummification and the preservation of soft tissues, and he was interested in involving the scientific community of the time. A few months later, Pettigrew's friend Dr John Lee presented him with the mummy of a twenty-first-dynasty female priest that had also been bought at the auction of Henry Salt's collection. The unrolling of this mummy occurred on 24 June 1833. In attendance was John Davidson, who, enthusiastic about the event, asked Pettigrew to unroll his own mummy as well. This unrolling occurred on 13 July 1833 at the Royal Institute.[31] Once more, substances had stuck the bandages to the skin and rendered the unrolling difficult for some parts of the body. Davidson observed that 'finding that considerable time would be requisite for the removal of the remaining portions of bandage, and not wishing to weary the patience of my audience, I determined on postponing any further attempt'.[32]

In the decade between his first unsuccessful mummy opening in 1823 and the series of unrollings in 1833, Pettigrew kept his medical practice but retained his interest in the ancient Egyptian civilisation. He used this time to do thorough research into ancient Egyptian writing and culture, which he combined

with his anatomical expertise to study Egyptian mummies. By the time he had returned to unrollings in 1833, his knowledge was so extensive that he published *A History of Egyptian Mummies* a year later. *A History* presented a thorough examination of the mummy. Rather than concentrating solely on the embalming process, which had been the focus of previous publications, Pettigrew opened with the many uses of mummies, such as 'Chap. II. On Mummy as a Drug'. He then continued with the religious and funerary beliefs of the ancient Egyptians and the setting of the mummy – the 'Egyptian tombs' – before looking in detail at the embalming, substances, bandages and associated objects (amulets, sarcophagi, manuscripts etc.). The publication also covered other mummies – that is, mummies from other locations, especially Peru, but also pseudo-mummies, which he called 'deceptive specimens of mummies', as well as modern mummification. The publication featured thirteen illustrative plates, including the one we have seen above. The other illustrations give us an insight into private collections that Pettigrew had either visited or was aware of. In particular, he noted the collections of Giuseppe Passalacqua in Paris. In fact, Pettigrew's book, which brought together the existing knowledge about mummification, was based on documents both ancient and modern and made thorough references to the study and dissection of Egyptian mummies by his contemporaries. He produced what we could think of as the first modern history of both the study and reception of Egyptian mummies in Europe, including the first ever overview of the practice of mummy unrolling, and with himself in a starring role.

Pettigrew had created a new kind of celebrity: the mummy unroller.

When he returned to dissecting mummies, Pettigrew had become incredibly popular. In January 1834, for example, he opened a mummy at the Royal College of Surgeons in London, which attracted so many people that 'many were obliged to stand; and many others retired from all the doors who could not find admission'.[33] The unrolling session, which sold out rapidly, was followed by the exhibition of the body: 'Gentlemen who may be disappointed in witnessing the unrolling of the Mummy this day, will have an opportunity of viewing it in the Museum every Monday, Wednesday, and Friday, from 12 till 4 O'clock.'[34]

The success of Pettigrew's oversubscribed unrollings led to the creation of a series of seminars, followed by the unrolling of a mummy. This was a turning point for Pettigrew. The combination of his Egyptological and anatomical skills, together with the growing interest in ancient Egypt, as well as the growing success of entertainment under many forms, could now profit him: he could turn his original, relatively private endeavours into larger public events. These new unrolling sessions were ticketed, and the prices were set according to the custom of theatrical performances: the better the view, the higher the price. They proved enduringly popular:

> In 1837, Giovanni D'Athanasi, the former agent of Salt, asked Pettigrew to unroll one of his mummies. Over 500 people attended the event at Exeter Hall. The unrolling was complicated by some difficulty in breaking the outer wrappings of the mummy, and even the use of a hammer did not suffice. An announcement had to be made that the work would be continued elsewhere and that the result would be made available to the public.[35]

The *Literary Gazette* of 1848 reported on the unrolling of an Egyptian mummy by Pettigrew at the studio of the Scottish

painter David Roberts, known for his prolific series of litho-
graphs of Egypt and the Near East. Roberts had set sail for
Egypt on 1 August 1838, where he toured the country and
produced a vast collection of sketches. The mummy had
been given to Pettigrew by Thomas Arden. The event was
described in the *Literary Gazette*, which noted that 'the unroll-
ing of the mummy was skilfully performed, with observations,
as the task proceeded, worthy of Mr Pettigrew's long experi-
ence, and having (we believe) done as many as forty or fifty
similar subjects'.[36]

The enthusiasm Pettigrew demonstrated for the advance-
ment of the mummy studies, including publication and pub-
licity, was combined with a strong personality that earned him
many enemies within medical circles. In particular, his dedi-
cation to self-advancement was often a cause for reproach.
Pettigrew had a habit of inviting prestigious individuals whom
he named in each publication and account of unrolling sessions,
and he also acquired a reputation for having a bad temper and
getting involved in quarrels. An episode of particular interest
occurred in 1833, when Pettigrew made a request to unroll a
mummy at the British Museum, which was rejected. The case
was recorded in Pettigrew's *A History of Egyptian Mummies*:

> I regret to have here to state conduct of an opposite nature on
> the part of the Trustees of the British Museum, to whom I made
> application to be permitted to examine one or two of the speci-
> mens contained in that *national* establishment. The Trustees were
> of opinion that it would destroy the *integrity* of the collection![37]

So displeased was Pettigrew that he returned to the episode in
the 1836 *Magazine of Popular Science and Journal of Useful Arts*: 'It is
to be hoped that the Trustees of the British Museum will relax

from their determination not to allow any of the specimens contained in that national collection to be unrolled, as much curious if not useful information may be obtained by such a research.'[38] This refusal could indicate the museum's acknowledgement of the destructive nature of unrollings. However, Pettigrew's strong personality was perhaps also perceived as the wrong image for the museum. Consequently, his intellectual respectability was questioned by the museum, which rejected any affiliation with him.

Nevertheless, Pettigrew's unrollings echoed around the world, and in 1864, a series of seminars given at the New York Society on Egyptian civilisation was concluded with the unrolling of a mummy, performed by Professor Henry J. Anderson.[39]

Following Pettigrew's death in 1867, Samuel Birch, curator of oriental antiquities at the British Museum, took up the mantle of the country's greatest mummy unroller. Birch's knowledge of ancient Egyptian civilisation was much more complete, but he lacked anatomical expertise, and as a result his publications did not reveal physiological details like those of his predecessors. Birch had already conducted an unrolling in Shrewsbury Shire Hall in 1842, reported in the *Literary Gazette*,[40] and in 1850, he conducted the opening of a mummy brought from Qurna by Arden. The opening occurred in the house of Lord Londesborough and was announced by an invitation that stated: 'At home, Monday 10th June, 1850, 144 Piccadilly. A mummy from Thebes to be unrolled at half-past two'. Later, Birch studied the mummies brought from Egypt by the Prince of Wales in 1869 at Clarence House and, in 1875, he unwrapped a mummy gifted by the consul of England in Egypt to the Duke of Sutherland.[41]

*

The unrollings performed by Pettigrew had for the first time attracted a paying audience who felt 'delight in witnessing the unrolling of endless bandages, smiling at the hieroglyphics, and then staring at the dried remains of a being who moved on the earth three or four thousand years ago'.[42] What drew so many people to the experience of seeing these dead bodies being unrolled publicly? In some ways, the Egyptian mummy provided the perfect canvas for voyeuristic entertainment. Curiosity about the hidden body and the possibility of uncovering amulets and jewellery kept the audience interested, and the common idea of unrolling – removing what seemed like a large piece of cloth in one go – provided dramatic effect: the big reveal. In reality, unrollings proved complex, sometimes requiring the use of force, and often led to disappointment, either due to poor conservation or simply the lack of any ornaments. However, the excitement of the possible captured the public imagination, and the idea that more could be uncovered kept audiences coming. Both Belzoni and Pettigrew had grasped that they needed to attract, control and retain public attention in order to pursue their endeavours and to obtain funds for future projects.

It is also clear that the attendance of hundreds of people at ticketed mummy unrollings had a lot to do with a European fascination with 'otherness'. Different bodies, different cultures and different religious practices were increasingly sources of voyeuristic curiosity in France and in England, at a time when fairs, exhibitions and so-called 'freak shows' were making money from displaying the differences between individuals and cultures. Behind all this was the core idea that bodies could be poked at, studied and made fun of as innocent entertainment – a pretend innocence that masked a political reality. The French and English were colonisers, and colonial activity only makes

sense when the colonisers consider themselves superior to the people whose lands and cultures they have decided to control – something we will see again in the next chapter.

The unrolling of an Egyptian mummy at the 1867 Exposition Universelle in Paris, seen in the introduction to this chapter, demonstrated a shift in the consumption of ancient Egypt. Museums had been political in their collecting of Egyptian artefacts since Napoleon's expedition, but the mummy had been relatively untouched in the museum. The unrolling at the Exposition, an event showcasing power and cultural dominance, by a French archaeologist who held an eminent position, made the mummy into a political object. The scathing review by the Goncourt brothers suggests that the excitement that accompanied unrolling during Pettigrew's heyday had finally passed, and what had once appeared as an exhilarating form of amusement was now simply 'death in a bundle', or a 'parody of life'.

A televised unrolling

It is 1975, and the people of England are sitting comfortably in front of their TVs to watch a much-anticipated show. The tension is palpable. They are about to witness the dissection of a body removed from its tomb.

It is generally accepted that the last great public unrolling of an Egyptian mummy in Britain occurred on 15 December 1889 in the Botanic Lecture Theatre at University College London, presided over by Wallis Budge, a British Museum curator we met in an earlier chapter. However, this is not true. Physical dissections of Egyptian mummies lasted well into the 1980s. And in 1975, the paying audience this time was an entire country, sitting

in front of its TV screens. The transcript of the Manchester Museum programme based on the investigation reads:

> One human mummy, of an adolescent of about thirteen years of age, was selected and was taken to the medical school to be unwrapped ... finally the unwrapping of mummy one double seven o began ...

> But the exact identity of the person must, even then, have been uncertain. This much, we can deduce; we can even reconstruct a possible likeness. But the name, the origin, and the true appearance of one double seven o – they will always remain a mystery.[43]

This transcript is not very different from the autopsies, dissections and unrollings that took place from the mid-eighteenth to the mid-nineteenth century. The Manchester Museum was the host of this televised event, and the dissection was conducted by members of its team. Led by a group of medical practitioners, in a museum setting, surrounded by individuals with knowledge of the ancient Egyptian culture and accessible to the public via recording in a documentary, the programme's intended purpose was scientific. Today, the Manchester Museum remains an active institution researching Egyptian mummies, and hosts the Manchester Museum Mummy Tissue Bank.[44]

A televised dissection is not very different, as a concept, from the unrolling of Egyptian mummies performed by Thomas Joseph Pettigrew, a qualified medical surgeon and a scholar of ancient Egypt, who opened Egyptian mummies in front of a paying audience. The study of the tissues is not so very different from Rouelle's extensive and attentive study of the *natron* in mummy wrappings (Chapter 1). The facial reconstruction of the mummy is also not very far from Denon's fascination

with the mummy as a human being, and let's not forget the focus on the facial features of the ancient Egyptians by Johann Friedrich Blumenbach, Georges Cuvier and Augustus Bozzi Granville (whom you will meet in the next chapter). And the viewers at home, sitting comfortably for an entertaining night of television, having paid their licence fee, are not very different from those who queued in London to enter Charing Cross Hospital to see Pettigrew. Although presented as cutting-edge science, this performance was part of the same tradition of the European obsession with looking beneath the surface of mummies, peeling back the layers to see the human remains underneath. Our detachment from the viewing of bodies on screen does not make it any more scientific, or more ethical.

Having looked at mummy unrolling in greater depth, we can see certain things about the assumptions that have allowed mummies to be treated in this way over the centuries. The next chapter will explore this further. The viewing of real people, dead or alive, in fairs, shows and national exhibitions was not just a morbid curiosity inherited from the anatomy museum: in the nineteenth century, this began to carry an insidious political message. It was to be understood that some people were not just different – they were inferior. And in this sordid display of racism and othering, the Egyptian mummy became a powerful tool of persuasion.

Chapter 6

The White mummy

In late December 1815, a young Black woman died in Paris. Her name was Saartjie Baartman, and at her death, an influential curator collected her body to dissect her. He put her body parts on display in a public museum.

The name Saartjie Baartman may not be familiar to you, but you may have heard of one of the men who studied her: Georges Cuvier. If you have walked to the Jardin des Plantes in Paris, you will have taken the rue Cuvier. And if you have climbed the Eiffel Tower to admire the views of Paris, then you will have passed his name, engraved as one of seventy-two men recorded for posterity on one of the most famous monuments in the world.[1] You may, however, be unaware that Cuvier was a prominent European figure in the proliferation of racist theories, and that he was a collector of bodies – especially African bodies and Egyptian skulls. This is the story of a young Black woman traded as a slave, and a man on a mission to prove that the ancient Egyptians were white. The story of Saartjie Baartman is one that unites England and France in the trading of slaves, the promotion of racist theories and the quest for the White mummy.

Saartjie Baartman was born in 1789 in the Camdeboo Valley in the eastern part of what was then the Cape Colony.[2] Today this area is part of South Africa. The story of her youth is hard to trace, but what we do know is that in 1810, she was taken to London by two men, Hendrik Cesars and William Dunlop, with one purpose: to display her as public entertainment. This was a time when individuals who looked different from the established norm – white, abled bodies – were exhibited in public shows across Europe. Saartjie Baartman had steatopygia, characterised by the presence of substantial levels of tissue on the buttocks and thighs. The two men thought to turn her female body into a money-making enterprise, exploiting a European obsession with 'exotic' bodies. For four years, she was exhibited across England and Ireland. For a varying sum, you could see her; touch her body; and even, for the right price, touch her genitals in public. Her treatment was so poor that it raised the concerns of British abolitionists, who proclaimed that she was doing this against her will and was being exploited – but a court ruled that she was a willing participant in her fate.[3] Similar comments were made about her later turn to prostitution.

In 1814, after Cesars had left and Dunlop had died, a man named Henry Taylor took Baartman to France, where she suffered an even worse fate. There, she was sold to an animal trainer, and her time in Paris was marked by physical abuse, public displays and prostitution. Her display in Paris was more than racist entertainment: she became the central subject of so-called nineteenth-century 'scientific racism'.[4] To understand this, we need to shift our attention to two very influential men: Geoffroy Saint-Hilaire and Georges Cuvier.

Cuvier developed an interest in natural history at an early age and wanted to transform the field of zoology. His main

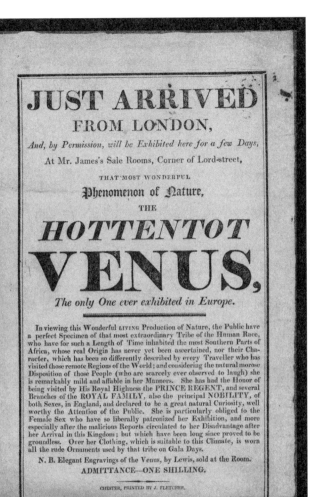

26 Poster announcing the arrival of Saartjie Baartman in an English town. The poster reads 'Just arrived from London, and, by Permission, will be Exhibited here for a few Days, At Mr. James's Sale Rooms, Corner of Lord-street, that most wonderful Phenomenon of Nature, the Hottentot Venus, the only One ever exhibited in Europe.'

contribution was to establish comparative anatomy and verte-
brate palaeontology as significant fields of research.[5] Cuvier did
not believe in evolution, and when he studied Egyptian birds
brought from Egypt by Saint-Hilaire, he stated that the speci-
mens from ancient Egypt were no different from their modern
counterparts.[6] His ideas were opposed to those of his con-
temporaries, including Saint-Hilaire, who believed in change-
able animal morphology. Cuvier and Saint-Hilaire had both
been offered positions as naturalists on Napoleon's expedition
to Egypt, but Cuvier, who had joined the Muséum national
d'Histoire naturelle, declined, claiming he had more substantial
work under way. Indeed, he wanted to focus on applying the
comparative classification system he had developed with ani-
mals to humans.

In 1799, Georges Cuvier, then curator at the Muséum
national d'Histoire naturelle in Paris, observed that there were
not, as yet, any comparative analyses of the skeletons of white
and Black people, and that these would be most useful to both
his research and that of his contemporaries.[7] He stated 'Entire
skeletons would be infinitely valuable. Can it be conceived that
we have not yet, in any work, the detailed composition of the
skeleton of the Negro, and that of the White?'[8] To remedy
the situation, he created guidelines for such research, and in
1817 published *Excerpts of Observations on the Cadaver of a Woman
Known in Paris and in London under the Name of Venus Hottentote.*[9]
The woman in question was Saartjie Baartman, who had died
in poverty in her small room in Paris in December 1815, aged
only twenty-six.

Cuvier had first met Baartman in March 1815, when she
was showcased in front of scientists at the Muséum national
d'Histoire naturelle at the demand of Saint-Hilaire, at that time

the administrator of the museum. While he studied her alive for his own research and voyeuristic curiosity, Cuvier did not stop there. At her death, he quite simply claimed her body. He did not conduct an autopsy to determine her cause of death. Instead, he produced a full cast of her body, dissected her, set her skeleton apart, and put her brain and genitals in jars. He then used these two parts of her anatomy to attempt to demonstrate that her people were the missing link between humans and apes. Saint-Hilaire subsequently applied to retain them, and they were put on display in the Muséum national d'Histoire naturelle, before they were moved to another Parisian institution, the Musée de l'Homme, in 1937.

In his report, Cuvier stated that '[Neither the] bushman, nor any race of Negros, gave birth to the celebrated people who established civilisation in ancient Egypt and from whom one could say that the entire world has inherited the principle of law, science and perhaps even religion.'[10] In a twisted exploitation of a very real person such as Baartman, Cuvier had one aim: to prove that people like her – Black people – could not have created the ancient Egyptian civilisation. This series of events fitted within investigations of African women by thinkers who used the Black body as a frame to compare, construct and assert racial theories. Although Cuvier did not dissect full Egyptian mummies, he did study a large number of Egyptian mummy skulls. He had his own cabinet, which contained nearly fifty Egyptian human skulls, amongst 11,000 human and animal remains.[11]

Cuvier's investigations were commented upon in James Cowles Prichard's *Researches into the Physical History of Mankind*, which reported that Cuvier 'concluded that the Egyptians belonged to the same race of men as the Europeans [and] that their cranium and brain was equally voluminous with ours',

and alluded to 'that cruel law, which seems to have condemned to an eternal inferiority those races with small and compressed skulls'.[12] It was a time when people believed in craniology, whereby the size and shape of your skull were deemed to be scientific data that could define your abilities and your place in society. This is of course the precursor to another racist pseudo-science, eugenics, which would also use archaeology and ancient Egypt as sources of supposed evidence.[13]

Georges Cuvier wanted to prove that the ancient Egyptians were in no way related to Black African individuals. But why go to such lengths to prove the racial origins of a people that lived some 3,000 years ago? How would such study benefit Cuvier and his contemporaries? The answer involves the appropriation and theft by white men of intellectual, cultural, political and religious achievements.

The origin of the ancient Egyptians

At the turn of the eighteenth century, naturalists, travellers, politicians and philosophers were concerned with one question: were the ancient Egyptians a white or a Black people? These findings would have colossal implications.

In 1788, French traveller and politician Constantin-François Volney wrote 'How are we astonished when we reflect that to the race of negroes, at present our slaves, and the object of our extreme contempt, we owe our arts, sciences, and even the very use of speech; and when we recollect that, in the midst of those nations who call themselves the friends of liberty and humanity, the most barbarous of slaveries is justified: and that it is even a problem whether the understanding of negros be of the same species with that of white men!'[14]

Volney was responding to a central concern about the ancient Egyptians at the time: how could a civilisation located on the African continent produce the advanced technologies, understanding of the world, and system of artistic and intellectual production that lay at the foundation of western civilisation? And how could this be reconciled with a colonial system based on the inferiority of any non-white people, and especially people from Africa? While Volney suggested that seeing the land of the ancient Egyptians as inferior was ludicrous, considering how incredibly advanced the ancient Egyptians were, and how much Europeans had gained and learnt from them, most men in Europe were concerned with changing the narrative and rewriting history to fit their agendas. As a result, the Egyptian mummy became entangled in something quite enormous: it became the clue to answering the question of the origin of mankind. In this scenario, the exceptional preservation of the mummified bodies and their availability meant they could be investigated – to the point of destruction – using methods such as craniology to compare and to contrast bodies. This was the beginning of the quest for *the White mummy*.

Why did this become such an important subject of investigation at the turn of the eighteenth century? Racial thinking predates the period, and an early attempt at categorising races can be found in French physician and traveller François Bernier's 'New Division of the Earth', published in 1684.[15] Bernier wrote that he had 'noticed that there are four or five Species or Races of men whose difference is so remarkable that it may serve as a just foundation for a new division of Earth'.[16] In the eighteenth century, the impulse to categorise races into a definite number and to connect them with separate narratives of origin became a subject of major debate.[17] Westerners explored further the

question of race and origin. A rhetoric of racial differentiation appeared in Europe and then spread internationally. What were the criteria for racial distinction? Did all European thinkers agree about them? And what were the implications for the study of the ancient Egyptians?

These questions were addressed by Europe's leading natural scientists and cultural philosophers, including Carl Linnaeus, Georges-Louis Leclerc, Comte de Buffon, and Johann Friedrich Blumenbach, as well as Petrus Camper and Immanuel Kant.[18] These men presented diverging and sometimes opposing views as to the reason behind the differences among humans. For example, Linnaeus's *Systema naturae*, published in 1735, proposed a classification of mankind into four groups: *Europaeus*, *Americanus*, *Asiaticus* and *Afer*.[19] In his *Histoire naturelle*, Buffon defined a system to classify humans in relation to an ideal.[20] His theory was that anyone who was not white was showing a form of degeneration, which implied the supremacy of a white race. This approach will be of interest when considering the racial origin of the ancient Egyptians and some other more modern theories, such as aliens building the pyramids (see next chapter).

Of particular interest here are Camper and Blumenbach, for their focus on skull measurement, or craniology. In *The Works of the Late Professor Camper* of 1794, Camper introduced his influential facial angles.[21] The angles he devised were reused by individuals such as Saint-Hilaire and Cuvier, and relied on distinctions in the shape of skulls among individuals from different races. Westerners became obsessed with measuring and comparing skulls: here was the key to understanding the differences between people, or so they believed. Camper and Blumenbach's approaches to the body, and in particular the

skull, were a turning point in the study of human beings in general and the Egyptian mummy in particular.

What made the Egyptian mummy such an important part of these studies? The rediscovery of the ancient Egyptian civilisation had led to the realisation that the ancient Egyptians had an advanced understanding of certain subjects. This realisation was in part due to the discovery of mummies that had survived intact for centuries, because the mummification process was evidence that the ancient Egyptians had a good understanding of anatomy, as well as of the natural and chemical preservation of organic materials. Over time, it became evident that the body of knowledge of the ancient Egyptians extended to astronomy, mathematics, literature and religion. But Egypt was in Africa, and Europeans believed that African peoples were inferior or primitive. How could both things be true? To resolve this contentious debate, the mummy became the subject of intellectual and physical investigation.

Volney, who had expressed his confusion as to why Europeans thought people from Egypt would be considered inferior, concluded that the ancient Egyptians were in fact Black Africans:

> When I visited the Sphinx, I could not help thinking that the figure of that monster furnished the true solution to the enigma (of how the modern Egyptians came to have their 'mulatto' appearance). In other words, the ancient Egyptians were true Negroes of the same type as all native-born Africans. That being so, we can see how their blood, mixed for several centuries with that of the Greeks and Romans, must have lost the intensity of its original color, while retaining nonetheless the imprint of its original mould.[22]

His view that the ancient Egyptians were Black Africans was not widely shared. The question as to whether the ancient Egyptians were a Black or white people became of central concern. Very few considered, at this time, the possibility of a multiethnic culture.

In James Boswell's *The Life of Samuel Johnson* of 1791, a conversation is reported that mentions the race of a mummy: 'I mentioned Lord Monboddo's notion that the ancient Egyptians, with all their learning, and all their arts, were not only Black, but woolly-haired. Mr Palmer asked how it did appear upon examining the mummies? Dr Johnson approved of this test.'[23] This conversation is the first mention of the use of a 'test' – an unwrapping, autopsy or dissection – to answer the question of the racial origin of Egyptian mummies. And museums across Europe set out to do just that: dissect Egyptian mummies to figure out their racial origins – and sometimes to construct the answers so that they would fit conveniently with the kind of narratives that colonisers needed to promote in a time of Empire.

Race at the British Museum

At the end of the eighteenth century, the British Museum was the theatrical location for the dissection of two Egyptian mummies that had the sole purpose of exposing the racial origin of the chosen bodies.

The British Museum invited a German anatomist, Johann Friedrich Blumenbach, to pursue this research into the racial origins of the ancient Egyptians.[24] Between 1792 and 1794, Blumenbach conducted a series of examinations of Egyptian mummies in London, first in private locations and then at the

Museum. Blumenbach's interventions are the first clear link between mummy dissections and investigations into the classification of race. Blumenbach was also the first, and only, individual to conduct dissections of mummies inside the British Museum, which banned the practice thereafter.[25]

In 1794, Blumenbach recalled in his 'Observations on Some Egyptian Mummies Opened in London' the 'uncommon, and to me very interesting, opportunities that were afforded to me, to open and examine several Egyptian mummies' at the British Museum.[26] Although he pointed out the originality of the event, it was not Blumenbach's first encounter with a mummy: he had previously unwrapped one in the academic museum of the University of Göttingen in Germany, on 25 August 1781.[27]

His first examination of an Egyptian mummy in London took place on 21 January 1792 at the house of a friend, Scottish physician Dr Maxwell Garthshore.[28] Garthshore had his own collection of Egyptian antiquities, which included a small, one-foot-long mummy. Blumenbach's dissection of this mummy was conducted in private in front of a select audience, which included the president of the Royal Society and several of its members. The small mummy he opened had a relatively well-preserved mask and breastplates. The mummy was cut open at the side for inspection, but the resin was so hard that Blumenbach had to use a saw to finish the job. Far from being put off by this, he decided to open another mummy on 29 January. This time there was a different kind of setback: the mummy wasn't real. It contained no human remains at all but, instead, the skeleton of an ibis!

This convinced Blumenbach to approach Sir Joseph Banks to ask permission to open a small mummy at the British Museum.

Banks was well placed to answer this query: he was the president of the Royal Society, a trustee of the British Museum and a member of the Society of Antiquaries of London, which gave him considerable influence. As a result, Blumenbach was allowed to open the small mummy he had asked to see, and the museum also invited him to choose another from among four large ones. And just like that, the British Museum allowed Blumenbach, a renowned comparative anatomist, to completely destroy two Egyptian mummies to pursue his own research interests.

The dissection of the two mummies occurred on 18 February 1792 at the British Museum. The precise location in the museum is unknown, but we do know that the dissection was done in the presence of numerous attendees, by invitation only. Blumenbach started his operations with the small mummy, which he opened with a heated saw. Once again, it proved to be what he considered to be a fake. Blumenbach noted that 'although when viewed externally nothing appeared suspicious in this little mummy, I found, however, on examining carefully the successive integuments that the outward ones had some traces of our common lint paper, with which it seemed to have been restored, and afterwards painted over'.[29] A fabricated mummy!

The large mummy appeared to be the body of a young person. The soft tissues of the body had all disappeared, leaving only the skeleton and a large amount of resin. It was during the dissection of this mummy that Blumenbach began introducing comments on the racial origin of mummies. He noted the presence of the *maxillae* (the upper jaw), which he pointed out was 'sensibly prominent, but by no means so much as in a *true Guinea face*; and not more so than is often seen on handsome negroes, and not seldom on European countenances.'[30] This comment

reflects Blumenbach's interest in identifying racial origins from the facial structure of Egyptian mummies – an obsession with facial structures that has pervaded Egyptology and the study of human remains up until now.[31] Blumenbach continued his detailed description, recording the absence of amulets or an onion (this is a direct reference to Hadley's dissection and the onion on his mummy foot; see Chapter 4).

What new insights did Blumenbach take away from this most unusual visit to the British Museum?

To begin with, Blumenbach learnt first-hand that many Egyptian mummies in museum collections were not actually human mummies – sometimes they were complete fabrications, and sometimes they contained animal bones instead. Almost all of the mummies he inspected showed evidence of forgery, either on the body itself or on the coffin. His encounters with such deceptions led Blumenbach to call, in his *Observations*, for better study of the ancient Egyptian culture. He wrote:

> How many other artificial restorations and deceptions may have been practised in the several mummies which have been brought into Europe, which have never been suspected, and may perhaps never be detected, may well be admitted, when we consider how imperfect we are as yet in our knowledge of this branch of Egyptian archaeology, which, as a specific problem, few have hitherto treated with the critical acumen it seems to deserve.[32]

But his main concern was to call not for a better knowledge of ancient Egypt, but for a better knowledge of the different races of humans, a very topical subject of investigation at the time. Before the opening of the mummies in London, Blumenbach had already published fundamental work on the study and

categorisation of mankind, in particular on race. He had studied at the universities of Jena and Göttingen, graduating from the latter in 1775. His thesis, 'De generis humani varietate nativa' ('On the Natural Variety of Mankind') formed the basis of his research on racial classification. It was reissued in 1795.[33] It divided humans into 'types of races': in the first edition, Blumenbach proposed four races and then changed this to five categories in the second edition. The five races he established were: (1) the Caucasian, (2) the Mongolian, (3) the Malay, (4) the Ethiopian and (5) the American.

In his call for a better understanding of Egyptian mummies, Blumenbach noted the need for 'a very careful technical examination of the characteristic forms of the several skulls of mummies we have hitherto met with, together with an accurate comparison of those skulls with the monuments', that is, representations of people on Egyptian monuments.[34] In reality, Egyptian art was far too symbolic to be used as comparison with research on humans. On the race of the Egyptian mummies, Blumenbach noted that the Egyptians 'will find their place between the Caucasian and the Ethiopian' group. He insisted on something that was very important to Europeans at the time, the existence of a '*true*, if I may so call it, *ideal* archetype', which was of course to satisfy the very people who devised these theories – European/white people.[35]

Throughout his studies, Blumenbach strived to classify human races, but he emphasised the disconnection between race and ability, detaching his research from other contemporary racial theories.[36] This is very important, because most men involved in the racial classifications of the ancient Egyptians, including Cuvier, strongly believed that one's racial

origin determined one's ability, and that the most capable and erudite were white people. This was an opinion shared by a man called Augustus Bozzi Granville.

Granville's mummy dissection

Precise drawings of the pelvis of a woman were made and published, with measurements written on the side. The pelvis in question belonged to a woman. According to a medical practitioner, she was a white ancient Egyptian.

On 14 April 1825, Granville, a medical practitioner and Fellow of the Royal Society from Italy presented a paper on the results of the dissection of a mummy. Based in London, Granville had travelled widely and spent eighteen months in Paris studying obstetrics, a speciality he pursued upon his return to England. In Paris, Granville had attended lectures given by the greatest medical scientists and naturalists of his time, including none other than Cuvier.

Granville had received the mummified body of a woman and a coffin from one of his patients, Sir Archibald Edmonstone, who had travelled to Egypt in 1819. The *London Medical Repository and Review* reported that Edmonstone had purchased the mummy at Qurna on 24 March 1819. The mummy was received intact, and Granville noted that 'it was precisely in the state in which it was found when the case was first opened by Sir Archibald Edmonstone, covered with cerecloth and bandages most skilfully arranged, and applied with a neatness and precision, that would baffle even the imitative power of the most adroit surgeon of the present day'.[37] The body was that of a fifty-year-old Theban woman.

Granville's unrolling was carried out in two stages: first the unwrapping – the removal of the fabrics covering the body – which took an hour, and then the meticulous dissection of the body, which took place at his house over the course of six weeks. The proceedings of these operations were recorded in Granville's 'An Essay on Egyptian Mummies'.[38] His background in medical surgery is obvious throughout the report in his use of medical terms: he refers to the wrappings as 'bandages' on several occasions, and carefully distinguishes between each type of bandage. In Granville's report, medical observations are combined with an awareness of the contemporary research in the study of ancient Egyptian funerary customs. For example, he compared the wrappings of the dissected mummy to those described by Jomard in the *Description de l'Égypte,* the colossal publication commissioned by Napoleon Bonaparte on his return from Egypt.

After the removal of the wrappings, Granville moved on to the autopsy of the mummy, beginning with the analysis of the sex (female) and of the main physical characteristics. The next stage of his report concerned the careful measurement of the body, linked to the determination of the individual's race, echoing Blumenbach and Cuvier. He started by comparing the height of the mummy with an ideal, that of the 'Venus de Medici' – the same Venus that had given Saartjie the derogatory nickname of 'Vénus hottentote'.

Of all the observations, it is Granville's investigation of the pelvis of the mummified woman that reveals most about his research. In order to prove his point regarding the mummy's racial origins, Granville brought the dissected pelvis of a Black girl to the Royal Society, ready for inspection. The comparison

led him to declare that 'the pelvis of our female mummy will be found to come nearer to the *beau idéal* of the Caucasian structure, than does that of women of Europe in general'.[39] He was so keen to prove that his ancient Egyptian mummy was perfectly Caucasian that he concluded it resembled the ideal skeleton of white Europeans more than ordinary European people themselves. In the same manner, Granville moved onto the examination of the cranium, once again demonstrating its apparent European origin, noting that it resembled the skull of the Georgian female represented in Blumenbach's *Decas tertia craniorum*. Granville also referred to Cuvier's work, declaring that 'It may be affirmed then, that Cuvier's opinion respecting the Caucasian origin of the Egyptians, founded on his examination of upwards of fifty heads of mummies, is corroborated by the preceding observations.'[40] With this statement, the Egyptian mummy united two countries that in most respects were bitter rivals. England and France, in conflict over the control of modern Egypt, became allies in the control of ancient Egypt. By asserting and disseminating the idea that ancient Egyptian mummies were white, Granville validated and condoned both countries' colonial ambitions. According to the theory, ancient Egypt had been peopled with white individuals, who were at the origin of the great ancient Egyptian achievements. Over time the population changed – a process referred to as 'degeneration' – until Egypt was no longer a white country. This meant that it could be controlled and colonised, and its ancient achievements appropriated.

Granville kept the remains of the mummy he dissected, and in 1853 he sold the wooden box with the remains and textiles to the British Museum, where it remains – a story of concealment we will return to.

Making the mummy White

In the 1840s, the theory of the White mummy reached a country that was search-ing for new reasons to discriminate against its Black African population: the United States of America. The White mummy was travelling the world.

The results of the three sets of investigations covered in this chapter are varied: Blumenbach opted for a mixed-race approach to the racial origin of the ancient Egyptians, while Cuvier and Granville asserted a strict white origin. The accuracy of these results is not to be questioned or refuted here – as it turns out, it is likely that the mummies acquired by these researchers were from the later, Roman or Greek, periods from which more mummies have survived, and would present a European bias (one that remains in contemporary studies; see Chapter 8). It is evident, however, that the investigations of mummies by Cuvier and Granville were not open to interpret-ation: the Egyptian mummy needed to be found to have a white origin, as it needed to fit into existing intellectual views on the supremacy of a white race, which formed the foundation of a strong colonialist and imperialist ideology in that century.

The dissections of human mummies for racial reasons were not widespread at the turn of the nineteenth century, but those who engaged in such practices were highly influential in nat-ural history and medicine, and their research was widely pub-licised. Blumenbach was appointed curator at the Natural History Museum of Göttingen in 1776, and then professor of physiology and anatomy at the same establishment in 1778, a position that he held for almost fifty years. He was also elected a member of seventy-eight societies and published extensively on comparative anatomy and natural history, which meant that

his achievements resonated internationally. In France, Cuvier was an important figure, not just through his position at the Muséum national d'Histoire naturelle, but more widely on the European scene. Therefore, the mummy was situated in a network of scholars who were linked to major institutions: the British Museum and the Royal Society of London, the Muséum national d'Histoire naturelle and the Académie des Sciences in Paris. The research these men were conducting and disseminating soon enough reached the United States, a country that was likewise looking for justifications to discriminate against and control others.

In 1844, the American physician Samuel George Morton used skull measurements to conclude that ancient Egypt was 'originally peopled by a branch of the Caucasian race' and that Egypt was then penetrated by other people, creating what he called 'an endless confusion of races'.[41] Morton, a natural scientist and writer, argued against the genesis storyline of monogenism – one common descent for all of humanity – and instead supported polygenism, the idea that different races came from different origins. This was a convenient theory to separate one race entirely from others – that is, white people from non-white people. Morton strongly believed that different races had different skull sizes, and that the size of one's skull alone could determine one's abilities and thus place in society. This theory was reused by American surgeon and anthropologist Josiah Nott, who referred to the racial diversity after the original Caucasian presence in ancient Egypt as 'barbarism'.[42] Nott was a slave owner and used the pseudo-science of craniology to defend enslavement, on the basis that Black people could be scientifically shown to be inferior.

27 Broca goniometer for measuring angles of the face, at the Science Museum, London.

This reuse of theories of the racial origin of the ancient Egyptians across the Atlantic shows just how powerful they were. They resonated internationally and did much damage in a world where creating justifications for the dominance of white people was of central importance.

The return of Saartjie Baartman

*Less than fifty years ago, you could pay to stare at the skeleton and body-cast
of Saartjie Baartman, a display that was meant to ridicule, insult and prove
the inferiority of a deceased young Black woman.*

The display was at the Musée de l'Homme, Place du Trocadéro
in Paris. Until 1974, you could visit the museum and see
Baartman's skull on display, and until 1976, you could see her
full body-cast. While these were removed from public display in
the 1970s, the museum held the skeleton, full body-cast, genitals
and brain in two separate jars in its collection until 2002, along
with a separate cast of her genitals. When a commission was
tasked with the study and inventory of the museum's collection,
the presence of these casts and remains was initially hidden from
the French Government. A history to hide? For the Muséum
national d'Histoire naturelle director at the time, 'the remains
of Saartjie Baartman must remain in the museum, the people
of the museum received her well and she is well looked after'.
He lamented that, by making restitution, 'we empty museums.
They still represent a scientific interest.'[43] Nearly 200 years after
her birth, Saartjie Baartman was still considered a source of
scientific knowledge and curiosity: a prized possession, rather
than a human being.

In 1994, the newly elected South African president Nelson
Mandela began negotiations for the return of the remains of
Saartjie Baartman. It took until 2002 for the remains and the
skeletons to be repatriated, while the cast remains the property
of the natural history museum in Paris – an ongoing violation
and appropriation of her body. On 9 August 2002, the remains
of Saartjie Baartman were buried in South Africa, with a live

television broadcast. The speech given on the day of the repatriation read: 'We cannot undo the damage that was done to her. But at least we can summon the courage to speak the naked but healing truth that must comfort her wherever she may be.'[44]

This speech delves into the truth of Saartjie Baartman, a woman collected as a specimen, and an example of 'otherness' at a time when racial classification was the norm in museums and other institutions, with the aim of proving the superiority of a white race.[45] It is a pursuit that fundamentally shaped the collecting of human remains and casts at the Muséum national d'Histoire naturelle in Paris, and that continued to shape displays in the institutions that followed it, including the Musée de l'Homme. Today, the Musée de l'Homme holds an extensive collection of human remains, including thirty-three Egyptian mummies and fifty-two mummy heads from Egypt and South America, along with other body parts. While we close here the chapter on Saartjie Baartman and race studies at the turn of the eighteenth century, we will return to the Musée de l'Homme in the next chapter.

Saartjie Baartman, a woman from what is now South Africa, became entangled in studies of the inhabitants of ancient Egypt, at the very extreme opposite of Africa. The racial studies of the ancient Egyptians at the turn of the eighteenth century demonstrated an ambition to rewrite the origins of mankind and the narratives of the Egyptian civilisation, to fit a political, colonial and imperial agenda. But while visible colonialist agendas have ended, at least officially, these same countries remain preoccupied with the origins of the ancient Egyptians. With new technologies come new levels of exploration, and in recent years, the work has continued. In the next chapter, the (White) mummy returns.

Chapter 7

The (White) mummy returns

It is January 2020 and researchers have just solved the mystery as to how an ancient, mummified woman on display at the Ulster Museum in Belfast died. It was no usual death. The 'shocking truth' is to be announced shortly.

But what was this shocking truth revealed in the press?[1] That the woman, named Takabuti, had died in a knife attack in ancient times. Takabuti was a woman in her twenties at the time of her death, who lived in Thebes around 2,600 years ago. She had been stabbed in the upper back near her left shoulder, a wound that apparently killed her.

In 1834, she was brought to Belfast by a man named Thomas Greg, who had displaced her from her tomb and taken her out of Egypt. On 27 January 1835, only a year later, she was unwrapped in front of a select audience of the Belfast Natural History and Philosophical Society. The unwrapping was for the purpose of making 'measurements'. An 1836 report in the *Phrenological Journal* read:

> This mummy was unrolled on the 27th of January 1835, in the presence of a large number of the shareholders in the Museum,

the members of the Natural History Society, and other scientific gentlemen.

[…]

As the remarks on the probable character of the individual were written for an audience few of whom had given any attention to the study of Phrenology, all the terms peculiar to that science have been sedulously avoided, and the subject has been illustrated by reference to the works of some of our most popular authors.[2]

The report was followed by a list of her head measurements, as well as the dimensions of the rest of her body, then a lengthy text outlining all her personal qualities and dispositions, based on those measurements. The text notes, for example, that 'Highly social in her disposition, and attached to her native city, she would regard with pride the everlasting pyramids and other works of her countrymen.'[3] It continues, noting her sadness at being an orphan, her love for her friends and her character, all written in a rather sentimental prose. The article concludes that 'Such appear to have been the characteristics of this Egyptian girl, so far as they can be deduced from her skull, and on the presumption that the organic constitution of her brain was good.'[4]

This is phrenology, a pseudo-science that linked the shape of a person's head to their intellectual and social abilities. And, once more, the skulls of the ancient Egyptians were being measured, studied, dissected and analysed by individuals who were keen to attach what they saw as western attributes to these dead bodies. As a result, Takabuti's personality was compared with characters in *Othello*, Beatrice in *Much Ado about Nothing* and characters in Wordsworth. Her love of the pyramids, somehow visible in her skull measurements and professed by the writer on

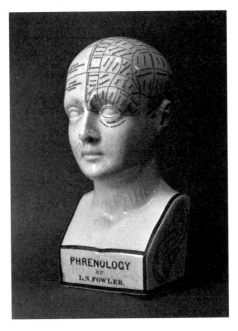

28 Ceramic phrenology head at the Science Museum, London.

her behalf, remains an everlasting obsession of westerners when it comes to ancient Egypt.

The unwrapping of Takabuti in 1835 brought about questions about her cause of death, which were answered in 2020 thanks to the use of medical imagery. However, there was another truth to be gleaned from this press release: that we are not done talking about the origins of the ancient Egyptians. After a mere four lines on Takabuti's death, the 2020 news report continued by stating that 'The team, whose findings are made public on the 185 year anniversary of Takabuti's unwrapping in 1835, also show that her DNA is more genetically similar to Europeans

than modern Egyptian populations.'[5] The study into Takabuti's death had been taken as an opportunity to examine the DNA of this person. The report continued, with the person responsible for the DNA testing noting that 'Takabuti's genetic footprint H4a1 is relatively rare as it has not been found to my knowledge in any ancient or modern Egyptian population. My results agree with previous studies about ancient Egyptians being more genetically similar to Europeans than modern day Arabs.'[6] The report takes us very swiftly from one mummy being European-like, to all of the ancient Egyptians being more closely related to Europeans than to the modern-day Egyptians.[7] Which studies are we talking about and how far back do we want to look? Certainly, the early nineteenth century provides a lot of studies that claimed the European origin of the ancient Egyptians, but do universities and museums still want to be affiliated with Eurocentric studies that were rooted in a colonial and imperialist agenda? Is this the best use of science today?[8] The press release completely ignored the long history of pseudo-scientific research that for the past 200 years has been trying to prove that the ancient Egyptians were a white people: a history of whitewashing African and Middle Eastern achievements that is consciously or unconsciously influencing interpretation and public responses in museums and the media.

Have you ever wondered why virtually every European museum has a separate section for ancient Egypt and one for Africa? Have you ever wondered why human remains from other countries are being removed from display while Egyptian mummies remain on public display?

In this chapter, we are going to look at the return of the White mummy. We'll see that Egyptian mummies are not neutral bodies in museums, and that their very presence in these

institutions is a result of studies and attitudes that are deeply rooted in a colonial and racist rhetoric. From the eugenicist theories of one of the world's most famous archaeologists, whose museum is located inside University College London (UCL), to fiction writing and major documentaries that encourage the theories that aliens built the pyramids, to museums removing their historical links to race studies, the twentieth and twenty-first centuries are seeing a revival of dismissive theories about both ancient and modern Egyptians. Are universities and museums complicit because of their communication, or because of its absence?

Eugenics at the Petrie Museum

Yellow panels adorn buildings on the campus of University College London. They are markers of a history hidden in plain sight. One is placed on the wood-and-glass door of a small, internationally recognised museum of archaeology.

A statement that isn't deliberate can still say something … It's Petrie's key contribution to archaeology that relates to our story about the history of eugenics at UCL. In 1902, Petrie published an article in the journal *Man*, which included a graph called 'Diagram of climate and intelligence of races'. In it, he reproduced ideas about the effect of climate and environment on a species, in this case historical and modern humans, along with the scientifically racist assumption which was based on the idea that skull size correlated with intelligence. This assumption dated back to the early days of the Enlightenment and was one of the scientific principles used to justify the enslavement of African people.[9]

In this abstract, taken from the *Bricks + Mortals* podcast, Subhadra Das, who was a curator at UCL Culture, introduced

two important ideas: buildings and institutions are often the physical manifestation of hidden stories that have long been concealed by universities and museums, and have a lot to say about what are often called 'uncomfortable stories', and the pervasive link between Western Egyptology and racism, via once more, the study of Egyptian skulls.[10]

The building that bears the yellow panel of the *Bricks + Mortals* project is the Petrie Museum of Egyptian Archaeology, located on Mallet Place inside the university campus, part of UCL Culture.[11] It is located a few minutes' walk from the Wellcome Collection, and only ten minutes away from the British Museum, and its collections relate to both these institutions.[12] And yet the Petrie Museum is easily missed, owing to UCL's refusal to offer it a suitable home.[13] As a result, today, the incredibly vast collection of this museum – considered one of the most important collections of Egyptian archaeology outside Egypt – is hosted in a former stable, between a pizzeria and the university's central heating system. An unusual location for a museum with a considerable collection of artefacts and bodies. Even more unusual is the history of its namesake, Sir William Matthews Flinders Petrie, and his link to archaeology, Egyptian human remains and racism.

If a visitor looks more closely at the yellow sign, they will find a QR code that links to a podcast. The podcast explores a history of archaeology that looks beyond explorations and discoveries, and instead focuses on a man who has long been called 'The Father of Modern Archaeology'. This man helped two others, Francis Galton and Karl Pearson, to reinvent a pseudo-science rooted in racism and classism so that it gained credibility as a legitimate science. This is the history of eugenics at UCL,

and how Egyptology and museums have helped to support a theory of superiority that has a pervasive influence up to today.

Flinders Petrie, born in 1853, first travelled to Egypt at the age of twenty-six, to survey the Great Pyramid complex. His career spanned a grand sixty years, during which he produced surveys and collected archaeological evidence, mainly in Egypt and Palestine, while contributing to thousands of publications. Among his contributions to archaeology, it is his classification that stands out: he introduced the sequence dating of the Predynastic period and its synchronism with pottery as a way to date sites. Another somewhat less noted, but equally important, contribution of his was his insistence on standardised excavation and recording.[14] His collecting interests were more varied than those of most archaeologists of his time – in particular, he was interested in collecting small, everyday objects. Petrie's legacy is linked to two institutions that still exist in London: the Egypt Exploration Fund (now Egypt Exploration Society) and the Petrie Museum at UCL.[15] The university offered Petrie the first chair of Egyptology in England.[16] In recent years, the use of Petrie's name has raised concerns, and conversations have started over a potential renaming.[17] The reason? Petrie's interests were not limited to a better understanding of the ancient past: he was very much interested in the present and the future, too. At the heart of this interest was a central idea: the possibility of bettering British society by selecting who would live in it.

While Petrie's studies of ancient Egyptian sites are well known, for a long time his link to pseudo-scientific theories were conveniently left out of the limelight. Petrie was a committed eugenicist who formed a friendship with the founding figure of eugenics, Francis Galton.[18] For a while, Galton treated Petrie as his protégé

and funded some of his work. Throughout his life, Petrie emphasised the importance of precise measurements and it was Petrie's mathematical skills that first caught Galton's attention.

In 1883, Francis Galton published *Inquiries into Human Faculty*, in which he coined the term 'eugenics'.[19] Eugenics was a rhetoric and pseudo-science that aimed to 'improve' society by selecting individuals that corresponded to certain criteria of excellence and ensuring that they reproduce among themselves so that society would eventually be constituted of only the best humans. It was essentially selective breeding. But of course, the criteria of excellence were elitist and racist, as well as ableist. Eugenics was grounded in the idea that intellectual traits and physical abilities were inherited, and it was anchored in a very clear obsession with inheritance, ancestry and ensuring that the 'best' of the British people would remain in control of society. Eugenics stems from fear and disgust towards difference (especially the mixing of people from different ethnic origin and the reproduction of disabled people) that was so visceral that it called for the eradication of some individuals who were not 'perfect'. Unsurprisingly, it inspired much Nazi propaganda, but while its scientific credentials have been discredited, many still vouch for its principles. Most recently, we saw this demonstrated during the worldwide pandemic with discussions of herd immunity that originated in eugenicist thinking. The past is never really just in the past.[20]

From the very beginning, Petrie was interested in Galton's data collection, and Petrie's own classifications were of interest to Galton and other eugenicists. As Debbie Challis, author of *The Archaeology of Race*, noted, 'their mutual interest in race and defining different racial types in antiquity was shared with a wider number of individuals working in archaeology'.[21] This

inspired Petrie's studies into skulls, and his consistent interest in collecting skulls from Egypt and Palestine. Petrie was also interested in the visual representations of scientific data, and skulls could serve this purpose, as we have seen with research into skulls in the eighteenth and early nineteenth century.[22] When Karl Pearson, a biostatistician and mathematician at UCL and an avid eugenicist, put out a call for skulls to be collected in order to define racial difference, Petrie responded immediately and sent 100 skulls from his excavation at Naqada in 1894. Pearson wrote during this period:

> My view – and I think it may be called the scientific view of a nation, is that of an organized whole, kept up to a high pitch of internal efficiency by ensuring that its numbers are substantially recruited from the better stocks, and kept up to a high pitch of external efficiency by contest, chiefly by way of war with inferior races.[23]

By supplying skulls, Petrie was deliberately helping along this programme of classification and eradication. But there is more to this story. The skulls that Petrie proposed were Naqada skulls, that is, the skulls of individuals who lived in ancient Egypt during the earliest period of its civilisation. This is the period Petrie was the most interested in – the Predynastic period – which is why there is such a substantial collection of Predynastic pots in the Petrie Museum of Egyptian Archaeology today. Except that Petrie had a theory about these early pots: that they belonged to a 'new race'.[24] According to Petrie, the skulls from Naqada belonged to a 'new race' that had a racial superiority over the local populations, and he asserted that this 'new race' was the one that had brought about the great ancient Egyptian culture.[25] Just like Cuvier had done before, Petrie used his academic

position and his connections inside an important institution to legitimise two racist theories: the first about the superiority of one race above another in his own time, and the other contending that an African population did not originate the civilisation and monuments that we now see in Egypt. Today, therefore, we have a museum in central London that hosts a considerable collection of material culture, and some human remains, but that is also the repository of a history that links archaeology, Egyptology and pseudo-science.[26] The inquiry into the history of eugenics at UCL is important and has already led to the renaming of some of the university buildings. There is another, equally important story in Petrie's work that helps us understand the pervasiveness of racist theories related to the ancient (and modern) Egyptians: the idea that 'other' people built the ancient Egyptian civilisation.

The truth about aliens

A man explains with all seriousness that there is tangible evidence of 'help given to an earthly civilisation by ancient aliens' that explains the engineering of the pyramids in Egypt. Egyptians could not build great monuments without aliens.

'So, one answer would have to be they had gotten it from ancient aliens. Might the early Egyptian builders have had access to extra-terrestrial knowledge and technology, or might the ancient builders have been aliens themselves? According to ancient astronaut theorists, the answer is yes.'[27] This is not the scenario of a science fiction movie, but twenty-first-century documentary-making. The *Ancient Aliens* multi-episode series is an American television production released in 2009 and

initially broadcast by the History Channel. In 2020, it was in its sixteenth season. In December 2010, the programme had over 2 million viewers for a single episode. Today available on major streaming services worldwide, *Ancient Aliens* is tedious watching, and at times can appear humorous. But one episode, 'Alien Engineering', is very serious about one thing: the ancient Egyptians – the people of Egypt, located on the African continent – could not have built pyramids or other architectural complexes without exterior help. While some thought it might have been a white European group that built these monuments and then left, and others considered invaders from neighbouring countries, others again thought that white Europeans built them, stayed, and then their race 'degenerated'. This documentary, however, proposes that it was quite simply an alien people that came, built the pyramids and other temples, and then did not like it there and left. These theories have in common one principle: to explain the building of majestic and skilful constructions in Egypt, we must look elsewhere.

How about outer space?

As early as 1898, science fiction writer Garrett Serviss wrote *Edison's Conquest of Mars* in which he posited that aliens built the pyramids. A century later, in 1968, Erich von Däniken published *Chariots of the Gods? Unsolved Mysteries of the Past*, one of the first hugely popular books to explore the idea that ancient civilisations were built by aliens – and this time the book did not present this as fiction but as fact. It has sold 65 million copies around the world. Today, shows such as *Ancient Aliens* continue the dissemination of the alien theories. In 2020, Elon Musk, who is developing plans to colonise Mars, declared to his 55 million followers on Twitter that 'Aliens built the pyramids.'

What have aliens got to do with Egyptian mummies and the return of the White mummy?

The alien trope is a recurring one, and yet few realise how rooted it is in deep racism and the exclusion of Egyptians from their own narrative. At the core of it is the idea that something we might not comprehend today – such as the full extent of the construction skills that were needed to build the pyramid structures – is a clear sign that ancient people could not have done it. It is the pervasive idea that civilisations evolve and progress, and that therefore we are entirely superior today in skills and intelligence to people who lived before; the idea that something we cannot understand or replicate today could not have been produced in the past. On top of that, the fact that the ancient Egyptians were a multiethnic people located on the African continent means accepting that the ancient Egyptians did build those structures, which in turn means accepting not only that ancient people could do something we do not understand today, but also that it was non-western and non-white people who did it. While the likes of Cuvier and Granville wanted to prove that the ancient Egyptians were a white people, the alien theories suppose that the achievements of the ancient Egyptians belonged to a species entirely alien to this planet. In both cases, they assume and assert that the ancient Egyptians – a non-white, multicultural people from the African continent – could not possibly be at the inception of grand developments in medicine, architecture, mathematics, the arts and astronomy, among others.

The ancient Egyptians need to have been white, or to have been aliens. Whichever works best to maintain a comfortable illusion of white supremacy. These are racist theories.

The alien theories are not just harmless jokes based on fictional writing or the genuine ideas of the deluded, they are

violent theories that reinforce harm and trauma. And sometimes they have led to destruction too. In 2014, for example, German pseudo-scientists damaged an inscription naming a king in the Great Pyramid on the Giza Plateau, linking their action to conspiracy theories relating to Atlantis.[28] These alien theories are not limited to ancient Egypt, but also target architecture in Zimbabwe, in Sudan and in South America.[29] But the greatest harm is not in the destruction of sites, but in the general humouring of these racist theories that continually diminish the history, culture and intellect of the ancient and modern populations of these regions, and as such reinforce inequality generally. As Julien Benoit noted:

> Who cares if relatively few people don't believe the ancient Egyptians built the pyramids? What's the harm? Actually, there *is* great harm: firstly, these people try to prove their theories by travelling the world and desecrating ancient artefacts. Secondly, they perpetuate and give air to the racist notion that only Europeans – white people – ever were and ever will be capable of such architectural feats.[30]

While many individuals do believe in these theories, others watch such documentaries with amusement, unknowingly tolerating their relationship to racism.

They might be 'silly' theories, at odds with education and science, but how can visitors to museums with Egyptian material culture know about the pervasive history of the whitewashing of Egyptian achievement if these stories are not told and interrogated? Let us return to the Musée de l'Homme for a moment, a museum we left in the last chapter when the remains of Saartjie Baartman were repatriated to South Africa. The story of this museum is unfinished.

Mummified

Untold museum stories

In 2017, the Musée de l'Homme in Paris organised a comprehensive exhibition on race studies and racism over the ages. Comprehensive? It quietly omitted its own history of displaying Black bodies to prove their inferiority.

We are walking by the Arc de Triomphe in Paris. The 'Étoile' (star) is an impressive crossroads, which on a busy day is a dizzying mass of cars trying to make their way down the Champs-Élysées. Once you escape the hustle and bustle of this famous avenue, you take the avenue Kléber, and walk down to the very end of it. In front of you, another intersection gives place to the Place du Trocadéro. Its view is unparalleled: two large buildings frame one of the most famous monuments in the world, the Eiffel Tower, which bears the name of Georges Cuvier, among others. But it is the building on the right that has caught our attention: a building with a well-hidden link to Cuvier.

This is the Musée de l'Homme, or museum of mankind. Recently renovated, it is a masterpiece in museum concealment. Let us explore this place, which has as its guiding principle an 'active commitment to the equality of all human beings in all their diversity'.[31]

The Musée de l'Homme is a museum with a complex history.[32] Once, I visited its library looking for documentation and I was told that some of what I was looking for was in the Muséum national d'Histoire naturelle (MNHN), some here at the Musée de l'Homme and some at the Quai Branly, all in Paris but in separate locations. I was told, as well, that these three museums were all on poor speaking terms. 'It's like a bad breakup', the documentarian told me. What caused this museum breakup, which was complicating my doctoral research? A combination of disciplinary feuds, changes in museum purposes and needs,

174

and a very French sense of administration. The Musée de l'Homme, created in 1937, is run by the MNHN, and for historical reasons holds the MNHN's collection of human remains. When the Musée du Quai Branly opened in 2006, the collections were split up, and it seems this did not go down well with all concerned.[33]

On 31 March 2017, the Musée de l'Homme opened its first major exhibition since its reopening in 2015: *Us and Them, from Prejudice to Racism*. A highly interactive exhibition, it questioned understandings of difference, through various intellectual, geographical and historical frames. In a room dedicated to the historical development of racial thinking, a series of individuals were mentioned, including Johann Friedrich Blumenbach and Georges Cuvier; you will remember the latter is a founding figure of the anthropological collections that are now in this museum, and we have discussed his violent acquisition and dissecting of Saartjie Baartman. While Baartman was mentioned in the exhibition, her link to Cuvier and the Musée de l'Homme – where, let us remember, she was displayed to the public until the 1970s – was not mentioned at all. In fact, today, if you visit the Musée de l'Homme, you will have a hard time finding any visible information on the history of this museum – yet the markers of race studies are everywhere in the collection, and one display in particular stands out.

The cast display.

The Musée de l'Homme holds a collection of bronze and plaster-cast busts, including some on display in a new installation called 'L'envolée des bustes'. The plaster busts are casts made from living models. This is the legacy of yet another colonial practice in nineteenth-century France: that of the display of living individuals. In 1877, a new type of exhibition was presented

in the Jardin d'Acclimatation, located in the west of Paris: a number of animals from Somalia and Sudan were put on display in the garden, together with fourteen 'Nubians'. These were real living people, displayed like animals.[34] Outside public opening hours, these individuals were studied by anthropologists to explore questions of race, in much the same fashion as Saartjie Baartman was studied by Cuvier. The Société d'Anthropologie de Paris noted on this exhibition that:

> Men of science, those who are especially concerned with anthropology, did not wish to allow such a good opportunity to study a group of humans from the great African continent to pass them by. As soon as it heard of the exhibition, the Société d'Anthropologie immediately designated a committee under the direction of its eminent general secretary, Dr Broca, charged with careful examination of the natives camped at the gates of Paris.[35]

This kind of exhibition was by no means unique in a climate of interest in the study and display of 'otherness', both as living people and as casts. Such exhibitions proved immensely successful, and although there was some criticism from a few isolated members of the Société, the general reception by scientists was favourable. But soon enough, these exhibitions lost their scientific emphasis and focused on the production of spectacular shows. This form of entertainment was popular for many decades: the 1931 Paris Exposition Coloniale Internationale, which took place only a few years before the opening of the Musée de l'Homme, included a similar showcase of living people.

The Musée de l'Homme is host to a number of casts that come from a similar interest in the representation and characterisation of individuals, not according to their name, but their ethnicity. As we have seen, the display called 'L'envolée

des bustes' includes two types of bust – bronze and plaster casts – in a new display that sees these individuals displayed together in what is meant as an aesthetic and artistic display. The bronze busts were created by Charles Cordier, who produced busts for the Museum's precursor (the Ethnographic Gallery of the MNHN) from 1851 to 1866.[36] The website of the Musée de l'Homme states that the casts 'served as the basis for nineteenth-century hypotheses on the characterisation of the human species and remains an internationally representative reference on human diversity'.[37] Rather than exposing the history of the characterisation of individuals according to racially biased theories, the new display is reinforcing the study of racial characterisation. There is little-to-no narrative accompanying the display, and nothing to explain why these items came into the collection. More importantly, there is no justification as to why they are on display now, or why the choice of display strategy turned these important and controversial objects into an aesthetic exhibition. Even more controversial is the choice to include, behind this structure, the busts of some men who were involved in the scientific study of races – including Geoffroy Saint-Hilaire, who was a great supporter of the display of people at the Jardin d'Acclimatation, and Georges Cuvier.

Can the Musée de l'Homme act as a laboratory-museum celebrating humanity as one, while rejecting from its storyline the historical links it has to some of the most divisive chapters of history? Where is this museum located in contemporary conversations on colonial collecting and the curation of human remains more generally?

Today, the museum holds an extensive collection of human remains, including thirty-three Egyptian mummies, as well as fifty-two isolated mummy heads from Egypt and South

America, and other body parts.[38] The website states that 'for reasons of conservation and ethics, they [the mummies] are rarely displayed in public'.[39] However, the Egyptian mummy of a small child is on display at the museum today in the space dedicated to death, next to a Peruvian mummy; neither has any information on display about its provenance or acquisition.[40] In fact, the museum has an extensive collection of human remains on display that includes the skull of René Descartes (which was collected by Cuvier after being lost during a transfer and passed from hand to hand throughout Europe) and a number of European skulls. Can the museum champion the ethical treatment of human remains when it has on display the mummy of an Egyptian child, a Peruvian mummy, and a stolen skull, the body of which resides in a tomb in Paris?

The year 2018 saw the release of a report commissioned by French President Emmanuel Macron on African heritage in French museums. It was the first step in the Government's plan for temporary or permanent restitution of looted material culture and human remains retained in French cultural institutions. The report is known as the Sarr–Savoy report, after its two authors: Felwine Sarr and Bénédicte Savoy.[41] The release of the report generated a huge amount of attention, in particular around the Musée du Quai Branly in Paris and its collection.[42] Strangely, the Musée de l'Homme seldom appeared in conversations on the future of French museums. This is surprising considering its collection of contentious human remains. There are also the ties that both the Quai Branly and the Musée de l'Homme have to the MNHN, which has been the recipient of objects and human remains that were directly linked to scientific racism and colonial heritage. Were the revamp and rebranding of the Musée de l'Homme so successful that France

has collectively forgotten this museum's history? The current debates surrounding the Musée du Quai Branly and the Sarr–Savoy report suggest that this cultural amnesia surrounding collections from colonial eras is going to be challenged and that we can finally hope that the contemporary relevance of these collections will be questioned.[43]

<center>★</center>

You are in a museum's indoor court. The view is impressive, dazzling – dizzying, even. Where to start? On your right is the great Egyptian gallery with its colossal sculpture. The Egyptian mummies are upstairs. Africa? Downstairs.

This is the British Museum, a museum that has dedicated two floors to the great ancient Egyptian civilisation, separated clearly from anything to do with the rest of the continent it is located on. But this could be the Louvre too, where the ancient Egyptian galleries cover two very large floors, separated not only from African art, but also from Islamic and Coptic art. In the museum world, Ancient Egypt exists in a vacuum. And more often than not, ancient Egyptian artefacts are displayed next to the Greek and Roman sections, far, far away from the production of its continent or even its current inhabitants. In the twenty-first century, the ancient Egyptian civilisation is still idolised by museums, institutions that seem to be concerned that affiliation with the rest of Africa might tarnish the image of this civilisation.

Two floors for ancient Egypt, a basement for Africa. This is the contemporary museum worldview.

The British Museum, not unlike the Musée de l'Homme, is the host of untold stories that relate to the complex relationship between Egypt in Africa and race studies. You will remember the 1821 dissection of a mummy by Augustus Bozzi

Granville, with the purpose of observing the racial origin of the ancient Egyptians. The remains of this thorough examination were kept in a wooden box with quite an inventory: parts of a dissected body, parts of a 'North-African' mummy that Granville used as a comparison with the Egyptian mummy, four human foetuses, and four miscellaneous arms and a leg belonging to persons unknown. These latter were used by Granville to experiment with mummification. The box remained in Granville's possession until it was purchased by the Trustees of the British Museum in 1853.[44] The box was initially on display, but Granville was unhappy. It was placed in the Egyptian rooms 'not displayed in the manner best adapted for the instruction or the amusement of the public'.[45] Granville was quite upset that his wooden box was not visible *enough* to the public; today, the box is not on public view at all. It is a highly problematic object, with its involvement in offering evidence, according to Granville, of the Caucasian origin of the ancient Egyptians. It is precisely because it is such a problematic object, though, that its history needs to be addressed.[46]

The legacies of race studies are pervasive, and they are not solely reflected in which objects are on display and which are not. Categorisation in museums is a silent set of hierarchies and divisions, and nothing is more revealing of this than the categorisation of objects according to supposed geographical distinctions. The origins of the ancient Egyptians is a topic that is still current: from Afrocentrism, to continuous DNA testing of dead bodies (an invasive process, let us not forget) to understand the ethnic origins of the ancient Egyptians, to heated online debates, to museum categorisation and the erasure of historical narratives in museums. There is no doubt that the origins of the ancient Egyptians, and their relation to the modern Egyptians,

is at the heart of any conversation on Egyptian mummies.[47] Ignoring those conversations is not just unhelpful, it is harmful. As Angela Saini noted in *Superior: The Return of Race Science*, 'there are plenty of ignorant racists, but the problem is not ignorance alone. The problem is that, even when people know the facts, not all of them actually want an end to racial inequality, or even to the idea of race.'[48]

Chapter 8

The mummy of the future

A man is playing tennis in London. Close by, someone is meditating in a yoga position. You can join in too, resting on loungers, listening to soothing music. That is, if you do not mind being surrounded by desiccated cadavers.

On a stormy day in May 2019, I was making my way to a newly opened exhibition in London. It had previously been touring the world, but found its permanent home in an impressive building dominating Piccadilly Circus, taking over from the former Ripley's *Believe It or Not!* show for a ten-year stint. This was an exhibition like no other: a display of cadavers pretending to act like living humans. But this was not Madame Tussauds. The cadavers were real, made of human flesh and bones, from deceased people who had, supposedly, donated their bodies to this showcase. That day, I was visiting the infamous *Body Worlds*.

The *Body Worlds* exhibitions have been touring the world for over two decades, taking with them controversies wherever they go. This time they had set up shop in one of the most visited locations in London, with photographs of human remains 'in the flesh' plastered all over London, on buses and the tube,

so that whatever your feelings about bodies or museums, you were subjected to the sight of cadavers on your daily commute. Unlike other exhibitions of human remains in England, this one is commercially motivated and privately owned. *Body Worlds* is the brainchild of a man named Gunther von Hagens, who uses a preservation technique he calls plastination. In his own words, 'Plastination creates beautiful specimens as a sensuous experience that are frozen at a point between death and decay. Thanks to this realistic quality, plastination represents the most attractive form of exhibiting durable human specimens.'[1] The process of plastination was developed in 1977 and consists of replacing the water and lipids in deceased bodies with curable polymers (plastics), after which the bodies are made to assume life-like positions. The technique was originally practised on separate organs before Hagens started applying it to complete bodies and animals in the 1990s. The current London exhibition in Piccadilly Circus contains around 25 plastinated full bodies and over 150 tissues and organs.[2] This is not your usual conservative display of dissected bodies in medical collections: at *Body Worlds*, full bodies are displayed in active, lifelike positions, which include highly theatrical staging. For example, a scene presents three men (without their skin, leaving their flesh visible) playing poker around a table, while another shows an individual meditating in a yoga pose, while a woman is seen dancing, and a man is riding a plastinated horse. Some bodies still have their skin on, while some are partly dissected, and others have only their veins and bones left. One individual is even carrying his own skin. These highly sensationalised positions and scenes are complemented by a large number of dissected body parts on display – for example, organs that have

been altered by various illnesses. The human remains are accompanied with explanations of their bodily functions, but there is no information at all about the humans themselves. They are completely anonymous.

The *Body Worlds* London exhibition is framed around an educational purpose: if you come here to learn about the body and its function, what better way to do so than by peering at the insides of bodies? In reality, there are many problems with *Body Worlds*.[3] It lacks medical references, and has no disability representation whatsoever;[4] there are issues with its depictions of gender and sexuality;[5] there are many foetuses on display, including a woman who died in pregnancy carrying a foetus in her womb. *Body Worlds* is ableist and heteronormative, but it has also been condemned on countless occasions for the very obscure provenance of its human remains,[6] against a backdrop of accusations of the body smuggling of prisoners.[7] None of this sounds too dissimilar to the eighteenth-century scenarios we have encountered.[8]

Body Worlds is an exhibition that makes money by employing showmanship to make a spectacle out of dead bodies.

Professor Dame Sue Black, an acclaimed professor of anatomy and forensic anthropology, wrote about such popular exhibitions that:

> It is this sense of responsibility that underpins my personal views on the public display of cadavers and the tipping point at which this can no longer be justified as educational and becomes nothing more than ghoulish voyeurism. Charging a high admittance fee in the name of education to bring in the public to gasp at cadavers as if they were playing chess or riding a bike, or vulnerably exposed in their third trimester of pregnancy, does not make such an exhibition educational. I find the showmanship element

distasteful and cannot think of any circumstance in which I would ever support such a commercial venture.[9]

The subtitle to *Body Worlds* is *The Museum Experience*, although it is in fact a commercial exhibition and does not fit the contemporary definition of a museum, with all the responsibilities that entails. While the very definition of a museum is ever changing, in 2019, the International Council of Museums (ICOM) proposed this:

> Museums are democratising, inclusive and polyphonic spaces for critical dialogue about the pasts and the futures. Acknowledging and addressing the conflicts and challenges of the present, they hold artefacts and specimens in trust for society, safeguard diverse memories for future generations and guarantee equal rights and equal access to heritage for all people.
>
> Museums are not for profit. They are participatory and transparent.[10]

It is clear that *Body Worlds* is not a museum at all: it is for profit above all, and it defies every ethical guideline that museums have to follow. In fact, *Body Worlds* is not required to have an ethics committee, and does not answer to or follow ethical standards on acquisitions, consent, retention and display, and its narratives and contents are not challenged by anyone internal or external to the institution.

Body Worlds, in its sensational public display of dead bodies, is a lesson in what the future display of ancient Egyptian human remains might look like if we do not stop to ask these questions:

Why are Egyptian mummies still on display in museums today? What is their educational, scientific and emotional purpose?

Where do we go from here ('we' meaning not just the museum, but you and I)?

The past few years have demonstrated that there are new challenges brought about by new technologies, and that the future of Egyptian mummies, if we are not careful, could be a bleak commercial showcase comparable to *Body Worlds*. In this final chapter, I want to take you on a journey to the future. From a voice reconstruction to virtual unwrapping, from redisplay, removal from display and the angst at never seeing a mummy again, to talking about the hard topics, about life and death; it is a future that is uncertain and full of possibilities, a future that we have the power to shape.

Giving mummies a voice

'The Egyptians placed such emphasis on maintaining the offering cult and speaking the names of the dead that they might have been horrified by museums' displays of anonymous mummies.'[11]

This comment, by late Egyptologist Dominic Montserrat, was an important one: museums have been displaying nameless Egyptian mummies for too long. At times, a simple label – often just 'mummy' – is used to refer to the real, ancient people who had been so concerned with their names being remembered. At the Louvre, for example, you will not meet Pacheri when you visit; instead you will meet a 'momie' (mummy). He is nameless, with little identification, resting in a case with objects that do not even belong to him; the canopic jars (jars meant to receive your internal organs) that are displayed with him are not even his, nor is the mask resting next to his face – but you will not

know this when you visit him. He is an unidentified wrapped *thing*, displayed with randomly picked objects. The label does not even state that he is made of human remains at all, but instead just notes the presence of linen and cartonnage (a type of papier mâché decorated with paint).[12]

To quote the Goncourt brothers, the human mummy at the Louvre is 'death in a bundle'.[13]

Montserrat's comment about the naming of the name, and making the ancient Egyptians heard and known for eternity, has encouraged positive changes in temporary and permanent exhibitions. At the Ashmolean Museum in Oxford, for example, not only is the name of the displayed mummy written down, but the formula for the afterlife written on the coffin has been translated, while the exhibition *Digging for Dreams*, curated by Montserrat, not only protected the human remains with linen shrouds, but also invited visitors to read out the name of the deceased and formulas translated from ancient Egyptian.[14] But the concept of keeping the name alive was also reused recently for a bleak and controversial project: a twist on the concept of making a mummy's voice heard, in the name of science.

*

It is January 2020, and the internet is buzzing with words of a mummy coming to life. At last, we could talk to an actual ancient person and learn more about his life! This was the premise of a newly released study. That month, researchers from the United Kingdom announced that they had, in their words, 'successfully' recreated the voice of an ancient Egyptian mummy using 3-dimensional modelling.[15] They modelled the voice of this long-dead Egyptian, who was named Nesyamun, and shared the recording of the voice together with images of

his unwrapped body online. The team involved noted that, in ancient Egypt,

> It was also a fundamental belief that 'to speak the name of the dead is to make them live again' (alternatively translated: 'a man is revived when his name is pronounced'), both by living relatives and by the deceased themselves when appearing before the gods of judgement. Only those able to verbally confirm that they had led a virtuous life were granted entry into eternity and awarded the epithet 'maat kheru', 'true of voice', as applied to Nesyamun himself throughout his coffin inscriptions. In these texts, Nesyamun asks that his soul receives eternal sustenance, is able to move around freely and to see and address the gods as he had in his working life. Therefore his documented wish to be able to speak after his death, combined with the excellent state of his mummified body, made Nesyamun the ideal subject for the 'Voices from the Past' project for which his body was re-examined using state-of-the-art CT scanning equipment.[16]

The result: a single sound, made from the manipulation of a dead person's dry vocal cords. The newspaper headlines read 'This ancient talking mummy is now the new internet sensation!'[17] and 'This mummy speaks, but it doesn't say much.'[18] Nesyamun, like many of the ancient Egyptian people you have met in these pages, had been unwrapped as part of a scientific investigation in 1824.[19] In 2020, this repeat performance reached a much wider audience and attracted a great deal of media attention.[20] The BBC reported:

> Archaeology professor John Schofield, also of the University of York, told the BBC it was Nesyamun's 'express wish' to be heard in the afterlife, which was part of his religious belief system. 'It's actually written on his coffin – it was what he wanted', Prof.

Schofield said. 'In a way, we've managed to make that wish come true.'[21]

This one grotesque sound, proposed as the only way to keep the mummy's name alive, was played and replayed in the media. Using a very selective interpretation of ancient Egyptian beliefs, they managed to make something that caused hilarity and mockery in equal parts in the press and online.[22] Other than the questionable usefulness of such a study, it is the ways in which individuals spoke *for* the human remains to legitimise such a study that caught my attention: are our displays and our uses of technology simply realising our own fantasies about Egyptian mummies coming to life, under the pretence of respectfully fulfilling their wishes for the afterlife?

Does this have to be the future of Egyptian mummies in museums?

Paradoxically, although they are part of the problem, these new technologies were initially introduced to resolve ethical challenges related to the display of Egyptian mummies in museums. In Chapter 1, we saw how X-rays and then CT scans have transformed the scientific study of Egyptian mummies, especially when it comes to their cause of death, their health and disease, and their genealogy. These CT scans allow us to view the body, under the wrappings and the skin, without damaging anything.[23] In recent decades, they also served a new function, by offering an alternative format of display. Initially, X-rays and scans started to be used in museums as photographic evidence of the information on display, sometimes illustrating causes of death. Progressively, new technologies including touch screens were introduced in exhibitions of those bodies to bring them to life, through what is known as virtual unwrapping.

The British Museum has been at the forefront of the use of these new technologies in Europe.[24] In 2004 and then in 2011, the British Museum produced a temporary exhibition, *Mummy: The Inside Story*, with an individual named Nesperennub as a focal point of the exhibition.[25] Nesperennub was a male priest who lived in the Third Intermediate period (*c.* 800 BCE), and was buried in Luxor. He was excavated in the 1890s and displaced by Wallis Budge to the British Museum.[26] The body and the case were shipped by the company Moss of Alexandria in 1899. We know from the coffin inscription that Nesperennub was a priest in the temple of Khonsou in Karnak. In 2000, the body was examined via CT scanning, thanks to a collaboration between the British Museum and Silicon Graphics Inc. From the scans, we learn that the individual died at the age of about forty and had bone disease. The temporary exhibition at the British Museum consisted of an interactive board, where visitors could proceed to investigate the mummy using a touch screen. The touch screen was located in the room where the mummy was displayed at the museum. This was part of an active consultation with the public. The response was positive, and this led to the development of a larger exhibition, *Ancient Lives, New Discoveries*, which opened in 2014, and has been touring ever since.[27] This exhibition focuses on eight individuals from Egypt and Sudan, covering a large time span, from the Predynastic to the Coptic period in Egypt. The bodies on display had been preserved through the two techniques we saw in the introduction: natural and artificial preservation.

Each mummy has a story to tell. This was the premise of the exhibition, which focused on the lives of these individuals, instead of the culture of the afterlife and death. One of the interactive boards in the exhibition allowed visitors to physically

engage with the technology by conducting the virtual unwrapping of a man using a touch screen that removes the layers of the scan. This also rotated the body – so it seems the inventor of the rotating mummy had a legacy to offer, after all.[28]

This technology has huge potential. It allows scientists to learn a tremendous amount about the ancient Egyptians, but also about diet, climate, health, mobility, population and so on. We are learning more than ever about the ancient Egyptians and their lifestyle; we are also able to make more and more information available to the public via ever-evolving display strategies. All of those advances in learning are being made at an incredibly fast pace – and in the case of the mummy's voice, it happened so fast that nobody stopped to ask: is this necessary? Where is the boundary? Do we really need to hear a single sound made from dried vocal cords that have been printed and manipulated, and do not actually sound like anything at all?

The great challenge of technological changes lives in these endless possibilities, with very few limits to what is possible, and little time to reflect on what's actually needed. But there is another challenge that comes from the new visitor interfaces that appear in museums around the world in the display of ancient Egyptian human remains. The touch screens that allow virtual unwrapping are often presented as a non-invasive, and more ethical, way to glimpse under the wrappings of these mummies. The screen is the new ethical solution. *Or is it?* How do we weigh the ethical values and implications of this interaction with mummies against past interactions? Is a visitor virtually unrolling a mummy much more ethical than historical mummy unwrappings, or is it equally intrusive to a dead person who gave no consent to their insides being displayed to all? What if the virtual unwrappings offered to the public today

are just the twenty-first-century equivalent of public unrollings? The latest technologies used by curators to bring new life to mummies are changing our understanding of the ethics of displaying bodies, but if we put them at the most recent end of a historical timeline, they are not all that different from when spectators paid to attend the unrolling of a mummy in nineteenth-century London. Of course, they are non-invasive physically in that they don't destroy the mummies, but how invasive is it to have one's organs on display for public enjoyment and curiosity? This equation of 'non-invasive' with 'non-destructive' rather than 'respectful' or 'humanising' means that we are finding exciting new technological methods to objectify the mummies all over again.

As visitors, we participate in these voyeuristic experiences that are offered to us, but do we question *why* we participate?

The challenges of technologies and their role in the display and study of human remains are only going to increase as new methods develop. The proliferation of images of human remains online is already out of control.[29] On social media platforms, entire accounts are dedicated to the dissemination of images of human remains from different cultures,[30] while the sale of looted human remains online is allowed because of a lack of restrictions, combined with a notable absence of any loud awareness-raising or visible condemnation of the practice.[31] Blogs, websites and other online forums are making conversations on ethics in museums more accessible to the general public, but at times they are part of the problem, hosting the next press release containing frivolous and dehumanising stories about Egyptian mummies.[32] There is a deeper conversation that comes from these new technological challenges, a call to return

to the roots of museum display and to ask: why do we display these human remains, why do we feel entitled to see them and what is the next step in the future of these interactions? Let us continue our journey to the future…

To display or not to display

The case is dark. It looks empty at first. But if you come just a little closer, it lights up, and in the glass box is lying an old woman, covered with a shroud. She is the surprising symbol of a museum revolution.

Her name is Asru. She was a singer in the temple of the god Amun during the twenty-fifth dynasty in ancient Egypt, and possibly lived in Luxor. While Asru had a life in ancient Egypt, her physical afterlife is spent in Manchester, England.[33] She was taken to the city in 1825 and donated to the collection of the then Manchester Natural History Society by Robert and William Garnett. She was unwrapped there, and her wrappings are now completely gone.[34] In 1868, when the collection was auctioned off, she was donated to Owens College and later became part of the collection of the Manchester Museum. Ever since, she has been the symbol of an ever-evolving question: what should one do with displaced Egyptian mummies held by museums around the world?

Between 2008 and 2012, the Manchester Museum led a public conversation on its display of Egyptian human remains. It initiated some radical changes to its display, in various stages. At one point, three of the mummies – all unwrapped bodies – were covered up entirely with a shroud, while still on display.

Curator Dr Karen Exell noted, during the early stages in 2008, that:

> Last week, the unwrapped mummy of Asru, and the partially wrapped mummy of Khary, and the loaned child mummy from Stonyhurst College, were covered. The covering was carried out in order that the human remains be treated with respect and to keep the bodies on display in line with the Manchester Museum Human Remains policy.[35]

The public consultation resulted in generally negative responses,[36] and the *Manchester Evening News* reported that 'Manchester Museum has reversed its decision to cover up its Egyptian mummies in response to public opinion. The museum covered up three unwrapped mummies on display, sparking accusations of political correctness, two months ago.'[37] Different options were tried and tested, and public opinion probed. At the reopening of the galleries in 2012, the body of Asru was, this time, partially covered with a linen fabric that stretched from her ankles to her neck, and set in a case partially obstructing its view. You had to come really close to see the body. This not only meant that Asru was less of a focal point, but it also afforded visitors the choice to view the mummy, or instead to visit the galleries without having to be confronted with a dead body.

For the past four decades, the Manchester Museum has led the study of ancient Egyptian bodies, in particular via a collaboration with the Manchester University NHS Foundation Trust, allowing access to medical imagery. Manchester is also the location of extensive studies into mummy tissues, via the Mummy Tissue Bank.[38] As I write, the galleries are closed, and the mummies are destined to be re-exhibited with more

contextual information, following current conversations on the ethics of display.

When bodies are removed from display, or when displays change and do not fit expectations, visitors often have strong reactions – and so do some curators and academics. In the autumn of 2019, I saw this first-hand. I was a guest lecturer at a conference on human remains in Turin, Italy, where I presented the idea that we should view Egyptian mummies as displaced people. We looked at this in Chapter 2: that forced displacement is an important practice to keep in mind when we think about the presence of these bodies in museums in the context of colonialism, looting and racism.

'But, if we are to think of Egyptian mummies as displaced people, does this mean we have to give them back?', said a man in the audience, bemused by my suggestion.

A world without visible Egyptian mummies on display. There were a lot of strong feelings in his question, and also quite a few misconceptions about who refugees and displaced people are, as well as what they want. But the overwhelming reaction was this: entitlement.[39] I responded that, of course, if Egyptian mummies are the subject of calls for repatriation, then they should be sent back. They are humans who have been displaced to foreign countries, and they should be able to return home. But restitution was not the focus of what I was discussing: I was simply pointing out that these are displaced people, that they have been forcibly removed from their country during times of violence, and they should be seen as such. The Museo Egizio was an ideal location to have this discussion, as it is at the forefront of positive engagement with refugees and displaced people, as well as looking at innovative ways to signal the presence of human remains to its audience.[40]

The idea that it is our right, as westerners, as museum visitors, to see the human remains of others is engrained in our consciousness. When human remains have been removed from display – or even when the idea that they should not be there in the first place is brought up – this feeling of entitlement, of our right to see these bodies, often comes into full focus. We have been brought up with the spectacle of these bodies on our TV screens, in comics and films, in documentaries, and in museums. They have been commodified, and commercialised to the point where they are non-human cultural objects to most of us. It is uncomfortable to be faced with the stark reality that we have been using ancient dead people for our enjoyment and learning, without asking questions.

Today the public discussion in museums centres on removal and restitution.[41] This is a very relevant and pressing question when it comes to extra-European human remains. In 2020, the Pitt Rivers Museum in Oxford announced that it was removing all human remains from display.[42] While the headlines focused on the removal of tsantsas (known to the public as shrunken heads), Egyptian mummies were removed too. In total, 120 bodies and body parts were taken to storage. The museum director, Laura Van Broekhoven, pointed out that 'our audience research has shown that visitors often saw the Museum's displays of human remains as a testament to other cultures being "savage", "primitive" or "gruesome" '. Van Broekhoven continued: 'Rather than enabling our visitors to reach a deeper understanding of each other's ways of being, the displays reinforced racist and stereotypical thinking that goes against the museum's values today. The removal of the human remains also brings us in line with sector guidelines and code of ethics.'[43]

The decision led to intense conversations on social media, fuelled by this sense of entitlement that so many share. Many visitors complained that it was their favourite display in the museum, and they were upset that this imagined right had been taken away from them. To feel outraged that looted or displaced objects are taken away from you when they are removed from display, but not especially bothered that they have been taken away from their own communities: that's entitlement.

The removal of Egyptian mummies from display is not, however, a simple outcome – even when it is needed or wanted. Once removed from display, Egyptian mummies are kept deep within museum storage facilities, and their afterlife there is quite opaque. I have spent time in museum stores on many occasions, and while conservation is usually (not always) done properly to ensure the bodies do not decay, they are often relegated to shelves, and at times I have seen them in boxes on the floor in large national museums, labelled with a simple handwritten tag. Relegated to a shelf or to the floor of a side room today, as they were in the early years of the Egyptian galleries at the Louvre. Is this a dream afterlife for Egyptian mummies? Would they mind? Only they could tell us. But as we have seen many times, the ancient Egyptians who could access mummification had imagined their afterlife underground, with their treasured funerary objects, undisturbed other than by those bringing offerings.

We have seen in the pages of this book that often, throughout history, Egyptian mummies never made it to display in European museums, and instead were crowded into museum storage, over-collected, bodies piled up on shelves, with curators unsure about what to do with them. When Egyptian mummies and other human remains are removed from public display – either

29 & 30 Critical changes to the displays as part of the decolonisation process at the Pitt Rivers Museum. Photographs courtesy of the Pitt Rivers Museum, University of Oxford.

relegated to stores or returned to their places of origin, what do we do with the empty space? Should we refill the gaps, or should the empty spaces remain to show the history of the museum itself? Is the total removal of the display an erasure of history, as many have suggested? There have been successful attempts in museums not just to use the spaces for other things, but to use them to provoke conversations. This is what the Pitt Rivers Museum has opted for, with panels covering some of the empty cases to engage the public in much-needed conversations. These deeper narratives have been missing from museums for a long time.

New technologies could offer new opportunities for mummy displays in the absence of human remains. At the Ashmolean Museum in Oxford, as you enter the grandiose hall, and walk towards the Egyptian collections, there are two small, mummified children on display on your right. They are from the Roman period. Two small children who died so young and were moved to this museum in England. In between the two cases, there is a third body on display – but it is not a human body, it is an artwork, made by acclaimed artist Angela Palmer. *Unwrapped: The Story of a Child Mummy* is an artwork made from the CT scans of one child mummy.[44] Using about 2,500 slides from the CT scan of this small body, the artist created a life-size rendition, made of 111 sheets of glass, each of them with lines drawn on the glass with ink. The lines come from the scans and produce together a 3D image of the child. To see it, you need to move around, allowing the optical illusion to operate. As you move, this child appears. Could the future of the display of human remains be just that – an optical illusion, a rendition of what was once visible and is no more? An intimate and emotional encounter, without needing to peer at a long-lost child?

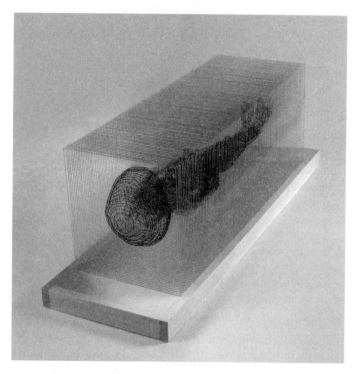

31 Angela Palmer, *Unwrapped: The Story of a Child Mummy*, Ashmolean Museum, Oxford. Photo: A. C. Cooper, courtesy of Angela Palmer.

The future is full of possibilities, if we stop and have an honest discussion about what we are truly viewing.

Death.

*

The object of the curious, and the love of the erudite
Victim of death for four thousand years
Despite death, I remain alive.[45]

The mummy of the future

In 1691, this poem was written to celebrate the arrival of a mummified person in Paris: dead, but alive. A hundred and fifty years later, when Scottish geologist and newspaper editor Hugh Miller visited the Egyptian galleries at the British Museum in the 1840s, he was struck by the ancient Egyptians. It was not their material creations that startled him, but rather the survival of their bodies:

> What most impressed me, however, were the Egyptians themselves – the men of three thousand years ago, still existing entire in their framework of bone, muscle, and sinew. It struck me as a very wonderful truth, in the way in which truths great in themselves, but common-placed by their familiarity, do some-times strike, that the living souls should still exist which had once animated these withered and desiccated bodies; and that in their separate state they had an interest in the bodies still.[46]

The mummies offered something quite different from other objects displayed in the museum: a human connection. For this devout Christian, his encounter with the ancient Egyptians created a closer connection between the past and the present. But there was something else in what Miller envisioned: the possibility of *the mummy alive*. He was not imagining a mummy coming back to life, but rather he was amazed at the preservation of these bodies and imagined that their souls still existed inside. Dead but alive. Of course, Miller's version was shaped by his Christian beliefs, and yet it was not very far from what the ancient Egyptians had imagined: a body that could allow a spiritual entity (often compared a little inaccurately to the soul) to travel between the body and another world, the afterlife.

Mummified

The Egyptian mummy is both dead and alive: physically and in the collective consciousness. And yet, so many see Egyptian mummies today and forget about the crucial part: an Egyptian mummy is a corpse. Behind their astonishing preservation, their fine wrappings and ornate cartonnage, behind the beautifully rendered mask, from the golden ones to the Fayum portraits, when we peer at ancient Egyptian mummified bodies, we stare at death.

This is the mummy conundrum: a displaced body that forces us, from within its glass case, to bear witness to a body that is dead, and yet has survived incredible times. The Egyptian mummy is death and life embodied; it is the rare opportunity to go and visit death, time after time. Today, you can buy a museum ticket, enter a cold museum room and see a future that is yours (death), but also so different from yours (unless you plan on being mummified), and should probably not be yours (should you really stare at this dead person? Would you want thousands of people to stare at you when you're dead?). The body you see is not just a physical materialisation of a dead person. It is also a projection of yourself.

These silent bodies are an invitation to have new conversations. Perhaps this is the imperfect future: one where we share uncomfortable conversations, but also moving stories – one where we see removal and change as an opportunity, and technology as a tool to use wisely. I hope this future is one that is inclusive, one that is certainly more *human* – a word I like to use for ethics. Being ethical is about being more human. That is certainly quite a journey for museums, for you and for me: a human journey I wish for the ancient Egyptian people too, and one that we owe them.

Epilogue

It was the hand that first caught my eye. The closely wrapped fingers. The way the wrappings were delicately, finely draped around each finger individually. Then there was the ear, materialising under the bandages. This was a human being.

Let me take you one last time to the Musée du Louvre. It is a quiet weekday morning. The walk to reach the mummy is rather long, but it is designed to take you on a journey. We are going to start this stroll in the reconstructed funerary chapel of Pharaoh Tuthmosis III. It is a somewhat hidden spot in the Louvre, but you will find it as you walk past the columns room and just before you walk downstairs to the crypt. As you step outside the mastaba, just before you enter the crypt, make sure to look up at the back of the room. Symbols of French power everywhere.

Large stone steps take you down to the crypt, where a large sarcophagus sits in the middle of the room. On either side are beautifully crafted objects. Osiris, Isis and Nephthys are watching over the space. As you take the steps back up, you arrive in a room filled with coffins and sarcophagi made of different materials.

The ancient Egyptian body is not far from here.

As I walk these rooms, which are at times crowded but, since the pandemic, eerily quiet, I think about the journey of these objects, and the ways it is entangled with my own journey. I grew up in these rooms, and they feel comforting to me, but I have learnt that this is not a common experience. I have learnt that these rooms are places of enjoyment for some, but that it came at a great cost to many people, who either cannot visit them or feel the great harm caused by looting and displacement and the violence of colonialism. As I walk these rooms, I remember my mentors: the ones I never met, such as the late curator Dr Christiane Desroches-Noblecourt, and the ones who supported me in the Egyptian department of this very museum when I was an intern. But I also think about my new mentors, Egyptian women who are trailblazers, inspirations and friends. It is because of this museum that I have had the great joy of meeting many people and developing my thinking, not just as a researcher but as a human being learning about life and death and everything in between. All those emotional engagements, with human remains, and with living human beings, can only be authentic with a full awareness of all the stories that inhabit the museum, and its manifestations in other cultural forms, even if those stories are uncomfortable. As you have read these pages, you may have learnt some stories that do not sit quite right with you – stories that are not the ones you have heard before about Egyptian mummies, Egyptology and the museum. It is important to sit with the uncomfortable. What you do from now on, you do with awareness.

I still go to the Louvre and walk around the galleries. I stop by the heavy wooden doors at the very end of the funerary gallery and stay there for a moment, looking at visitors, asking myself that same question I had when I started this book. *Why?*

Epilogue

Why do people come and see the dead bodies of other people? *Do they know?*, I wonder. These questions will never leave me, but I hope someday to have conversations with these visitors. I want to know what their mummy stories are, what they think and how they will become active contributors in the change we need. Before I leave the room, I come closer to the glass case where Pacheri has been displaced, retained and looked after for over 250 years, and I can't help silently saying 'Hello'. Pacheri has been my silent companion for many years, and it is his incongruous presence, in this building of white stone, marble and French symbolism, that has made me want to ask more questions. I suspect I will return to see him again, hoping that one day the information that surrounds his display is more detailed and more contextual than it is now. Perhaps someday I will meet you there, on one of my tours or by chance, and we will share stories about life and death, and the museum.

As I leave this ancient body in its case, making my way back under a modern-day glass pyramid, I think about what a privilege it is to meet an ancient Egyptian person, but I never lose sight of the historically loaded weight of this privilege. I think about the immense joy and privilege it is to know and connect with the living, colleagues and friends and strangers, here and far away, who remind me of what truly matters: recentring the *human* and the *emotional* in all our conversations.

There is pain and trauma in the museum, and there is joy and learning in it too. It is the museum that brought you and me to this journey through life and death and displacement; it is time for us to take these conversations to the living. A human conversation. I carry with me the stories of this book, the ancient and modern ones, and they shape the ways I interact with these bodies, their narratives and the museum. Now it is your turn to

shape and share your thoughts, with a greater awareness of the challenges and possibilities of the conversations we are having. It is your turn to be an actor in your own forms of engagement, whether it is visiting a museum in person or online, or interacting with their representation in the media. Alice Procter tells us, in *The Whole Picture*, 'if those stories are not on show, ask the institution why. Ask yourself where they might be instead. Find them, share them. You are not being difficult when you ask for a fuller, deeper history. You are a visitor – you have powers – and you can make trouble if you want to.'[1]

The Pharaohs' Golden Parade

Mummy stories happen in museums and cities all around the world, but in 2021, these stories took centre stage in the home country of Egyptian mummified bodies: Egypt.

On 3 April 2021, one event stole the attention of the world: the Pharaohs' Golden Parade.[2] This was no ordinary parade. Twenty-two royal Egyptian mummies and seventeen coffins were transferred to their new home, a museum. The highly anticipated event started in Tahrir Square, where the Egyptian Museum is located, and the parade moved towards its destination, the National Museum of Egyptian Civilization (NMEC). The Egyptian mummies are now housed in a new hall in the NMEC, known as the Royal Mummies Hall. They were moved to a museum that is not solely dedicated to ancient Egypt but spans from the ancient Egyptian civilisation to today. What was striking about this live, televised event was the showcase of many guests and performers, offering a display of today's Egyptian artists, speakers, performers, Government

representatives and population at large, together with a cele-
bration of the ancient Egyptians.[3] As Heba Abd el Gawad has
noted, Europeans have long been more interested in ancient
Egyptian objects than they have been in the modern-day popu-
lation and culture of Egypt; and this has combined with a per-
sistent idea that today's Egyptians are not interested in their
heritage – an idea that could not have been more firmly dis-
proved by the sheer number of Egyptians cheering on this
event.[4] This was a celebration of Egypt, ancient and modern.

I found it interesting that an event dedicated to human
remains – Egyptian mummies – managed to foreground the
idea of these bodies, and the importance of their presence,
while never sensationalising them. There were no images, no
photographs, no videos and no glass cases. No peering at the
bodies. No eavesdropping. With the music, the performances,
the recitals (including ancient Egyptian prayers) and the incred-
ible talent displayed on that night, there was no shortage of
emotional impact for the viewers. The event proved that it is
possible to celebrate ancient Egyptian human remains without
actually displaying them. This could be a valuable lesson for
museums around the world.

Is the future of Egyptian mummies one where we no longer
see them in museums, or is it one where we see them in different
environments that are curated in a way that encourages respect?
If so, respect for whom – the living or the dead? What would it
be like for you to experience Egyptian mummies without seeing
them? Would you be able to make sense of this encounter with
death without viewing its physical manifestation? The question
of how we can collaboratively create spaces for sensory and
emotional engagements that do not disrespect others is perhaps

our greatest challenge, as museum visitors, as researchers, as curators or simply as curious individuals.

The human mummy

26 September 1976. A plane lands at Le Bourget, the military airport just outside Paris. The Republican Guard and French officials are here to welcome a very special guest. He is the oldest head of state ever to travel to Paris.

In the 1970s, French Egyptologist and Louvre curator Christiane Desroches-Noblecourt was visiting Cairo to prepare for a major exhibition, scheduled to take place in Paris in 1976, organised by the Egyptian Ministry of Culture.[5] She was looking forward to studying a man with whom she had been fascinated for decades, an ancient Egyptian pharaoh.[6] When she entered Cairo Museum to visit this ancient man, she noticed that something was not quite right with him: he was starting to smell. It was not the powerful and somewhat intoxicating odour of the resins and ointments applied in ancient Egypt for the mummification process. No, this was a more worrying smell: decay. Like her predecessor Jean-François Champollion in 1826, she was facing a deteriorating mummy. But this was the mid-1970s, and together with her Egyptian colleagues, Desroches-Noblecourt arranged for this ancient man to make his first trip in about 3,000 years.

This ancient man was Ramses II, and he was about to be taken on a rescue mission.

The afterlife of Ramses II was never a quiet, peaceful one comprising journeys between his earthly body resting in his tomb and his otherworldly life. Almost immediately after his burial his tomb was desecrated. In the twenty-ninth year of the reign of Ramses III, individuals tried to force the entrance to

Ramses II's tomb, unsuccessfully. In the following years and decades, both his tomb and his temple, the Ramesseum, were violated on numerous occasions, as we know from the accounts of individuals who were caught and questioned. Looting was not tolerated, and yet was not uncommon. In fact, few tombs in Thebes were left unopened in ancient times. The main motivation of tomb robbers has remained much the same throughout history: material wealth, whether for basic survival or for greed. It is not surprising, when we think about it, that tombs were looted in ancient times too, and that Ramses II's tomb did not escape this fate. The looting led to the decision to move the remains of some of the most well-known pharaohs, including Ramses II, to other tombs that could be more easily looked after. The mummies were placed in the coffins that had been best preserved, even if these had originally belonged to someone else. That is how Ramses II was reburied in what was perhaps his grandfather's coffin in 1090 BCE.

But this was not the last misadventure for Ramses II, as his new burial place was disturbed soon after, and the mummy was moved again between 979 and 960 BCE, when the reburial was carried out with lavish funerary rituals. And then, for about 2,800 years, Ramses II was undisturbed in his deep underground hiding place, where he lay without any of his own funerary equipment. When his resting place was opened once more, it was the end of his underground afterlife. Ramses II was taken to the museum in Boulaq, where, in 1896, he was unwrapped to ascertain his identity.[7] The pharaoh had by this point been on quite a series of unwanted adventures, but things kept going downhill when his body did not take all these changes too well and started to deteriorate.[8]

This is how he found himself on a return trip to Paris, to visit none other than the Musée de l'Homme, which had the necessary laboratories to treat the parasites on his body. On 26 September 1976, Ramses II left his museum in a military van, under the care of a military general, coincidentally also named Ramses. The two Ramses headed to the airport, taking the long avenue named none other than … Ramses! And this is how the pharaoh Ramses II ended up flying over the pyramids in a French military plane on his way to Paris. On his arrival, Desroches-Noblecourt insisted that the driver make a detour to the Place de la Concorde, where an obelisk has been standing since 1836.[9] It is one of the obelisks of the Luxor temple, built during the reign of Ramses II himself and gifted to Charles X with the assistance of Champollion (you will remember them both as instigators of the first national Egyptian galleries in Paris). This was a moment loaded with cultural meaning: centuries of exchanges and looting, culminating in cooperation, as the body of Ramses II was brought respectfully to this obelisk that he originally had built, now only a few blocks away from the Musée du Louvre.

After seven months of intense treatment in Paris, Ramses II was brought back to Cairo. Before the return, Desroches-Noblecourt had asked the embroidery teams at the Musée du Louvre to create a shroud to cover the large box containing the mummy.[10] The shroud was made of velvet the colour of lapis lazuli with gold threads, reminiscent of the two precious materials most prized by the ancient Egyptians. On the top and bottom of the shroud, lily and papyrus plants had been embroidered. These are both ancient Egyptian symbols, watching over the pharaoh's rebirth for all eternity.

A gift for a pharaoh who had been received as a head of state, and treated as a sick patient. As a *human being*.

*

I think about this story a lot, because it is not one you often hear when it comes to ancient Egypt, and especially Egyptian mummies, whether in the media or in museums. And yet, it is a deeply human story, and a story about what researchers and institutions can do, from the symbolic (Ramses received as a head of state, touring his obelisk and going home with a shroud gifted by the French Government), to the scientific (the restoration of his body), to the curatorial (his display in Cairo, and today in a dedicated room at the NMEC).

Ramses II is the epitome of all of this: an incredibly powerful, wealthy and extraordinary ruler,[11] whose afterlife was disturbed so many times that it is almost absurd. But it is the aura of respect surrounding his journey to Paris that is especially startling, because it contrasts so much with the ways that Egyptian mummies are approached in the media and in some museums, including in France and in Britain. This was a moment of respect that relied on something very simple: from the outset, Ramses II was considered as a human being, and his life story as a person is what dictated this conduct. He used to be a governing royal,[12] and therefore he was received with the usual respect and honours that France shows such individuals.[13] Nothing less, nothing more.

The story of Egyptian mummies in museums is definitely a human story. It is a story about death; about faith; and about the strangeness of human attitudes towards passing, wealth and respect – or what we sometimes call ethics.

A conversation, human to human.

Illustrations

Illustrations

Acknowledgements

It was a warm summer evening in 2014, and I was sitting alone in the office I shared in the Département des antiquités égyptiennes at the Musée du Louvre, in the very corridor where Jean-François Champollion had his own office in the 1820s. That evening, I received an email that I had been eagerly awaiting. It came from the School of Museum Studies at the University of Leicester, where I had done my MA. The message was brief, and yet changed everything: I had been accepted to do a PhD on Egyptian mummies in museums. That summer was a pivotal moment in my personal journey: for me, there is a before- and an after-summer 2014, professionally and personally.

At the Musée du Louvre, where I received that momentous email, I must thank Sylvie Guichard and Hélène Guichard, and all of the curatorial and research team, for inviting me to do a placement there for two months that summer, for helping with my doctoral research and for welcoming me so warmly in a summer that was full of uncertainty. It was during that summer that I was diagnosed with a severe chronic illness, and the entire department rallied and rooted for me, especially when I showed up with a full leg splint in a museum full of marble steps! During the writing of this book, I have been tremendously lucky to have access

to the library of the Département des antiquités égyptiennes, and I cannot thank Béatrice Perreaut-Dubois enough for access to the special collections, for stimulating conversations and for getting the *Description de l'Égypte* off its shelf for me!

Rejoining the School of Museum Studies in 2014 I met my supervisor, mentor and greatest supporter, Simon Knell, and there is no doubt that this book would not exist without you, Simon. While I had wanted to be an Egyptologist since I was thirteen, I never really believed that I could, and writing a book always felt an impossible task: here it is, *the* book, and I am forever grateful. At the School of Museum Studies, I met a community unlike any I had met before: the creativity, support and friendships I encountered there will stay with me forever. I am grateful to all the staff and the students, past and present, and to the entire community of Leicester, which has become a second home.

Before I moved to Leicester, London was my base, and there it was the Petrie Museum of Egyptian Archaeology that was my home and transformed my life. When I was about twenty, I met a group of wonderful women who generously took me in, taught me English, introduced me to wonderful people and looked after me when I was unwell: Tracey Golding, Helen Pike and Jan Picton made me feel as though I was at home, and that I mattered. At the Petrie Museum, I met Chloë Ward, without whom none of my work would exist – Chloë, thank you for being the most generous, fun and encouraging friend, and the best editor there is. I will always cherish the memories we share together, and I look forward to the next decade of adventures. I also remember meeting a brilliant speaker at the Petrie Museum and being completely captivated by his talks; I often observed him preparing for his lectures, thinking I wanted to do

this one day! This wonderful and exceptionally talented speaker is John J. Johnston, who did me the honour of writing the foreword to this book, a gift I will cherish forever. It was special to have John J. Johnston as part of this journey, because the writing of this book was also marked by the passing of our dear friend Helen Pike, to whom this book is dedicated. Helen, this book would not exist if I had not had the serendipitous chance to meet you all those years ago; you had this special gift of making people shine and of connecting curious and wonderful people, and I have been transformed by those connections. At the Petrie Museum and at University College London, my home university then, I must thank Alice Stevenson, Gabriel Moshenska, Debbie Challis and Pia Edqvist for their enduring encouragement.

I have been lucky to meet many wonderful colleagues during my research over the past decade, and to have been welcomed by very special institutions. I must thank Natasha McEnroe at the Science Museum in London for giving me the opportunity to think about human remains and medical collections for a year, and to work with Farrah Lawrence-Mackey, Shelley Angelie Saggar and Kay Nias; Emma Martin at the World Museum in Liverpool for welcoming me for two debates on human remains; Sam Elliott, Ian Trumble and Pierrette Squires at Bolton Museum for the warm welcome; Christian Greco and Paolo Del Vesco for inviting me to contribute to their human remains symposium, and for doing such exceptional work at the Museo Egizio; the team at the British Museum, especially John H. Taylor and Daniel Antoine for generous access to collections and documents over many years; and, last but not least, the team at the Leicester Museum & Art Gallery, my creative home for many years, for hosting my workshops and community

Acknowledgements

relabellings so generously. I have also been inspired by many scholars, thinkers and curators who have been trailblazers, including Heba Abd el Gawad, Monica Hanna, Fatma Keshk, Subhadra Das, Angela Saini, Miranda Lowe, Alice Procter, Campbell Price and Dan Hicks; thank you for taking risks and leaving a path for others to continue on this journey.

This work has benefited from the support of many academics and institutional access, but it simply would not exist without the support of a great number of people in my life, over many years, while I pursued a rather unusual life path. My family has rallied behind my curious idea to become an Egyptologist, and then a human-remains researcher, ever since day one. I am tremendously lucky to have had the unwavering support of my parents, Patricia Millet and François Stienne, and my sister Flora Soupart-Stienne, my entire life. I could not have done it without you; thank you for supporting me and for coping with my incessant mummy talks. My grandparents, Yvette Stienne and Michel Stienne, have been fundamental in shaping me as a person and as a researcher going after her dreams; they took me to Egypt when I was sixteen, when they were in their seventies, and always thought I wrote perfect research, although they could not read English! This book is dedicated to them.

Thank you to my friends who stood by me during the writing of this book, in the middle of a pandemic that reconfigured my entire life. Special thanks to Aisha Almisnad, Joakim Lidman, Chloë Ward, Cécile Anger, Russell Hobbs, Henry Curtis Pelgrift, Justin Yoo, John J. Johnston, John Cunningham, Stephanie Boonstra, Thomas Bowers, Amy Hetherington, Elena Settimini, John Coster, Anna Tulliach, Richard Sandell, Geesun Hahn, Nuntamon Noma Kutalad, Megan Hinks, Stacey Anne Bagdi, Katie Clary, Nicole Cochrane, Abbey Ellis,

Ilenia Atzori, Gilbey Lund, Sarah Latrille and many more for the messages of encouragement; it made all the difference.

Navigating the changes caused by my declining health during my PhD up to the conclusion of this book was challenging, but being able to realise this dream in such extreme conditions has been the joy of my life; knowing this book was possible makes me believe that more is possible. I hope that its existence is testament to the fact that it is possible to live with a chronic illness and to go after one's dreams. I needed proof of this when I was young; this is mine to you.

I grew up wanting to be a writer, and yet I never imagined I would write a book in English. I must thank Simon Knell again for helping me refine my English writing; Will Buckingham at Wind & Bones for helping me work on the initial proposal; and my wonderful team at Manchester University Press for believing in the project from day one, especially Emma Brennan, Alun Richards and Jen Mellor. An enormous thank you goes particularly to Emma, for making this happen, for listening to me talking enthusiastically about coffins, and for allowing me to write a book that looks exactly like what I wanted to create: this is a rare gift.

This book is an extension of *Mummy Stories*, and my final thank you goes to the people around the world who sent a story to be shared on the website, engaged with the project on social media, came to my talks and shared the ethos of *Mummy Stories*, and picked up this book.

This project is yours now.

Notes

Foreword

1 Archive of Performances of Greek and Roman Drama: Royal Opera House (London, Greater London, England), www.apgrd.ox.ac.uk/productions/venues/826 (accessed December 2021).
2 Discover National Theatre: work pack for Sophocles, *Oedipus Rex*, www.nationaltheatre.org.uk/sites/default/files/oedipus_workpack_v2.pdf (accessed January 2022).
3 M. A. Murray, *The Tomb of the Two Brothers* (Manchester: Sherratt and Hughes, 1910).

Prologue

1 Throughout the book, I call him Pacheri, although I have called him Padicheri in previous work. His name is unclear. The Musée du Louvre has a dedicated webpage (it includes photographs of human remains): https://collections.louvre.fr/ark:/53355/cl010038221 (accessed September 2021).
2 There was only one Egyptian mummy in the pharaonic gallery on display at the time; there are more now in the Roman and Coptic Egypt galleries. A full list of the human remains at the Musée du Louvre, including those not on display, is available online. Be aware that the museum's online collections include numerous images of human remains, including children and body parts: https://collections.louvre.fr/en/recherche?q=momie (accessed July 2021). Interestingly, there is no 'human remains' category in the online collection.

Notes

3 See Chapters 6 and 7 for a thorough examination of Cuvier's research and legacy.

4 Collector Passalacqua accumulated a large collection of ancient Egyptian artefacts that he presented in 1826 at an exhibition in Paris at 52 Passage Vivienne. The display contained nine human mummies, two ears and a forearm. Among the mummies, two children and a woman were presented unwrapped. The collection was offered to the French Government for 400,000 francs but was rejected; it was acquired by Friedrich Wilhelm IV of Prussia for the Berlin Museum, of which Passalacqua was named curator between 1828 and 1865. See Giuseppe Passalacqua, *Catalogue raisonné et historique des antiquités découvertes en Égypte* (Paris: Galerie d'antiquités égyptiennes, 1826), 160.

5 We will explore the link between Cook and Egyptian mummies in Chapter 2.

6 On Egyptology as a discipline, see Elliott Colla, *Conflicted Antiquities: Egyptology, Egyptomania, Egyptian Modernity* (Durham, NC: Duke University Press, 2007); Donald Malcolm Reid, *Whose Pharaohs? Archaeology, Museums and Egyptian National Identity from Napoleon to World War I* (Berkeley and Los Angeles: University of California Press, 2002); William Carruthers, 'Thinking about Histories of Egyptology', in William Carruthers, *Histories of Egyptology: Interdisciplinary Measures* (London: Routledge, 2014), 1–15; Jason Thompson, *Wonderful Things: A History of Egyptology*, Vol. I, *From Antiquity to 1881* (Cairo: American University in Cairo Press, 2015); Jason Thompson, *Wonderful Things: A History of Egyptology*, Vol. II, *The Golden Age: 1881–1914* (Cairo: American University in Cairo Press, 2015); Morris L. Bierbrier, *Who Was Who in Egyptology*, 5th edn (London: Egypt Exploration Society, 2021). On the problems of Egyptology and its erasure of Egyptian Egyptology, see Okasha El-Daly, *Egyptology: The Missing Millennium* (London: UCL Press, 2005).

7 For a comprehensive cultural study of Egyptian mummies, including movies and literature, see (in French): Renan Pollès, *La momie de Khéops à Hollywood: Généalogie d'un mythe* (Paris: Éditions de l'Amateur, 2001).

8 Sumaya Kassim, 'The Museum will not be Decolonised', *Media Diversified*, 15 November 2017, https://mediadiversified.org/2017/11/15/the-museum-will-not-be-decolonised/ (accessed September 2021); Sumaya Kassim, 'The Museum is the Master's House: An

Notes

Open Letter to Tristram Hunt', *Medium*, 26 July 2019, https://med
ium.com/@sumayakassim/the-museum-is-the-masters-house-an-
open-letter-to-tristram-hunt-e72d75a891c8 (accessed October 2021).
The Black Lives Matter official website is https://blacklivesmatter.
com (accessed September 2021). On museum responses to Black
Lives Matter, see Manuel Charr, 'How Have Museums Responded
to the Black Lives Matter Protests?', *MuseumNext*, https://www.mus
eumnext.com/article/how-have-museums-responded-to-the-black-
lives-matter-protests/ (accessed September 2021); and resources
on Black Lives Matter from National Museums Liverpool (which
includes the International Slavery Museum), https://www.liverpool
museums.org.uk/black-lives-matter (accessed July 2021). Important
new publications on related topics (non-exhaustive) include Alice
Procter, *The Whole Picture: The Colonial Story of the Art in Our Museums
and Why We Need to Talk About It* (London: Cassell, 2020); Dan Hicks,
*The Brutish Musems: The Benin Bronzes, Colonial Violence and Cultural
Restitution* (London: Pluto Press, 2020); Angela Saini, *Superior: The
Return of Race Science* (London: Fourth Estate, 2020); and Olivette
Otele, *African Europeans: An Untold History* (London: Hurst, 2020).

9 *Mummy Stories* can be found at www.mummystories.com (accessed
December 2021). See also 'Egyptian Mummies and Their Stories
in Museums', *Nile Scribes*, https://nilescribes.org/2019/02/09/stor
ies-egyptian-mummies/ (accessed September 2021); 'Angela Stienne,
spécialiste des collections de restes humains dans les musées', *Le
Bizarreum*, https://lebizarreum.com/interview-de-chercheur-1-ang
ela-stienne-specialiste-des-collections-de-restes-humains-dans-les-
musees/ (accessed September 2021).

10 Rafaela Ferraz, 'Itinerary: From Egypt to Portugal, via the First
World War', *Mummy Stories*, https://www.mummystories.com/single-
post/rafaelaferraz (accessed July 2021).

11 Heba Abd el Gawad and Alice Stevenson, 'Egypt's Dispersed
Heritage: Multi-Directional Storytelling through Comic Art',
Journal of Social Archaeology, 20 February 2021, https://journals.sage
pub.com/doi/full/10.1177/1469605321992929 (accessed July 2021);
'Egypt's Dispersed Heritage: Views from Egypt', UK Research and
Innovation, https://gtr.ukri.org/projects?ref=AH%2FS004580%2F1
(accessed July 2021); 'International Award for Egypt's Dispersed
Heritage Project', UCL website, 3 December 2020, https://www.
ucl.ac.uk/archaeology/news/2020/dec/international-award-egypts-
dispersed-heritage-project (accessed July 2021).

12 See, for example, Stephen Quirke, *Hidden Hands: Egyptian Workforces in Petrie Excavation Archives, 1880–1924* (London: Duckworth, 2010).

13 *The Place and the People* is on Facebook at www.facebook.com/The-Place-and-the-People-2315808581791112 (accessed July 2021), and can be found in the press: Amira Noshokaty, 'The Place and the People: Exploring Egypt's Intangible Heritage', *Ahram Online*, 11 August 2020, https://english.ahram.org.eg/NewsContent/32/97/376378/Folk/Street-Smart/The-Place-and-the-People-Exploring-Egypts-intangib.aspx (accessed July 2021). See also Fatma Keshk, *A Tale of Shutb*, https://www.britishmuseum.org/sites/default/files/2020-05/Story%20Eng%20-%20Online.pdf (accessed July 2021).

14 Personal conversation, July 2021.

Introduction: The mummy

1 John H. Taylor, *Egyptian Mummies* (London: British Museum Press, 2010), 17.

2 I acknowledge here that saying it is the body of an ancient Egyptian person would be missing all the foreigners who were mummified, including the many Greek and Roman individuals buried in ancient Egypt.

3 On mummification, see for an introduction Taylor, *Egyptian Mummies*; and Salima Ikram and Aidan Dodson, *The Mummy in Ancient Egypt: Equipping the Dead for Eternity* (London: Thames & Hudson, 1998).

4 I use pottery and linen as an example because Sir William Matthew Flinders Petrie was precisely interested in those – in contrast with his contemporaries – and they can now be seen at the Petrie Museum of Egyptian Archaeology in London. We will explore Petrie further in Chapter 7.

5 Campbell Price, *Golden Mummies of Egypt* (Manchester: Manchester Museum Press, 2021), is an exploration of this obsession with the golden mummies and masks, but also a thorough study of the history of Egyptology and the contemporary issues related to Egyptian mummies in museums and culture today.

6 It is worth noting that what may look like a well-preserved mummy to the modern eye might not equal an ancient Egyptian standard.

Notes

Price, for example, notes that 'application of resin is interpreted as if somehow compensating for – or even covering up – a bad job. In fact, the application of resin was a key component of the ritual transformation of the deceased.' See Price, *Golden Mummies of Egypt*, 122. The challenge of applying modern conceptions of beauty, preservation and the afterlife onto the past is one that remains in the study of ancient people and practices.

7 While preservation of the body and its survival up to today are important in the lens of this book – especially when we will look at the destruction and displacement of bodies – it is useful to remember that preservation of the body was not the sole aim of mummification. For a further exploration of this, see Christina Riggs, *Unwrapping Ancient Egypt* (London: Bloomsbury Academic, 2014); and Price, *Golden Mummies of Egypt*.

8 Taylor, *Egyptian Mummies*, 24.

9 Price notes that 'the aim of the ritual of mummification was to create an image of the deceased fit for eternity – what is referred to in Egyptian texts as a "Sah"'; Price, *Golden Mummies of Egypt*, 124.

10 Nicola Harrington, *Living with the Dead: Ancestor Worship and Mortuary Ritual in Ancient Egypt* (Oxford: Oxbow Books, 2013).

11 Recent research has demonstrated that an Egyptian mummy might not be, in fact, truly what we think it is – and this rethinking of what mummification was meant for extends beyond the bodies and to the wrappings as physical material and the act of wrapping objects; it is clear that these had more expansive meanings in ancient Egypt than scholars had previously thought. See Riggs, *Unwrapping Ancient Egypt*.

12 Herodotus had some interesting theories about the ancient Egyptians. He noted, for example, that 'The Egyptians … are also the first of mankind who have defended the immortality of the soul. They believe that on the dissolution of the body the soul immediately enters some other animal, and that, after using as vehicles every species of terrestrial, aquatic, and winged creatures, it finally enters a second time into a human body. They affirm that it undergoes all these changes in the space of three thousand years.' In Herodotus, *The Histories*, Vol. I, trans. William Beloe (London: Jones, 1930), II.123.2.

13 We will return to the surprising use of mummies as medicine, or the *mumia* (which has varying spelling), in Chapter 1.

1 The mummy as medicine, the mummy in medicine

1 Gemma Angel, 'The Tattoo Collectors: Inscribing Criminality in Nineteenth-Century France', in *Prepared Specimens*, special issue of *Bildwelten des Wissens*, 9.1 (2012), 29–38.

2 At time of writing, more than 300,000 objects are being moved from London to a 545-acre new location in Wroughton near Swindon. 'Science Museum in "World's Biggest House Move" to Swindon', *BBC News*, 18 June 2021, https://www.bbc.com/news/uk-england-wiltshire-57511670 (accessed July 2021).

3 'Human Remains at the Science Museum', https://www.sciencemus eum.org.uk/human-remains (accessed July 2021). The list of human remains is downloadable as a PDF on this page and they include the human remains from the Wellcome Collection on loan at the Science Museum, https://www.sciencemuseum.org.uk/sites/default/files/2020–02/SMG-human-remains-full-list-2020.pdf (accessed July 2021).

4 Frances Larson, *An Infinity of Things: How Sir Henry Wellcome Collected the World* (Oxford: Oxford University Press, 2009); Ken Arnold and Danielle Olsen, *Medicine Man: The Forgotten Museum of Henry Wellcome* (London: British Museum Press, 2003).

5 Tony Gould (ed.), *Cures and Curiosities: Inside the Wellcome Library* (London: Profile Books, 2007), 10.

6 The Wellcome Collection has an online archive including images of the Wellcome Historical Medical Museum that attest to the display of skulls and heads. The most striking photographic evidence of this collecting of heads is an archival photograph of the 'hall of primitive medicine' at the Wellcome Historical Medical Museum, taken before 1946. It shows a display case full of heads, including tsantsas and Maori heads. At least twenty-five human heads were displayed in one single case. Some of these human remains can still be identified in the collections of the Wellcome Collection, on loan at the Science Museum. Interestingly, while communities have said that the display and retention of tsantsas and Maori heads are deeply offensive, and this has led to removal from display and repatriation by numerous museums, this photograph (and many others from this period) is under an Attribution 4.0 International licence on the Wellcome Collection website, which makes it reusable even for commercial purposes. I have chosen not to share the link to this image here. Another

photograph from *c.* 1915 (reference 14429i) shows members of staff at the Wellcome Historical Medical Museum posing for a photograph while holding artefacts and skulls.

7 Wellcome Historical Medical Museum, *Handbook to the Wellcome Historical Medical Museum: Founded by Henry S. Wellcome* (London: Wellcome Historical Medical Museum, 1920), 6.

8 Ibid., first page, unnumbered.

9 Ibid., 13.

10 Henry Wellcome, *Wellcome Excavations in Sudan: Jebel Moya* (London: Wellcome Trust Centre for the History of Medicine at UCL, 1949). On Wellcome at Jebel Moya, see the project of Isabelle Vella Gregory, who is Deputy Director of the Jebel Moya excavations: 'Decolonising the Excavations at Jebel Moya', https://wellcom ecollection.org/events/YDUIIhAAAB8AWlPB (accessed July 2021).

11 Larson, *An Infinity of Things*, 50.

12 Ibid., 49.

13 The Wellcome Trust website states that 'Wellcome is a politically and financially independent global charitable foundation, funded by a £29.1 billion investment portfolio. Our strategy includes grant funding, advocacy campaigns and partnerships to find solutions for today's urgent health challenges. Our founder, Sir Henry Wellcome, was a pharmaceutical entrepreneur. Our governance is based on an updated version of his will, in which he left us his wealth, his collection of historical medical items, and our mission to improve health through research.' https://wellcome.org/who-we-are (accessed September 2021).

14 For example, a letter of 6 November 1981 from University College, Swansea, and addressed to the Wellcome Museum states 'I have read your notice in the Museums Bulletin. As plaster casts of this kind might be exhibited in the new Arts Centre of Swansea University College, I should be grateful for "a full description and photographs".' To this letter is glued a cutting from the press release in the said Museums Bulletin that reads 'Egyptology. A series of full-size plaster casts of wall reliefs from Kom Ombo, Edfu, Deir-el-Bahari and other sites are available for disposal by the Wellcome Institute. A full description and photographs are available.' This letter and many more can be found in the Wellcome Collection archives, in the section 'Egyptian Relief Casts 1981–1982', WA/HMM/TR/Abc/C.4/14, Wellcome Historical Medical Museum and Library, https://wellcomecollection. org/works/p468rgt2/items?canvas=36 (accessed September 2021).

Notes

15 The archives of the Wellcome Historical Medical Museum, including transfers and disposals, are available online at https://wellcomecollection.org/works/k2fae5cz (accessed September 2021). In the section 'transfers'/'gift agreements', museums that have received artefacts are listed with correspondence.

16 The Wellcome Collection states that 'Our collections are built on collections assembled by Wellcome's founder, Sir Henry Wellcome. In the early twentieth century he founded a private historical medical museum, which, in common with others of the time, followed a racist, sexist and ableist system of cultural hierarchies. His successors collected books, manuscripts and paintings, and used these collections to present stories that privileged European medicine and the achievements of individual European scientists. Our museum and library collections, some of which are jointly held with the Science Museum, include many items that were taken from the people who made them, by individuals who were able to do so because colonial structures of violence and control allowed them to. We have a responsibility to be honest and transparent about the past injustices in which our collections are rooted, and we have begun a series of initiatives to change the ways we manage and use our collections.' https://wellcomecollection.org/pages/YLnuVRAAACMAftOt (accessed July 2021).

17 The guide to the Wellcome Historical Medical Museum has a singular design on its cover: it is Egyptian-themed. The design is imaginative and represents a figure similar to Isis, with her wings outstretched, but wearing a masculine *nemes* headcloth, while the bandages covering the body are similar to those of the male god Osiris. The fact that she is rendered frontally is also not in keeping with Pharaonic art. Above the figure are two serpents and an *ankh* sign. These symbols were used to indicate the focus of this museum: medical health and life and death. The Egyptian-themed illustration did not end on the cover: each chapter had its own frieze design. This stylistic choice is proudly highlighted in the guide itself, which notes that 'the decorative headings are reduced facsimiles of friezes specially designed and painted for the Museum'.

18 While the Wellcome Collection states that there are over 500 human remains in its 19 June 2018 entry, further study of the collection at the Science Museum has shown that it now amounts to about 1,000 human remains.

19 The list of human remains in the Science Museum Group collections accounts for a number of Egyptian and Sudanese human remains.

They included body parts (a mummified foot, for example), children (a mummified infant with no provenance), and skulls and other body parts. Some of those human remains are marked as having been excavated by 'Sir H. Wellcome', accompanied with excavation dates. For example, A263829, Jebel Moya, Sudan, 5000–1 BCE, 'Part of skull showing depressed fracture, prehistoric cemetery, Gebel Moya. From a late Neolithic combined cemetery and settlement locality in south-central Sudan. It was excavated from 1911–14 over four seasons by Sir Henry Wellcome.' The full list of human remains can be accessed at https://www.sciencemuseum.org.uk/sites/default/files/2020-02/ SMG-human-remains-full-list-2020.pdf (accessed December 2021), although the entries are not arranged by country as many entries are not provenanced. See also Shelley Angelie Saggar, 'Researching Culturally Sensitive Items in the Science Museum's Medical Collections', Science Museum Group blog, 27 May 2021, https://www.sciencemuseumgr oup.org.uk/blog/researching-culturally-sensitive-items-in-the-science-museums-medical-collections/ (accessed October 2021); Shelley Angelie Saggar, 'Secret Items in the Wellcome Historical Medical Collections', *The Polyphony*, https://thepolyphony.org/2019/11/14/secret-items-in-the-wellcome-historical-medical-collections/ (accessed October 2021).

20 The galleries take the name of Wellcome, having been named *Medicine: The Wellcome Galleries*. On human remains in medical collections, see Katie Hullock, 'The Colonial Origins of Medical Teaching Skeletons', *Museum of British Colonialism*, 19 November 2020, https://www.museumo fbritishcolonialism.org/ourblog/2020/11/17/the-colonial-origins-of-medical-teaching-skeletons (accessed October 2021).

21 Silvestre de Savy, *Relation de l'Égypte par Abd-Allatif* (Paris: Imprimerie Impériale, 1810), 200, my translation.

22 Matthaeus Platearius, *Livre des simples médecines* (1530), s.v. 'mumie'.

23 There are various ways to spell this word, and I have used *mumia* throughout this book. Karl H. Dannenfeldt, 'Egyptian Mumia: The Sixteenth Century Experience and Debate', *Sixteenth Century Journal*, 16.2 (1985), 163–180.

24 Ambroise Paré, *Discours d'Ambroise Paré* (Paris: Gabriel Buon, 1582); Ambroise Paré and Afriaan van de Spiegel, *The Workes of that Famous Chirurgion Ambrose Parey* (London: printed by Richard Cotes and Willi, 1649).

25 Pierre Pomet, *Histoire générale des drogues* (Paris: J.-B. Loyson et A. Pillon, 1694), 'Seconde partie, Chapitre premier. Des mumies', 2–8 (7), my translation.

Notes

26 Nicolas Lémery, *Traité universel des drogues simples* (Paris: L. d'Houry, 1698), 508–509.

27 K. A. Clark, Salima Ikram and R. P. Evershed, 'The Significance of Petroleum Bitumen in Ancient Egyptian Mummies', *Philosophical Transactions of the Royal Society*, 374.2079 (2016).

28 Antoine Furetière, *Dictionnaire universel*, Vol. II (La Haye and Rotterdam: Arnout et Reinier Leers, 1690), 654.

29 *Telliamed* is 'De Maillet' in reverse!

30 Jean-Baptiste Le Mascrier (Benoît de Maillet), *Description de l'Égypte* (Paris: L. Genneau et J. Rollin fils, 1735), 279, my translation. Because he had no background in publishing/writing, his book was published by the Abbey Le Mascrier.

31 In this chapter I use dissection, although at times it was rather a simple removal of the wrappings, without much medical knowledge on the part of the person doing it. This procedure can also be referred to as 'opening', in the sense that all these men wanted was to 'open' the mummies to have a look at what was under the wrappings (although this term is used more commonly in French, and I have used unwrapping throughout the rest of the book).

32 Claude-François Menestrier, *Lettre d'un académicien à un seigneur de la cour* (Paris: chez Robert J-B de la Caille, 1692). The document was accompanied by an engraving of a mummy, whose face is represented uncovered. The engraving was reproduced in full in *The Gentleman's Magazine: and Historical Chronicle* of August 1751, with the title 'Three Methods of Embalming an Egyptian Mummy, Two of Which Are Said to Be Lately Brought from Grand Cairo'.

33 Bernard de Mandeville, *An Inquiry into the Causes of the Frequent Executions at Tyburn* (London: J. Roberts, 1725), 26.

34 To learn more about anatomy dissections and the two acts, see Ruth Richardson, *Death, Dissection and the Destitute* (Chicago: University of Chicago Press, 2000); Sarah Wise, *The Italian Boy: A Tale of Murder and Body Snatching* (New York: Metropolitan Books, 2004); Lisa Risner, *The Anatomy Murders* (Philadelphia: University of Philadelphia Press, 2010); and Piers Mitchell (ed.), *Anatomical Dissections in Enlightenment England and Beyond: Autopsy, Pathology and Display* (London and New York: Routledge, 2012).

35 Simon Chaplin, 'John Hunter and the Museum Oeconomy', unpublished doctoral thesis (University of London, 2009), https://wellcomelibrary.org/content/documents/john-hunter-and-the-museum-oeconomy (accessed August 2021). The term 'museum oeconomy'

Notes

coined by Chaplin describes the system of relationships between dissections and the preserving, collecting and displaying of dissected body parts, which he examines in the context of London in the second half of the eighteenth century; Simon Chaplin, 'Nature Dissected, or Dissection Naturalized? The Case of John Hunter's Museum', *Museum and Society*, 6.2 (2008), 135–151.

36 For a cultural analysis of the relation between wrappings and bodies, see Christina Riggs, *Unwrapping Ancient Egypt* (London: Bloomsbury Academic, 2014).

37 Between 1752 and 1767, Caylus published *Recueil d'antiquités égyptiennes, étrusques, grecques et romaines*, a seven-volume work. Caylus acquired a hotel in 1736 to house his antiquity collection, located at 109 rue Saint-Dominique in Paris.

38 Jean-Paul Grandjean de Fouchy, 'Éloge de M. Rouelle', *Histoire de l'Académie des Sciences* (Paris: Imprimerie Royale, 1773), 142–143, my translation.

39 On Rouelle, see Remi Franckowiak, 'Les sels neutres de Guillaume-François Rouelle', *Revue d'histoire des sciences*, 55.4 (2002), 493–532; and Paul Dorveux, 'Apothicaires membres de l'Académie Royale des Sciences: IX. Guillaume-François Rouelle', *Revue d'histoire de la pharmacie*, 21.84 (1933), 169–186.

40 The *Mémoires* are: (1) 'Mémoire sur les sels neutres' (1744); (2) 'Sur le sel marin' (1745); (3) 'Sur l'inflammation de l'huile de térébanthine' (1747); (4) 'Sur l'embaumement des Égyptiens' (1750); and (5) 'Mémoire sur les sels neutres' (1754).

41 De Fouchy, 'Éloge de M. Rouelle', 143.

42 Rouelle was linked to two other Parisian cabinets: the Cabinet de Sainte Geneviève, founded in the seventeenth century by Father du Moulinet, which contained one full mummy as well as mummy parts, and the Cabinet des Célestins, which held two mummies. These two cabinets are mentioned in Rouelle's 1754 report to the Académie Royale des Sciences, in which he wrote 'The mummy that is preserved in the cabinet of Sainte Geneviève, & the two which are in the one of the Celestins, can shed new light on this passage by Herodotus and confirm my conjectures.' Anon. [Académie des Sciences], *Histoire de l'Académie Royale des Sciences* (Paris: J. Boudot, 1754), 136, my translation.

43 Anon., 'Ouverture de deux momies appartenant à M. Cailliaud', *Revue encyclopédique*, 21 (1824), 243–246.

Notes

44 The first Egyptian galleries, curated by Champollion, only opened in 1827.

45 Philippe Mainterot, *Aux origines de l'Égyptologie* (Rennes: Presses Universitaires de Rennes, 2011); Philippe Mainterot, 'La redécouverte des collections de Frédéric Cailliaud: Contribution à l'histoire de l'égyptologie', *Histoire de l'art*, 62 (2008), 1–12; Andrew Bednarski, *The Lost Manuscripts of Frédéric Cailliaud* (Cairo: American University in Cairo Press, 2014); Frédéric Cailliaud, *Voyage à l'Oasis de Thèbes* (Paris: Imprimerie Royale, 1821); Frédéric Cailliaud, *Voyage à l'Oasis de Syouah* (Paris: Imprimerie de Rignoux, 1823).

46 It was at this time that Cailliaud started building up his own collection of artefacts, which included about 1,130 objects. They were acquired in 1819 by the Département des Médailles et Antiques de la Bibliothèque du Roi, directed at the time by French archaeologist Désiré Raoul-Rochette. On his return to France in 1818, Cailliaud's collection caught the attention of Edmé-François Jomard, a former member of the French campaign in Egypt. Jomard's expert knowledge in publication – as a result of his involvement with the *Description de l'Égypte* – became indispensable in the publication of Cailliaud's own travel accounts. Their collaboration resulted in the publication of *Voyage à l'Oasis de Thèbes* and *Voyage à l'Oasis de Syouah*.

47 Frédéric Cailliaud, *Voyage à Méroé* (Paris: Imprimerie Royale, 1826), 258–263.

48 The so-called 'second Cailliaud collection' was finally acquired on 3 November 1824 for the sum of 36,000 francs. The first collection contained seventeen mummies and the second eighty-three mummies.

49 Anon., 'Ouverture de deux momies appartenant à M. Cailliaud', *Revue encyclopédique*, 21 (1824), 243–246 (243), my translation.

50 François René Herbin, *Padiimenipet, fils de Sôter* (Paris: Musée du Louvre, 2002).

51 Jean-François Champollion, *Lettre à M. Letronne, membre de l'Académie des Inscriptions et Belles-Lettres, sur l'expression phonétique des noms de Pétéménon et Cléopâtre, dans les hiéroglyphes de la momie rapportée par M. Cailliaud* (Paris: Imprimerie de A. Bobée, 1824).

52 Jean-François Champollion, *Lettre à Monsieur Dacier relative à l'alphabet des hiéroglyphes phonétiques* (Paris: F. Didot Père et Fils, 1822).

53 Dominique-Jean Larrey wrote *Relation historique et chirurgicale de l'expédition de l'armée d'orient, en Egypte et en Syrie* (Paris: Chez Demonville et S, 1803).

Notes

54 Mark Brown, 'Inside the Mummies' Embalmed Bodies – Courtesy of a Hospital CT Scanner', *Guardian*, 9 April 2014, https://www.theg uardian.com/science/2014/apr/09/mummies-embalmed-bodies-british-museum-scanner (accessed October 2021).

55 *Ancient Lives, New Discoveries: Eight Mummies, Eight Stories* (exhibition), British Museum, London, 22 May 2014–12 July 2015. John H. Taylor and Daniel Antoine, *Ancient Lives: New Discoveries. Eight Mummies, Eight Stories* (London: British Museum Press, 2014). For more details on the exhibition, see Chapter 8.

56 University of Manchester, 'Ancient Egyptian Mummies Travel to Manchester for Health Checkup', 17 September 2019, https://www.manchester.ac.uk/discover/news/ancient-egyptian-mummies-travel-to-manchester-for-health-check-up/ (accessed September 2021).

57 Ibid.

58 Carlos Prates, Sandra Sousa, Carlos Oliveira and Salima Ikram, 'Prostate Metastatic Bone Cancer in an Egyptian Ptolemaic Mummy: A Proposed Radiological Diagnosis', *International Journal of Paleopathology*, 1.2 (2011), 98–103.

59 Michaela Binder, Charlotte Roberts, Neal Spencer, Daniel Antoine and Caroline Cartwright, 'On the Antiquity of Cancer: Evidence for Metastatic Carcinoma in a Young Man from Ancient Nubia (*c.* 1200 BC)', *PlOS ONE*, 9.3 (2014).

60 Ibid.

61 The Francis Crick Institute has an ancient genomics laboratory, the Skoglund Lab: https://sites.google.com/view/skoglundlab/home (accessed September 2021). For an example of a study on Egyptian mummies specifically, see Odile Loreille, Shashikala Ratnayake, Adam L. Bazinet, Timothy B. Stockwell, Daneil D. Sommer, Nadin Rohland *et al.*, 'Biological Sexing of a 4,000-Year-Old Egyptian Mummy Head to Assess the Potential of Nuclear DNA Recovery from the Most Damaged and Limited Forensic Specimens', *Genes*, 9.3 (2018), 135.

2 The displayed mummy, the displaced body

1 'Museum of Sanctuary Award for Leicester Museum & Art Gallery', 8 February 2021, https://www.leicestermuseums.org/news/museum ofsanctuary/ (accessed July 2021).

Notes

2 According to City of Sanctuary Leicester, there are over 1,000 asylum seekers in Leicester, making it one of the three cities in the UK with the largest number of individuals seeking asylum, https://leicester. cityofsanctuary.org (accessed July 2021). On the museum's inclusive programming, see https://www.leicestermuseums.org/learning-eng agement/community-engagement/ (accessed July 2021).

3 The catalogue of the exhibition with all the labels can be found at https://issuu.com/angelastienne/docs/museum_takeover_2018 (accessed September 2021). See also 'Museum Narratives and the Refugee Experience: Relabeling at New Walk Museum in Leicester', *The Attic*, 11 February 2019, http://attic-museumstudies.blogspot.com/ 2019/02/museum-narratives-and-refugee.html (accessed September 2021), and a feature in Charlotte Coates, 'Museums Working with Refugees and Migrants', *MuseumNext*, 30 July 2019, https://www.mus eumnext.com/article/the-social-impact-of-museums-working-with-refugees-and-migrants/# (accessed September 2021). The project is also part of the museum's website, https://www.leicestermuseums. org/learning-engagement/community-engagement/working-in-part nership/ (accessed September 2021).

4 The catalogue of this workshop can be accessed at https://issuu. com/angelastienne/docs/welcome_to_the_museum__refugee_week (accessed January 2022; contains photographs of human remains).

5 This story is told in the online resource 'Story of Leicester', https:// www.storyofleicester.info/city-stories/thomas-cooks-leicester/ (accessed September 2021).

6 In 1845 an Act of Parliament had allowed local councils to establish museums, and Leicester was one of the first cities to take advantage of the levy rate of one halfpenny. The city was influenced in this decision by the Leicester Literary and Philosophical Society, founded in 1835.

7 Cynthia Brown, *Cherished Possessions: A History of New Walk Museum & Leicester City Museums Service* (Leicester: Leicester City Council, 2002), 4.

8 It is unclear if this was a travelling exhibition, as the first mummy to be recorded in the collection is from 1859.

9 Brown, *Cherished Possessions*, 8–9.

10 Pa-Nesit-Tawy travelled for some time, visiting Taiwan, where he was part of an exhibition called 'Quest for Immortality'.

11 The new galleries, which opened in October 2018, were curated by Egyptologist Dr Stephanie Boonstra.

Notes

12 The Thomas Cook archives were acquired by the Record Office for Leicestershire, Leicester and Rutland, after the travel company collapsed in September 2019; http://www.recordoffice.org.uk/news/thomas-cook-comes-home/ (accessed July 2021).

13 Mary Wortley Montagu, *The Letters of Lady M. W. Montagu during the Embassy to Constantinople, 1716–1718* (London: Henry G. Bohn, 1825), 161.

14 To understand what a cabinet of curiosity is see Krzysztof Pomian, *Collectionneurs, amateurs et curieux, Paris–Venise: XVI–XVIII siècle* (Paris: Gallimard, 1987); Antoine Schnapper, *Le géant, la licorne et la tulipe: Les cabinets de curiosités en France au XVIIe siècle*, rev. edn (Paris: Flammarion, 2012); Oliver Impey and Arthur MacGregor, *The Origins of Museums: The Cabinet of Curiosities in Sixteenth and Seventeenth Century Europe* (Oxford: Oxford University Press, 1985); Arthur MacGregor, *Curiosity and Enlightenment: Collectors and Collections from the Sixteenth to the Nineteenth Century* (New Haven: Yale University Press, 2007); Stephanie Bowry, 'Thinking inside the Box: The Construction of Knowledge in a Miniature Seventeenth-Century Cabinet', in Susanne Bauer, Martina Schlünder and Maria Rentetzi (eds), *Boxes: A Field Guide* (Manchester: Mattering Press, 2020), 126–143; and Stephanie Bowry, 'Before Museums: The Curiosity Cabinet as Metamorphe', *Museological Review*, 18 (2014), 30–42. The term 'curio' has been discussed in the introduction to Alexander Marr and R. J. W. Evans (eds), *Curiosity and Wonder from the Renaissance to the Enlightenment* (Aldershot and Burlington: Ashgate, 2006). Aufrère defines the 'curiosity' of Egyptian material culture in a pre-Egyptology context in Sydney H. Aufrère, *La momie et la tempête: Nicolas-Claude Fabri de Peiresc et la 'curiosité égyptienne' en Provence au début du XVIIe siècle* (Paris: Alain Barthélemy, 1990), 31–52; Renan Pollès, *La momie de Khéops à Hollywood: Généalogie d'un mythe* (Paris: Éditions de l'Amateur, 2001), 54.

15 Okasha El-Daly, 'Ancient Egypt in Medieval Arabic Writings', in Peter J. Ucko and Timothy Champion (eds), *Wisdom of Egypt: Changing Visions through the Ages* (Abingdon: Taylor & Francis, 2016), 39–64; Charles Burnett, 'Images of Ancient Egypt in the Latin Middle Ages', in Ucko and Champion, *Wisdom of Egypt*, 65–100; Brian A. Curran, 'The Renaissance Afterlife of Ancient Egypt (1400–1650)', in Ucko and Champion, *Wisdom of Egypt*, 101–132. Also, by same authors: Okasha El-Daly, *Egyptology: The Missing Millennium* (London: UCL Press, 2005);

Notes

Brian A. Curran, *The Egyptian Renaissance: The Afterlife of Ancient Egypt in Early Modern Italy* (Chicago: University of Chicago Press, 2007).

16 Athanasius Kircher, *Oedipus Aegyptiacus* ([n.pl.], [n.pub.], 1652); Paula Findlen, *Athanasius Kircher: The Last Man who Knew Everything* (London: Routledge, 2004); Daniel Stolzenberg, *Egyptian Oedipus: Athanasius Kircher and the Secrets of Antiquity* (Chicago: University of Chicago Press, 2013); Joscelyn Godwin, *Athanasius Kircher: A Renaissance Man and the Quest for Lost Knowledge* (London: Thames & Hudson, 1979).

17 'Ichnographia cryptae mumiarum', in Kircher, *Oedipus Aegyptiacus*, Vol. III.

18 On the mummy pits see Tessa Baber, 'Ancient Corpses as Curiosities: Mummymania in the Age of Early Travel', *Journal of Ancient Egyptian Interconnections*, 8 (2016), 60–93.

19 Christian Hertzog, *Essay de Mumio-Graphie* (Gothe: Jean Andr. Reyher, Imprimeur Duc, 1718), 26, my translation.

20 Charles Irby and James Mangles, *Travels in Egypt, Nubia and Syria* (London: T. White, 1823), 45.

21 Jean-Baptiste Requier, *Vie de Nicolas Claude Peiresc* (Paris: Chez Musier, 1770); Aufrère, *La momie et la tempête*.

22 *Texte de Thou*, Bibliothèque Nationale de France, MS f.f. 95537, fol. 297, my translation.

23 Aufrère, *La momie et la tempête*, 163, my translation.

24 Pollès, *La momie de Khéops à Hollywood*, 47, my translation.

25 Edmé-François Gersaint, *Catalogue raisonné d'une collection considérable de diverses curiosités en tous genres* (Paris: Chez Jacques Barois et Pierre-Guillaume Simon, 1744), ii, my translation.

26 Ibid.

27 On Caylus see Marc Fumaroli, *Le comte de Caylus et Edmé Bouchardon: Deux réformateurs du goût sous Louis XV* (Paris: Éditions Louvre, 2016); Hector Reyes, 'Drawing and History in the Comte de Caylus's *Recueil d'antiquités*', *Studies in Eighteenth-Century Culture*, 42 (2013), 171–189. On the fragments given by Lironcourt to Caylus, see mention in Paolo Maria Paciaudi, *Lettres de Paciaudi au comte de Caylus* (Paris: chez Henri Tardieu, 1802), 351.

28 Pollès, *La momie de Khéops à Hollywood*, 53, my translation.

29 Other Parisian private collections containing Egyptian mummies in the eighteenth century included that of Jean-Pierre d'Aigrefeuille, whose mummy had 'all the parts of the face and of the inside,

except for the eyes and the brain'; the cabinet belonging to natur-
alist Valmont de Bomare, whose catalogue mentions a mummy; and
the cabinet of Jean-Baptiste de Bourguignon de Fabregoules, magis-
trate and equerry of the city of Aix, which contained a mummy in its
sarcophagus.

30 Pollès, *La momie de Khéops à Hollywood*, 49, my translation.

31 Ibid., my translation.

32 'Expédition d'Égypte sous les ordres de Bonaparte' by Léon Cogniet,
1935, today in room 651, Sully Wing, first floor, https://collections.
louvre.fr/ark:/53355/cl010062203 (accessed September 2021). For an
analysis, see https://histoire-image.org/fr/etudes/expedition-egypte
(accessed September 2021).

33 'L'étude et le génie dévoilent l'antique Égypte à la Grèce', by
François-Edouard Picot, 1827, today in room 644, Sully Wing, first
floor, https://collections.louvre.fr/ark:/53355/cl010061562 (accessed
September 2021).

34 David Jeffreys, *View of Ancient Egypt since Napoleon Bonaparte: Imperialism,
Colonialism and Modern Appropriations* (London: UCL Press, 2003).

35 Vanessa Desclaux, 'L'expédition d'Égypte et la naissance de l'Institut
d'Égypte', *Le blog Gallica*, https://gallica.bnf.fr/blog/16052018/lexp
edition-degypte-et-la-naissance-de-linstitut-degypte?mode=desktop
(accessed October 2021).

36 In May 2021, France 24 published an article titled 'How Napoléon's
Invasion "Revealed Egypt to the World – and to Itself"', taking a
stance that suggests the Egyptians should be grateful for this inva-
sion. A French historian who has written extensively about the exped-
ition led by Napoleon stated that 'Bonaparte's scholars didn't just
uncover Egypt's ancient past for the world – but also for Egypt itself,
as Egyptians were uninterested in their pharaonic history at that point,
dismissing it as pagan.' In the same article, he notes that 'this was a vio-
lent imperialist operation and military operation'. He continues, 'one
should be careful not to lavish praise on the expedition, given the vio-
lence involved. But modern Egypt began with Napoleon's invasion.'
These hugely problematic comments are rooted in the idea that mod-
ernity is defined by, and brought about, by Europeans. In fact, the art-
icle laments that the expedition is not taught in Egypt – as if France has
not had enough control over Egypt already…, https://www.france24.
com/en/france/20210505-how-napoléon-s-invasion-revealed-egypt-
to-the-world---and-to-itself (accessed September 2021).

37 Col. Chalbrand, *Les français en Égypte; ou, Souvenirs des campagnes d'Égypte et de Syrie par un officier de l'expédition* (Tours: A. Mame, 1955 [1855]), my translation.

38 Dominique Vivant Denon, *Voyage dans la basse et la haute Égypte* (Paris: P. Didot l'aîné, 1802), 329, my translation.

39 The term 'partage' comes from the French *partager*, to share, to divide. On the partage of archaeological finds, see work by Dr Alice Stevenson, 'Conflict Antiquities and Conflicted Antiquities: Addressing Commercial Sales of Legally Excavated Artefacts', *Antiquity*, 90 (2016), 229–236; Alice Stevenson, *Scattered Finds: Archaeology, Egyptology and Museums* (London: UCL Press, 2019).

40 In an interview he gave in a bid for re-election, the then director of the Louvre, Jean-Luc Martinez, was asked how he would respond to public opinion in Egypt that the ancient Egyptian antiquities had come from looting. He responded that 'it is untrue. They come as the result of partage from excavations.' He continued that France's policy was to 'save and safeguard heritage'. He added to this that the Louvre Abu Dhabi helps bring a message of universalism to the heart of the Arab world. In 2021, the aim of the Louvre was still 'universalism', and shared heritage as a justification for the museum's existence, despite awareness in museum studies that universalism in museums was never about shared heritage: it was always about power and exclusion. A few weeks after this interview was published, Jean-Luc Martinez failed to be re-elected to the Louvre; Benjamin Locoge and Gilles Martin-Chauffier, 'Jean-Luc Martinez: Le Louvre dans la peau', *Paris Match*, 16 March 2021, https://www.parismatch.com/Culture/Art/Jean-Luc-Martinez-le-Louvre-dans-la-peau-1728924 (accessed July 2021).

3 Mummies buried in a garden, and other incidents

1 Revd Weedon Butler, *A Walk through the British Museum* (1767). London, British Library, Western Manuscripts, Add. MS 27276.

2 *The Surveyors and Workmen's Estimates*, Vol. II (1783), British Museum Archives.

3 Stephanie Moser, *Wondrous Curiosities: Ancient Egypt at the British Museum* (Chicago: University of Chicago Press, 2006), 245.

Notes

4 Alexander Gordon, *An Essay towards Explaining the Hieroglyphical Figures on the Coffin of the Ancient Mummy Belonging to Capt. William Lethieullier* (London: edited by Gordon, 1737).

5 Ibid., 1.

6 'The Bequest of Colonel William Lethieullier' (1756). British Museum Department of Ancient Egypt and the Sudan Archives.

7 Robert Dodsley and James Dodsley, *London and Its Environs Described* (London: R. and J. Dodsley, 1761), 31.

8 Edmund Powlett, *The General Contents of the British Museum: With Remarks. Serving as a Directory in Viewing That Noble Cabinet* (London: R. and J. Dodsley, 1761), 12.

9 'New Egyptian Room, British Museum', *Penny Magazine of the Society for the Diffusion of Useful Knowledge*, 10 November 1838, 436–437 (437).

10 Letter 'autorisation d'ensevelir des momies', Archives Nationales 20144775/2, section administration, my translation.

11 Jean-François Champollion, *Précis du système hiéroglyphique des anciens Égyptiens* (Paris: Treuttel & Würtz, 1824). This work resulted from the document: Jean-François Champollion, *Lettre à Monsieur Dacier relative à l'alphabet des hiéroglyphes phonétiques* (Paris: F. Didot Père et Fils, 1822).

12 Champollion, *Précis*, 400, my translation.

13 'Ordonnance de Charles X du 15 mai 1826', mentioned in Champollion, *Précis*, x, my translation.

14 Jean-François Champollion, *Notice descriptive des monumens égyptiens du Musée Charles X* (Paris: Imprimerie de Crapelet, 1827).

15 See the augmented re-edition of Champollion's *Notice* by Guichard, which this time contains photographs of objects (no human remains): Jean-François Champollion, *Notice descriptive des monuments égyptiens du Musée Charles X*, ed. Sylvie Guichard (Paris: Editions Khéops, 2013).

16 On a similar reaction, see Moser, *Wondrous Curiosities*.

17 Pierre-François-Léonard Fontaine, *Journal, 1799–1853* (Paris: École Nationale Supérieure des Beaux-Arts, 1987), 767, my translation.

18 Champollion, *Notice descriptive* (1827), 111, my translation. In reality, Greek and Roman mummies have survived the best, and constitute the majority of mummified remains in collections today. At the Louvre, for example, Pacheri is from the Ptolemaic period, a Macedonian Greek dynasty.

19 Nestor l'Hote, *Papiers et dessins du voyageur et égyptologue Nestor L'Hôte* (1804–1842), XIXe siècle, IX Dessins et plans, Bibliothèque nationale

Notes

de France, Département des Manuscrits, NAF 20402, accessible online at https://gallica.bnf.fr/ark:/12148/btv1b53103965n/f1.planchecont act.r=%22btv1b525045086%22%22btv1b53103965n%22%22btv1b55 000580w%22%22bpt6k91064180%22 (accessed July 2021).

20 Nestor L'Hote, *Bulletin Férussac*, 9 (1828), 137 n. 117, my translation.
21 Alexandre Lenoir, *Examens des nouvelles salles du Louvre, contenant les antiquités égyptiennes, grecques et romaines* (Paris: Farcy, 1828), 3, my translation.
22 Jean-François Champollion, 'Au comte Roget de Cholex, Turin Juin 1824', in H. Hartleben (ed.), *Lettres de Champollion le Jeune: Lettres d'Italie* (Paris: E. Leroux, 1909), 16, my translation.
23 John Woodward, 'Of the Wisdom of the Ancient Egyptians', *Archaeologia; or, Miscellaneous Tracts Relating to Antiquity*, 4 (1777), 212–310 (235).
24 Emmanuel de Rougé, *Notice des monuments exposés dans la galerie d'antiquités égyptiennes* (Paris: Vinchon, Imprimeur des Musées Nationaux, 1849); Emmanuel de Rougé, *Notice sommaire des monuments égyptiens exposés dans les galeries du Musée du Louvre* (Paris: Imprimerie Simon Raçon, 1855); Emmanuel de Rougé, *Description sommaire des salles du musée égyptien* (Paris: Librairies-Imprimeries réunies, 1895); Charles Boreux, *Guide-catalogue sommaire*, Vol. II, *Salles du premier étage (Salle Charles X)* (Paris: Musées Nationaux, 1932), 295–296.
25 In 1932, the catalogue mentions three mummies in the Salle du Scribe (Room of the Scribe): these are the two child mummies brought from Egypt by Jean-François Champollion, and the mummy of Siophis (now known as Pacheri). The catalogue also mentions an unwrapped mummy of a man, brought by Baron Larrey (see Chapter 4), displayed in a glass case, located in the passage between the funerary room and the Colonnade Room – he did not remain on display very long, and he too was relegated to the basement of the museum.
26 The lack of research on, and ethical debate about, the display of Egyptian mummies at the Louvre, compared, for example, with the British Museum, is representative of France's approach to human remains generally. While a few publications have appeared in recent years on the display and ethics of human remains, the practice remains rather unchallenged compared with other countries. Regarding the existence of more Egyptian human remains in different departments, it is worth noting that the Louvre has a separate department now for Roman and Coptic Egypt, which includes numerous

human remains, including full bodies and body parts on display (see Chapter 4 on mummified heads). On the study of human remains in museums in France, see Laure Cadot, *En chair et en os: Le cadavre au musée* (Paris: École du Louvre, 2009), especially 94–104; and the special issue of *Techné* on human remains: Noëlle Timbart, Hélène Guichard and Alain Froment (eds), *Archives de l'humanité: Les restes humains patrimonialisés*, *Techné*, 44 (2016). On human remains in the UK, see Graeme Were and J. C. H. King (eds), *Extreme Collecting: Challenging Practices for the 21st Century Museum* (London: Berghahn Books, 2012); and Myra Giesen (ed.), *Curating Human Remains: Caring for the Dead in the United Kingdom* (Woodbridge: Boydell Press, 2013).

27 'Very Proper to the Place', entry on University of Cambridge website, https://exhibitions.lib.cam.ac.uk/curiousobjects/case/very-proper/?fbclid=IwAR2Dr8_1q7oNOpCF6-kNvlKHOWxm2c79InCu57_mHGgB8wYLrDfKxEdDNZ4 (accessed July 2021). The coffin was transferred to the Fitzwilliam Museum in 1869 and later catalogued by E. A. Wallis Budge as Roman, *c.* 350 CE. Only the cartonnage coffin survives in the museum today.

28 Sydney H. Aufrère, *La momie et la tempête* (Paris: Alain Barthélemy, 1990).

29 Pollès, *La momie de Khéops à Hollywood: Généalogie d'un mythe* (Paris, Éditions de l'Amateur, 2001), 77.

30 On the Unlucky Mummy, see Roger Luckhurst, *The Mummy's Curse: The True History of a Dark Fantasy* (Oxford: Oxford University Press, 2012).

31 On Wallis Budge, see Matthew Ismail, *Wallis Budge: Magic and Mummies in London and Cairo* (Kilkerran: Hardinge Simpole, 2011).

32 E. A. Wallis Budge, *By Nile and Tigris: A Narrative of Journeys in Egypt and Mesopotamia* (London, 1920), 389.

4 The mummy's foot

1 All the labels are available online (they contain images of human remains): https://issuu.com/angelastienne/docs/welcome_to_the_museum__refugee_week (accessed July 2021).

2 Although the legend of a passport being issued has been common currency for six decades, I have been unable to locate any evidence to substantiate this claim. However, there is indeed a story about him travelling abroad, and we will return to it in the Epilogue.

Notes

3 'Le baron Denon dans son bureau, au milieu de sa collection' by Théodore René Berthon can be viewed at https://histoire-image. org/fr/etudes/vivant-denon-1745-1825-museum-central-arts-musee-napoleon (accessed October 2021).

4 For ease of reference, I call it the Musée du Louvre throughout the book, although its name changed following the changes in French government; it was for a while called Musée Napoléon, for example.

5 Dominique Vivant Denon, *Monuments des arts du dessin* (Paris: B. Denon, 1829).

6 On Dominique Vivant Denon, see Jean Chatelain, *Dominique Vivant Denon et le Louvre de Napoléon* (Paris: Librairie académique Perrin, 1999); Philippe Sollers, *Le cavalier du Louvre, Vivant Denon (1747–1825)* (Paris: Gallimard, 1995); and Marie-Anne Dupuy, *Dominique Vivant Denon: L'œil de Napoléon* (Paris: Édition de la Réunion des Musée Nationaux, 1999).

7 Dominique Vivant Denon, *Voyage dans la basse et la haute Égypte* (Paris: P. Didot l'ainé, 1802), 1, my translation.

8 Léon Jean Joseph Dubois, *Description des objets d'art qui composent le cabinet de feu M. Le Baron V. Denon* (Paris: Imprimerie d'Hippolyte Tilliard, 1826).

9 Denon, *Voyage*, 201, my translation.

10 Ibid., 207, my translation.

11 Lady Sydney Morgan, *La France* (Paris: Treuttel et Würtz, 1817), 87.

12 Théophile Gautier, 'Le pied de momie' (1840), in John J. Johnston and Jared Shurin (eds), *Unearthed* (London: Jurassic London, 2013), 35–48 (39). This is the edition used in this chapter, with the edition's translation into English. The French title has been kept, rather than the edition's translation.

13 As a full novel: Théophile Gautier, *Le roman de la momie* (Paris: Hachette, 1858).

14 Ibid., Prologue. Translation from Brian J. Frost, *The Essential Guide to Mummy Literature* (Lanham: Scarecrow Press, 2008), 6.

15 See Chapter 6. Edmond de Goncourt and Jean de Goncourt, entry of 27 May 1867, *Journal des Goncourt: Mémoires de la vie littéraire*, 3.1 (1866–1870), 129–133.

16 *Catalogue de la vente de la collection de Joséphine de Beauharnais*, 1819. Archives Nationales.

Notes

17 Female mummy head, E3442. Purchased from the collection of Joséphine de Beauharnais by Nils Gustaf Palin for the Louvre in 1859.

18 Dominique Vivant Denon, 'Procès-verbal de l'ouverture d'une momie', in Denon, *Monument des arts du dessin*, 66–73.

19 Jasmine Day, *The Mummy's Curse: Mummymania in the English-Speaking World* (London: Routledge, 2006), especially 19–63; Eleanor Dobson, *Victorian Literary Culture and Ancient Egypt* (Manchester: Manchester University Press, 2020).

20 Denon, 'Procès-verbal', 67.

21 Dubois, *Description des objets d'art*, 55, no. 244. The mummy, unwrapped following its dissection by Denon, is not currently on display, but remains in the Museum's collection as ID 238903.

22 Dominique-Jean Larrey wrote *Relation historique et chirurgicale de l'expédition de l'armée d'orient, en Egypte et en Syrie* (Paris: Chez Demonville et S, 1803).

23 A striking and disturbing example is a photograph of 'Horatio Robley, seated with his collection of severed heads of Maori', now in the Wellcome Collection archives. I have chosen not to add a link to this photograph, which represents a collection entailing violence. It is one of many examples; we have seen some in Chapter 1, on the Wellcome Historical Medical Museum.

24 On the collecting of heads, see the important article by Lizzie Wade, 'The Ghost in the Museum: Anthropologists Are Reckoning with Collections of Human Remains – and the Racism that Built Them', https://www.science.org/news/2021/07/racist-scientist-built-collection-human-skulls-should-we-still-study-them (accessed September 2021). See also Chapters 6 and 7.

25 There are traces in archives of the mummy being on display in the early years of the museum, but it has been taken off display for a while, and remained in a box in the storage area of the museum's Egyptian department in 2014. The stored collections have now been transferred to an external storage centre in the north of France.

26 It is important to note that the department relating to pharaonic Egypt (including Ptolemaic) and that focusing on Roman and Coptic Egypt are two separate departments at the Musée du Louvre, and therefore choices and preferences regarding the display of human remains diverge. On this specific mummy head, see the entry (contains images of human remains) at https://collections.louvre.fr/ark:/53355/cl010036139 (accessed September 2021).

Notes

27 Price, *Golden Mummies of Egypt*, 145–148.
28 *What Does It Mean to Be Human? Curating Heads at UCL*, 2 October–28 February 2018, Octagon Gallery, UCL.
29 Hannah Reder, 'The Curious Case of Jeremy Bentham', *Mummy Stories*, https://www.mummystories.com/single-post/jeremy-bentham (accessed September 2021).
30 See Chapter 7; and Debbie Challis, *The Archaeology of Race: The Eugenic Ideas of Francis Galton and Flinders Petrie* (London: Bloomsbury, 2013).
31 The term 'specimen' was used at the time but is generally avoided now, because of its dehumanising character.
32 John Hadley, 'An Account of a Mummy, Inspected at London 1763', *Philosophical Transactions of the Royal Society*, 54 (1764).
33 Nehemiah Grew, *Museum regalis societatis; or, A Catalogue and Description* (London: W. Rawlins, 1681), 1.
34 See previous engagement with the problems of this museum: Research Centre for Museums and Galleries, 'Stories of a Different Kind', https://le.ac.uk/rcmg/research-archive/stories-of-a-different-kind; and 'Exceptional & Extraordinary: Unruly Minds and Bodies in the Medical Museum', https://www.rcplondon.ac.uk/news/exceptional-extraordinary-unruly-minds-and-bodies-medical-museum (accessed September 2021).

5 Mummies unrolled

1 The guide to the Egyptian section is: Auguste Mariette, *Exposition universelle de 1867: Description du Parc Égyptien par Auguste Mariette* (Paris: Dentu, Libraire, Palais-Royal, 1867).
2 Elisabeth David, *Mariette Pacha 1821–1881* (Paris: Pygmalion, 1997); Amandine Marshall, *Auguste Mariette* (Paris: Bibliothèque des Introuvables, 2011).
3 Auguste Durand (ed.), *Compte rendu des séances de l'année – Académie des Inscriptions et Belles-Lettres* (Paris: Imprimerie Nationale, 1884), 563, my translation.
4 Edmond de Goncourt and Jean de Goncourt, entry of 27 May 1867, *Journal des Goncourt: Mémoires de la vie littéraire*, 3.1 (1866–1870), 129–133, my translation.
5 Théophile Gautier, *L'Orient*, Vol. II (Paris: G. Charpentier, 1882), 101, my translation.

Notes

6 Samuel J. M. M. Alberti, *Morbid Curiosities* (Oxford: Oxford University Press, 2011); Simon Chaplin, 'Nature Dissected, or Dissection Naturalized? The Case of John Hunter's Museum', *Museum and Society*, 6.2 (2008), 135–151; Simon Chaplin, 'John Hunter and the Museum Oeconomy', unpublished PhD thesis (University of London, 2009).

7 Simon Chaplin, 'Dissection and Display in Eighteenth-Century London', in Piers Mitchell (ed.) *Anatomical Dissection in Enlightenment England and Beyond; Autopsy, Pathology and Display* (London: Routledge, 2012), 95–114.

8 *The New Lady's Magazine; or, Polite and Entertaining Companion to the Fair Sex*, Vol. III (1788), 220.

9 Richard Altick, *The Shows of London* (Cambridge, MA: Harvard University Press, 1978); Vanessa Toulmin, '"Curios things in curios places": Temporary Exhibition Venues in the Victorian and Edwardian Entertainment Environment', *Early Popular Visual Culture*, 4 (2009), 113–137; Robert Wood, *Victorian Delights* (London: Evans Brothers, 1967).

10 On the performance of science, see Bernard Lightman, *Victorian Science in Context* (Chicago: University of Chicago Press, 1997); Bernard Lightman, 'Mid Victorian Science Museums and Exhibitions: The Industrial Amusement and Instruction of the People', *Endeavour*, 37.2 (2013), 82–93.

11 Laura Anderson Barbata, *The Eye of the Beholder: Julia Pastrana's Long Journey Home* (Seattle: Marquand Books, 2017).

12 Nadja Durbach, '"Skinless Wonders": Body Worlds and the Victorian Freak Show', *Journal of the History of Medicine and Allied Science*, 69.1 (2014), 38–69.

13 On post-mortem photography, see Emily Ann Bronte, *Victorian Death Art: Postmortem Death Photography and Hair Art* ([n.pl.], [n.pub.], 2017); Alexander Coil, *Dead People Posing: The Mystery behind Dead Photographs* ([n.pl.], Create Space Independent Publishing, 2015).

14 See Jason Thompson, *Wonderful Things: A History of Egyptology*, Vol. I, *From Antiquity to 1881* (Cairo: American University in Cairo Press, 2015); Jason Thompson, *Wonderful Things: A History of Egyptology*, Vol. II, *The Golden Age: 1881–1914* (Cairo: American University in Cairo Press, 2015); Richard Parkinson, *Cracking Codes: The Rosetta Stone and Decipherment. Contributions by Whitfield Diffie, Mary Fischer, and R. S. Simpson* (London: British Museum Press, 1999). See also, as mentioned

Notes

previously, Okasha El-Daly, *Egyptology: The Missing Millennium* (London: UCL Press, 2005).

15 On Belzoni, see Ivor Noel Hume, *Belzoni: The Giant Archaeologists Love to Hate* (Charlottesville: University of Virginia Press, 2011); Stanley Mayes, *The Great Belzoni: The Circus Strongman who Discovered Egypt's Ancient Treasures* (London: Tauris Parke Paperbacks, 2008).

16 Giovanni Battista Belzoni, *Narrative of the Recent Operations and Discoveries within the Pyramids, Temples, Tombs, and Excavations in Egypt and Nubia* (London: J. Murray, 1820).

17 Ibid., 157.

18 William Jerdan, William Ring Workman, John Morley, Frederick Arnold and Charles Wycliffe Goodwin, 'Egyptian Antiquities', *The Literary Gazette: A Weekly Journal of Literature, Science, and the Fine Arts*, 5 (1821), 268.

19 Jean-Marcel Humbert, *L'égyptomanie dans l'art occidental* (Paris: Art Creation Realisation, 1989); Jean-Marcel Humbert, Michael Pantazzi and Christiane Ziegler, *Egyptomania* (Ottawa: National Gallery of Canada, 1994).

20 On Bullock and the Egyptian Hall, see Altick, *Shows of London*; and Susan Pearce, 'William Bullock: Inventing a Visual Language of Objects', in Simon J. Knell, Suzanne MacLeod and Sheila Watson (eds), *Museum Revolutions: How Museums Change and Are Changed* (London: Routledge, 2007), 15–27.

21 Altick, *Shows of London*, 245.

22 Giovanni Battista Belzoni, *Description of the Egyptian Tomb, Discovered by G. Belzoni* (London: J Murray, 1822).

23 *Catalogue of the Various Articles of Antiquity to be Disposed of at the Egyptian Tomb by Auction or by Private Contract the Casts of Bas-Relief, etc; Together with all the Collection Part of the Project of Mr Belzoni's Researches in Egypt, Nubia etc. will be Sold after the 1st of April 1822* (London, printed by William Clowes, Northumberland Court, 1822).

24 Susan Pearce, 'Giovanni Battista Belzoni's Exhibition of the Reconstructed Tomb of Pharaoh Seti I in 1821', *Journal of the History of Collections*, 12.1 (2000), 109–125 (123).

25 See Moshenska on Pettigrew's connections, especially Robert Hay and John Gardner Wilkinson, who both attended Pettigrew's unrollings: Gabriel Moshenska, 'Unrolling Egyptian Mummies in Nineteenth-Century Britain', *British Journal for the History of Science*, 47.3 (2013), 451–477. Also, Gabriel Moshenska, 'Thomas "Mummy"

Notes

Pettigrew and the Study of Egypt in Early Nineteenth-Century Britain', in Carruthers, *Histories of Egyptology*, 201–214. See also Gabriel Moshenska, 'Esoteric Egyptology, Seed Science and the Myth of Mummy Wheat', *Open Library of Humanities*, 3.1 (2017), 1–42.

26 Thomas Joseph Pettigrew, *Biographical Memoirs of the Most Celebrated Physicians, Surgeons, etc. etc. who have Contributed to the Advancement of Medical Science* (London: Fisher, 1840), 31.

27 Charles Perry, *A View of the Levant: Particularly of Constantinople, Syria, Egypt and Greece* (London: T. Woodward, 1743), 470.

28 Thomas Joseph Pettigrew, *A History of Egyptian Mummies, and an Account of the Worship and Embalming of the Sacred Animals by the Egyptians* (London: Longman, Rees, Orme, Brown, Green and Longman, 1834).

29 Sylvanus Urban, *The Gentleman's Magazine, and Historical Chronicle: From January to June 1833*, 103 (1833), 356.

30 'Art and Sciences', *Literary Gazette*, 13 April 1833, 234.

31 Pettigrew, *A History of Egyptian Mummies*, xvii.

32 John Davidson, *An Address on Embalming Generally, Delivered at the Royal Institution, on the Unrolling of a Mummy* (London: J. Ridgway, 1833), 19.

33 Warren R. Dawson, 'Pettigrew's Demonstrations upon Mummies: A Chapter in the History of Egyptology', *Journal of Egyptian Archaeology*, 20.3/4 (1934), 170–182 (172).

34 Ibid., 173.

35 *Literary Gazette*, 15 April 1837, 2.

36 'Literary and Learned', *Literary Gazette*, 10 June 1848, 394.

37 Pettigrew, *A History of Egyptian Mummies*, xix.

38 Thomas Joseph Pettigrew, 'Account of the Unrolling of an Egyptian Mummy, with Incidental Notices of the Manners, Customs, and Religion of the Ancient Egyptians', *Magazine of Popular Science, and Journal of the Useful Arts*, 2 (1836), 17–40.

39 Bob Brier, *Egyptian Mummies: Unravelling the Secrets of an Ancient Art* (New York: Harper Perennial, 1996), 167.

40 'Unrolling of a Mummy', *Literary Gazette*, 17 September 1842, 651.

41 On the unrolling of a mummy now at the Royal Cornwall Museum, and the cultural and academic contexts of this event, see John J. Johnston, 'Lost in Time and Space: Unrolling Egypt's Ancient Dead', *Journal of the Royal Institution of Cornwall* (2013), 7–22.

42 'Egyptian Mummies', *Chamber's Edinburgh Journal*, 118 (1834/1884), 110–111.

43 Transcript from 'Mummy One Seven Seven O: The Unwrapping', https://www.youtube.com/watch?v=UH0EegCW8P0 (accessed September 2021).

44 On the Manchester Mummy Project, see Campbell Price, Roger Forshaw, Andrew Chamberlain and Paul Nicholson (eds), *Mummies, Magic and Medicine in Ancient Egypt: Interdisciplinary Essays for Rosalie David* (Manchester: Manchester University Press, 2016). For selected work by Rosalie David: *Mysteries of the Mummies: The Story of the Manchester University Investigation* (London: Book Club Associates, 1978); *Manchester Museum Mummy Project: Multidisciplinary Research on Ancient Egyptian Mummified Remains* (Manchester: Manchester Museum, 1979). See also Patricia Lambert-Zazulak, 'The International Ancient Egyptian Mummy Tissue Bank at the Manchester Museum', *Antiquity*, 74.283 (2000), 44–48.

6 The White mummy

1 The seventy-two names engraved on the Eiffel Tower can be found at https://www.toureiffel.paris/en/the-monument/eiffel-tower-and-science (accessed September 2021).

2 In my opinion the best and most accessible work introducing Saartjie Baartman in context is Robin Mitchell, *Vénus Noire: Black Women and Colonial Fantasies in Nineteenth-Century France* (Athens: University of Georgia Press, 2020). Other publications on Saartjie Baartman include Gérard Badou, *L'énigme de la Vénus hottentote* (Paris: Jean Claude Lattès, 2000); and Natasha Gordon-Chipembere, *Representation and Black Womanhood: The Legacy of Sarah Baartman* (Basingstoke: Palgrave Macmillan, 2011). On the representation of the body, and especially fat phobia and the Black body, see Sabrina Strings, *Fearing the Black Body: The Racial Origins of Fat Phobia* (New York: New York University Press, 2019).

3 The question regarding her free will is explored in Mitchell, *Vénus Noire*, especially pp. 30–35.

4 On scientific racism and the return of race science, see Angela Saini, *Superior: The Return of Race Science* (London: Fourth Estate, 2019).

5 On Cuvier's involvement in the transformation of the Muséum national d'Histoire naturelle de Paris, see Philippe Taquet, 'Establishing the Paradigmatic Museum: Georges Cuvier's Cabinet

d'anatomie comparée in Paris', in Simon J. Knell, Suzanne MacLeod and Sheila Watson (eds), *Museum Revolutions: How Museums Change and Are Changed* (London: Routledge, 2007), 3–14.

6 Cuvier's views are quoted by Flourens: 'Egypt has preserved, in its catacombs, said M. Cuvier, cats, dogs, monkeys, cattle heads, ibis, birds of prey, crocodiles etc., and certainly we do not see more differences between these beings and the ones we see, than between the human mummies and the skeletons of men today.' Pierre Flourens, *Analyse raisonnée des travaux de Georges Cuvier, précédée de son éloge historique* (Paris: chez Paulin, 1841), 257. For Cuvier's work on animals see Georges Cuvier, *Discours sur les révolutions de la surface du globe* (Paris: E. d'Ocagne, 1830). Studies of the ibis also appear in Georges Cuvier, *Recherches sur les ossemens fossiles, où l'on établit les caractères de plusieurs animaux dont les révolutions du globe ont détruit les espèces* ([n.pl.], [n.pub.], 1812). They are also reported in Aubin-Louis Millin, *Dictionnaire des beaux-arts* (Paris: chez Desray, 1806), 124–125 (not exhaustive).

7 Georges Cuvier, *Note instructive sur les recherches à faire relativement aux différences anatomiques des diverses races d'homme* (1799), in Jean Copans and Jean Jamin (eds), *Aux origines de l'anthropologie française* (Paris: J. M. Place, 1994), texte 2, my translation.

8 Ibid.

9 Georges Cuvier, *Extraits d'observations faites sur le cadavre d'une femme connue à Paris et à Londres sous le nom de Vénus hottentote* (Paris: G. Dufour, 1817).

10 Cuvier, *Extraits d'observations*, 273.

11 Jennifer Terry and Jacqueline Urla, *Deviant Bodies: Critical Perspectives on Difference in Sciences and Popular Culture* (Bloomington: Indiana University Press, 1995), 25.

12 James Cowles Prichard, *Researches into the Physical History of Mankind*, Vol. I (London: Sherwood, Gilbert & Piper, 1836).

13 Debbie Challis, *The Archaeology of Race: The Eugenic Ideas of Francis Galton and Flinders Petrie* (London: Bloomsbury Academic, 2013). See following chapter.

14 Constantin-François Volney, *Travels through Syria and Egypt in the Years 1783, 1784, and 1785* (London: G. G. J. and J. Robinson, 1788), Vol. I, 83.

15 Anon. [François Bernier], 'New Division of the Earth According to the Different Species or Races of Man that Inhabit It, Sent by a Famous Voyager', *Journal des sçavans*, 24 April 1684.

16 Ibid.

Notes

17 To understand racial thinking better, see (not exhaustive): Angela Saini, *Superior: The Return of Race Science* (New York: Fourth Estate, 2019); Nicolas Bancel, Thomas David and Dominic Thomas, *L'invention de la race: Des représentations scientifiques aux exhibitions populaires* (Paris: Éditions La Découverte, 2014); Michael Keevak, *Becoming Yellow: A Short History of Racial Thinking* (Princeton: Princeton University Press, 2011); Bruce Baum, *The Rise and Fall of the Caucasian Race: A Political History of Racial Identity* (New York and London: New York University Press, 2006); and Hannah Augstein, *Race: The Origins of an Idea 1760–1850* (St Augustine, FL: St Augustine Press, 2000).

18 David Allen Harvey, 'The Varieties of Man: Racial Theory between climate and Heredity', in *The French Enlightenment and Its Others: The Mandarin, the Savage, and the Invention of the Human Sciences* (Basingstoke: Palgrave Macmillan, 2012), 125–153; Augstein, *Race*; Bancel *et al.*, *L'invention de la race*.

19 Carl von Linné, *Systema naturae* ([n.pl.], [n.pub.], 1735).

20 Thierry Hoquet, 'Biologisation de la race et racialisation de l'humain: Bernier, Buffon, Linné', in Bancel *et al.*, *L'invention de la race*, 25–58.

21 For a study on Camper and his location in Dutch natural history, see Klaas van Berkel and Bart Ramakers (eds), *Petrus Camper in Context: Science, the Arts, and Society in the Eighteenth-Century Dutch Republic* (Torenlaan: Wilco, 2015). Thomas Cogan [Petrus Camper], *The Works of the Late Professor Camper* (London: printed for C. Dilly, 1794). See also, on the relation between race and aesthetics, David Bindman, *Ape to Apollo: Aesthetics and the Idea of Race in the 18th Century* (Ithaca: Cornell University Press, 2002).

22 Volney, *Travels through Syria and Egypt*, 80–83.

23 James Boswell, *The Life of Samuel Johnson, Comprehending an Account of His Studies and Numerous Works in Chronological Order*, Vol. IV (London: G. Walker, 1820 [1791]), 109–110.

24 Roj Bhopal, 'The Beautiful Skull and Blumenbach's Errors: The Birth of the Scientific Concept of Race', *BMJ*, 335 (2007), 1308–1319. See also Christina Riggs, *Unwrapping Ancient Egypt* (London: Bloomsbury Academic, 2014), 48–49, 52, 54 and 71.

25 You will remember that Pettigrew's demand to dissect a mummy in the British Museum was rejected.

26 Johann Friedrich Blumenbach, 'Observations on Some Egyptian Mummies Opened in London', *Philosophical Transactions of the Royal Society of London*, 84 (1794), 177–195.

Notes

27 Union der deutschen Akadamien der Wissenschaften, *Blumenbach – Online*, https://www.Blumenbach-online.de (accessed September 2021).

28 Blumenbach, 'Observations', 177.

29 Ibid., 180.

30 Ibid.

31 This has now translated into growing trends to carry out facial reconstructions of ancient mummified bodies, which come with a range of ethical issues, especially in terms of skin colour and facial structure.

32 Blumenbach, 'Observations', 187.

33 Johann Friedrich Blumenbach, 'De generis humani varietate nativa' (published as a doctoral dissertation, University of Göttingen, 1775); Johann Friedrich Blumenbach, *De generis humani varietate nativa* (Göttingen: Vandenhoek and Ruprecht, 1795).

34 Blumenbach, 'Observations', 189.

35 Ibid., 193. Saini notes that 'under Blumenbach's sweeping definition it [the term 'Caucasian'] encompassed everyone from Europe to India and North Africa. It was hardly scientific, even by the standards of his time, but his vague human taxonomy would nevertheless have lasting consequences.' She continues, 'Caucasian is the polite word we still use today to describe white people of European descent.' Saini, *Superior*, 3.

36 Sara Eigen noted that 'throughout Blumenbach's collective work and highlighted by the *Abbildungen* is the certainty that, on the one hand, race can function as a category of physical classification, and on the other hand, race must be rejected as an analytic category of culture.' Sara Eigen, 'Self, Race, and Species: J. F. Blumenbach's Atlas Experiment', *German Quarterly*, 78.3 (2005), 277–298.

37 On Granville see Riggs, *Unwrapping Ancient Egypt*, 49–55; Christina Riggs, 'An Autopsic Art: Drawings of "Dr Granville's Mummy"', *Notes and Records of the Royal Society of London*, 70.2 (2016), 107–133.

38 Augustus Bozzi Granville, 'An Essay on Egyptian Mummies: With Observations on the Arts of Embalming among the Ancient Egyptians', *Philosophical Transactions of the Royal Society of London*, 115 (1825), 269–316.

39 Ibid., 279.

40 Ibid., 281.

41 Samuel G. Morton, *Crania aegyptiaca; or, Observations on Egyptian Ethnography, Derived from Anatomy, History and the Monuments* (Philadelphia: John Penington; London: Madden, 1844).

42 Josiah C. Nott, *Two Lectures on the Natural History of the Caucasian and Negro Races* (Mobile, AL: printed by Dade and Thompson, 1844).

43 Sylvie Briet, 'Les tribulations de la Vénus hottentote', *Libération*, 21 February 2002, https://www.liberation.fr/sciences/2002/02/21/les-tribulations-de-la-venus-hottentote_394542/ (accessed July 2021).

44 'Speech at the Funeral of Sarah Bartmann, 9 August 2002', website of the International Relations and Cooperation Department, Republic of South Africa, http://www.dirco.gov.za/docs/speeches/2002/mbeko809.htm (accessed January 2022).

45 As recently as 2015, the question of race was still entangled with Saartjie Baartman when her tomb plaque was desecrated. The BBC reported in 2016 that 'Last year, a plaque at her burial site in Hankey was splashed with white paint, causing further distress. This happened a couple of weeks after the removal from Cape Town University of the statue of Cecil Rhodes, the 19th Century businessman and politician who declared the British to be "the first race in the world", following protests by students.' Justin Parkinson, 'The Significance of Sarah Baartman', *BBC News*, 7 January 2016, https://www.bbc.com/news/magazine-35240987 (accessed July 2021).

7 The (White) mummy returns

1 'Shocking Truth behind Takabuti's Death Revealed', University of Manchester, 27 January 2020, https://www.manchester.ac.uk/discover/news/shocking-truth-behind-takabutis-death-revealed/ (accessed July 2021).

2 Robert Patterson, 'Cerebral Development and Inferred Character of Kabooti, an Egyptian Mummy', *Phrenological Journal and Miscellany*, 9 (1836), 356–360 (356–357).

3 Ibid., 358.

4 Ibid., 360.

5 'Shocking Truth'.

6 Ibid.

7 The question here is not whether Takabuti was in fact more closely related to Europeans. Ancient Egypt was a melting pot of individuals from the Mediterranean basin, Africa and Asia. The issue is in the reporting and its lack of consideration for historical research that worked hard on demonstrating that the ancient Egyptians could not be anything but white. It is also a diminishing statement for the

modern Egyptians who, with a sweeping statement, are reminded of the pervasiveness of colonial control that once again wants to link ancient Egyptian achievement with European attributes.

8 'New Research into Egyptian Mummies Leads to Calls for Major Ethical Review', *Museum Association*, https://www.museumsassociat ion.org/museums-journal/analysis/2020/01/30012020-new-resea rch-into-egyptian-mummys-leads-to-calls-for-major-ethical-review (accessed July 2021).

9 *Bricks + Mortals* is a walking podcast that takes you on a tour of the UCL Bloomsbury campus to look at buildings linked to the history of eugenics at UCL. The full podcast and explanation can be found at https://www.ucl.ac.uk/culture/projects/bricks-mortals (accessed July 2021), while the episode on Petrie titled 'Flinders Petrie and the Archaeology of "Race" (the Darwin Building to the Petrie Museum)' can be found at https://mediacentral.ucl.ac.uk/Player/ 9725 (accessed July 2021).

10 Another great example of walking tours that debunk stories of empire and exclusion are Alice Procter's Uncomfortable Art Tours. See https://www.theexhibitionist.org (accessed January 2022). In the press: Bridget Minamore, 'Slaver! Invader! The Tour Guide who Tells the Ugly Truth about Museum Portraits', *Guardian*, 24 April 2018, https://www.theguardian.com/artanddesign/2018/apr/24/slaver-invader-tour-guide-ugly-truth-empire-uncomfortable-art-tours-alice-procter (accessed July 2021).

11 On the Petrie Museum of Egyptian Archaeology see Alice Stevenson (ed.), *The Petrie Museum of Egyptian Archaeology: Characters and Collections* (London: UCL Press, 2015); and Dominic Montserrat, *Ancient Egypt: Digging for Dreams. Treasures from the Petrie Museum of Egyptian Archaeology University College London* (Glasgow: Glasgow City Council, 2000).

12 You will remember from Chapter 2 that Petrie was in contact with Wellcome, who was looking to buy skulls. Both the Wellcome Collection and the British Museum have Egyptian material culture in their collections, and both were involved in the classification of race and the study of the ancient Egyptians to understand their racial origins.

13 Sally MacDonald, 'University Museums and the Public: The Case of the Petrie Museum', in Paulette M. McManus (ed.), *Archaeological Displays and the Public* (London: Institute of Archaeology, 2000), 67–86; Sally MacDonald, Roy McKeown and Stephen Quirke, 'Opening

the Stable Door: New Initiatives at the Petrie Museum of Egyptian Archaeology', in *Archaeology International* (London: Institute of Archaeology, 2000), 57–59.

14 Chloë Ward, 'Excavating the Archive/Archiving the Excavation: A (Re)Assessment of the Use of Documentary Archives from the 19th and 20th Centuries in the Archaeology of Egypt', unpublished PhD thesis (UCL, 2020), https://discovery.ucl.ac.uk/id/eprint/10117801/ (accessed July 2021).

15 On the Egypt Exploration Society see https://www.ees.ac.uk (accessed July 2021).

16 The Edwards Chair of Egyptian Archaeology and Philology was founded on the death of Amelia Edwards in 1892. Flinders Petrie was the first one to take the chair between 1892 and 1933.

17 On Friday 11 September 2020, the Friends of the Petrie Museum hosted a virtual event, 'What Is in a Name?' This event aimed to initiate discussion on the challenges presented by the eugenic and racist ideas of Flinders Petrie. See details at http://www.friendsofpetrie.org.uk/pdfs/Ideas-of-Petrie-11092020-updated.pdf (accessed July 2021). This follows conversations at UCL on the renaming of buildings: Joe Cain, 'Should UCL De-Name Petrie Museum of Egyptian Archaeology', https://profjoecain.net/should-ucl-de-name-petrie-museum-of-egyptian-archaeology (accessed July 2021); Jules Fynn, 'It's about Time UCL Scrubbed Galton's Name off Its Lecture Theatres, but Let's Never Ignore the History of Eugenics', *London Student*, https://londonstudent.coop/its-about-time-ucl-scrubbed-galtons-name-off-its-lecture-theatres-but-lets-never-ignore-the-history-of-eugenics/ (accessed July 2021); 'UCL to Review Naming of Buildings after Eugenicists', *UCL PI Media*, https://uclpimedia.com/online/ucl-to-review-naming-of-buildings-after-eugenicists (accessed July 2021).

18 Debbie Challis, *The Archaeology of Race* (London: Bloomsbury Academic, 2013).

19 Francis Galton, *Inquiries into Human Faculty and Its Development* (London: Macmillan, 1883).

20 Laura I. Appleman, 'Pandemic Eugenics: Discrimination, Disability, & Detention during COVID-19' (5 July 2021), *67 Loyola Law Review*, 101 (2021), 101–186; James Tapper, 'Fury at "Do Not Resuscitate" Notice Given to Covid Patients with Learning Disabilities', *Guardian*, 13 February 2021, https://www.theguardian.com/world/2021/feb/13/new-do-not-resuscitate-orders-imposed-on-covid-19-patients-with-learning-difficulties (accessed July 2021); 'The Disability

Notes

Report: Disabled People and the Coronavirus Crisis', *Scope*, May 2020, https://www.scope.org.uk/campaigns/disabled-people-and-coronavirus/the-disability-report (accessed July 2021); 'Abandoned, Forgotten and Ignored: The Impact of the Coronavirus Pandemic on Disabled People', interim report of Inclusion London, https://www.inclusionlondon.org.uk/wp-content/uploads/2020/06/Abandoned-Forgotten-and-Ignored-Final-1.pdf (accessed July 2021).

21 Challis, *The Archaeology of Race*, 81.

22 You will remember the extensive drawings of skulls made by individuals in Chapter 6 to classify different skulls and thus, according to them, different races.

23 Karl Pearson, *National Life from the Standpoint of Science* (London: Adam & Charles Black, 1901), 43–44.

24 Challis, *The Archaeology of Race*, 167.

25 Ibid., 167–185; Debbie Challis, 'Skull Triangles: Flinders Petrie, Race Theory and Biometrics', *Bulletin of the History of Archaeology*, 26.1 (2016), 1–8.

26 The Petrie Museum of Egyptian Archaeology has done tremendous work over the past decade to become an inclusive host, challenge its history and include Egyptian voices in its narratives. See, in particular, the exhibition 'Listen to Her!', curated by Heba Abd el Gawad, https://www.ucl.ac.uk/news/2018/sep/listen-her-egypts-women-fight-their-rights (accessed July 2021).

27 *Ancient Aliens*, History Channel (2009).

28 Jamie Seidel, 'Why Did Two German "Hobbyists" Deface a Cartouche of Khufu inside the Great Pyramid and What does It Have to Do with Atlantis?', *News*, 16 January 2014, https://www.news.com.au/why-did-two-german-hobbyists-deface-a-cartouche-of-khufu-inside-the-great-pyramid-and-what-does-it-have-to-do-with-atlantis/news-story/7db71b6e1e74976cdbe7736c0e5af4c4 (accessed July 2021).

29 For a comprehensive overview of the issues behind the alien theories, see Sarah Bond, 'Pseudoarchaeology and the Racism behind Ancient Aliens', *Hyperallergic*, 13 November 2018, https://hyperallergic.com/470795/pseudoarchaeology-and-the-racism-behind-ancient-aliens/ (accessed July 2021); and David S. Anderson, 'How TV Shows Use Serious Archaeology to Promote Bogus History', *Washington Post*, 27 December 2018, https://www.washingtonpost.com/outlook/2018/12/28/how-tv-shows-use-serious-archaeology-promote-bogus-history (accessed July 2021).

Notes

30 'Racism Is behind Outlandish Theories about Africa's Ancient Architecture', *The Conversation*, 17 September 2017, https://theconve rsation.com/racism-is-behind-outlandish-theories-about-africas-anci ent-architecture-83898 (accessed July 2021).

31 'Us and Them, from Prejudice to Racism', leaflet, March 2017–January 2018, Musée de l'Homme.

32 Alice L. Conklin, *In the Museum of Man: Race, Anthropology, and Empire in France, 1850–1950* (Ithaca and London: Cornell University Press, 2013); Claude Blanckaert, *Le Musée de l'Homme: Histoire d'un musée laboratoire* (Paris: Coédition Artlys, 2015).

33 Sally Price, *Paris Primitive: Jacques Chirac's Museum on the Quai Branly* (Chicago: University of Chicago Press, 2007). There has been relatively little research or discussion surrounding the Musée de l'Homme since its reopening. It was Sally Price's publication *Paris Primitive* on the Musée du Quai Branly that opened the path to considering the absence of contextual narratives about colonial collecting at the Musée du Quai Branly – and at the Musée de l'Homme as well. The Musée du Quai Branly is the latest in the chain of museums that have been constructed around the collections of the Muséum national d'Histoire naturelle de Paris, and hosts the collection of non-European objects from the Musée de l'Homme.

34 William H. Schneider, 'The Ethnographic Exhibitions of the Jardin Zoologique d'Acclimatation', in Pascal Blanchard, Nicolas Bancel, Gilles Boëtsch, Eric Deroo, Sandrine Lemaire and Charles Forsdick (eds), *Human Zoos: Science and Spectacle in the Age of Colonial Empires* (Liverpool: Liverpool University Press, 2008), 142–150; Sadiah Qureshi, *Peoples on Parade: Exhibitions, Empire, and Anthropology in Nineteenth-Century Britain* (Chicago: University of Chicago Press, 2011); H. Lebovics, 'The Zoos of the Exposition Coloniale Internationale, Paris 1931', in Blanchard *et al.*, *Human Zoos*, 369–376.

35 Girard de Rialle, 'Les Nubiens du Jardin d'acclimatation', *La nature: Revue des sciences et de leurs applications aux arts et à l'industrie*, 221 (1877), 198–203 (198).

36 Laure de Margerie and Édouard Papet, *Facing the Other: Charles Cordier (1827–1905), Ethnographic Sculptor* (New York: Harry N. Abrams, 2004).

37 'Buste de Mankanana', Musée de l'Homme website, https://www.museedelhomme.fr/fr/musee/collections/buste-mankanana-3847 (accessed January 2022), my translation.

38 Pauline Carminati, 'Les momies du Muséum national d'Histoire naturelle: Du cabinet anthropologique au musée de l'Homme', *La Lettre de l'OCIM*, 137 (2011), 26–34.

39 'Mummies', Muséum national d'Histoire naturelle website, https://www.mnhn.fr/en/collections/collection-groups/biological-anthropology/mummies (accessed July 2021).

40 There is now a page about the acquisition of the Peruvian mummy on the museum's website: 'Momie Chachapoya', Muséum national d'Histoire naturelle website, https://www.museedelhomme.fr/fr/musee/collections/momie-chachapoya-3857 (accessed July 2021).

41 Felwine Sarr and Bénédicte Savoy, *Restituter le patrimoine africain* (Paris: Éditions Philippe Ray/Seuil, 2018), also available online in English at http://restitutionreport2018.com/sarr_savoy_en.pdf (accessed July 2021).

42 Kate Brown, 'Western Museums Are Finally Reconsidering Their African Collections. We Gathered 3 Experts to Explain Why – and What Needs to Happen Next', *ArtNet*, 8 June 2021, https://news.artnet.com/art-world/benin-bronzes-roundtable-1976576 (accessed July 2021); Anny Shaw, 'Black Lives Matter Movement Is Speeding Up Repatriation Efforts, Leading French Art Historian Says', *The Art Newspaper*, 21 October 2020, https://www.theartnewspaper.com/news/black-lives-matter-movement-is-speeding-up-repatriation-efforts (accessed July 2021).

43 Anna Sansom, 'France's National Assembly Votes to Return Colonial-Era artefacts to Benin and Senegal', *The Art Newspaper*, 7 October 2020, https://www.theartnewspaper.com/news/france-s-national-assembly-votes-to-return-colonial-era-artefacts-to-benin-and-senegal (accessed September 2021); 'Restitution of 26 Works to the Republic of Benin', Musée du Quai Branly website, https://www.quaibranly.fr/en/collections/living-collections/news/restitution-of-26-works-to-the-republic-of-benin (accessed September 2021). The restitution took place at the end of October 2021.

44 Christina Riggs, 'An Autopsic Art: Drawings of "Dr Granville's Mummy"', *Notes and Records of the Royal Society of London*, 70.2 (2016), 107–133 (127); Christina Riggs, 'The Body in the Box: Archiving the Egyptian Mummy', *Archival Science*, 17.2 (2017), 125–150.

45 Augustus Bozzi Granville, *Autobiography of A. B. Granville*, ed. B. Granville, 2nd edn (London: Henry S. King, 1874), 211.

46 Engaging does not necessarily mean displaying objects or bodies – but neither does removal from display constitute carte blanche to avoid

engaging with complex, contested bodies and objects either. Public engagement is an important pathway to exploring these conversations with the public.

47 See 'The Nile Valley Collective: Talk with Our Experts on How to Situate Your Work on the Nile River Valley in Its African Context', https://nilevalleycollective.org/is-ancient-egypt-african/ (accessed July 2021).

48 Angela Saini, *Superior: The Return of Race Science* (New York: Fourth Estate, 2019), 292.

8 The mummy of the future

1 Gunther von Hagens and Angelina Whalley, *Gunther von Hagens' Body Worlds* (Heidelberg: Arts & Sciences Exhibitions and Publishing, 2018), 22.

2 The exhibition takes place over three floors of the imposing building and costs £25 per person. It is accompanied by a free audio guide, and no photography is allowed anywhere in the building.

3 For a longer analysis of the issues surrounding this exhibition, see Angela Stienne, 'The Medical Body as Spectacle: Body Worlds London', *Mummy Stories*, https://www.mummystories.com/single-post/body-worlds-london (accessed July 2021).

4 The exhibition's discourse places the responsibility for illness on the person visiting – illness is represented as exclusively the result of personal choices (diet, smoking etc.) and excludes individuals with illnesses and disabilities from its narrative. It is surprising that the Camden and Islington NHS Foundation Trust was in partnership with *Body Worlds* for the campaign 'Mental Health Matters' in May 2019 considering the overall narrative of this space. On the representation of disability in medical museums, see Research Centre for Museums and Galleries at the University of Leicester, 'Disorder, Dissent and Disruption', https://le.ac.uk/rcmg/research-archive/disorder-dissent-disruption (accessed January 2022); Richard Sandell, *Museums, Prejudice and the Reframing of Difference* (London: Routledge, 2007); and Richard Sandell, Jocelyn Dodd, Ceri Jones and Debbie Jolly, 'Disability Reframed: Challenging Visitor Perceptions in the Museum', in Richard Sandell, Jocelyn Dodd and Rosemarie Garland-Thomson (eds), *Re-Presenting Disability: Activism and Agency in*

the Museum (London: Routledge, 2011). For more on the representa-tion of invisible illnesses, see Angela Stienne, 'Making the Invisible Visible – Invisible Illnesses and Disabilities in Medical Collections', *ICOM Voices*, https://icom.museum/en/news/making-the-invisible-visible-invisible-illnesses-and-disabilities-in-medical-collections (accessed July 2021); Angela Stienne, 'The Lyme Museum Is Making the Invisible Visible', *Global Lyme Alliance*, https://www.globallymea lliance.org/news/the-lyme-museum-is-making-the-invisible-visible (accessed July 2021); and the website of the Lyme Museum, https://www.thelymemuseum.org (accessed January 2022).

5 The problem in assigning gender identities to human remains con-cerns the practice of archaeology at large and is significant for Egyptian human remains too.

6 'Bodyworlds Museum: Dr Gunther von Hagens Has Battled Legal Threats, Parkinson's Disease, and the Threat of Bankruptcy', *Independent*, 1 July 2015, https://www.independent.co.uk/news/peo ple/news/bodyworlds-museum-dr-gunther-von-hagens-has-battled-legal-threats-parkinson-s-disease-and-threat-bankruptcy-10359135. html (accessed July 2021).

7 The question of body smuggling has touched other similar exhi-bitions that have been inspired by *Body Worlds*. See, for example, 'Body Worlds Impresario "Used Corpses of Executed Prisoners for Exhibition"', *Telegraph*, 25 January 2004, https://www.telegraph. co.uk/news/worldnews/europe/germany/1452542/Body-Worlds-impresario-used-corpses-of-executed-prisoners-for-exhibition.html (accessed July 2021); 'The Jury's In: "Our Body" Exhibition Banned in France', *France 24*, 17 September 2010, https://www.france24.com/ en/20100917-our-body-controversial-exhibition-france-appeal-court-ban-china-prisons-justice-arts) (accessed July 2021); '"Real Bodies" Exhibition Causes controversy in Australia', *BBC News*, 26 April 2018, https://www.bbc.com/news/world-australia-43902524 (accessed July 2021); and 'Human Bodies Exhibition Cancelled in Bristol amid Fear It May Have Been a "Scam"', *Bristol Live*, https://www.bristolpost. co.uk/news/bristol-news/human-bodies-exhibition-cancelled-bris tol-3095101?utm_source=twitter.com&utm_medium=social&utm_ campaign=sharebar (accessed July 2021).

8 The question of the provenance of human remains for anatomical dissections is not new, and cases of body snatching in the United Kingdom were at the origin of a rethinking of the legislation of

the acquisition of corpses, leading to the 1832 Anatomy Act. See Sarah Wise, *The Italian Boy: A Tale of Murder and Body Snatching* (New York: Metropolitan Books, 2004); and Lisa Rosner, *The Anatomy Murders* (Philadelphia: University of Pennsylvania Press, 2010).

9 Sue Black, *All that Remains: A Life in Death* (London: Black Swan, 2019), 324. See also Sue Black, *Written in Bones: Hidden Stories in What We Leave Behind* (London: Doubleday, 2020).

10 At the time of writing, the definition has not been agreed upon, after this definition failed to be accepted by a majority of members; 'ICOM Announces the Alternative Museum Definition that Will be Subject to a Vote', https://icom.museum/en/news/icom-announces-the-alte rnative-museum-definition-that-will-be-subject-to-a-vote/ (accessed July 2021).

11 Dominic Montserrat, *Digging for Dreams: Treasures from the Petrie Museum of Egyptian Archaeology*, exhibition catalogue (Glasgow: Glasgow Council, Cultural & Leisure Services, 2000), 26.

12 The label reads: 'momie recouverte de ses "cartonnages", époque ptolémaïque, IIIe–IIe siècle av. JC. Lin, tissus de lins enduits et peints ("cartonnages")'.

13 Edmond de Goncourt and Jean de Goncourt, entry of 27 May 1867, *Journal des Goncourt: Mémoires de la vie littéraire*, 3.1 (1866–1870), 129–133, my translation.

14 *Ancient Egypt, Digging for Dreams*, was held at the Croydon Clocktower, 8 October 2000–28 January 2001, and at the Burrell Collection, Glasgow, 16 March–30 September 2001. See exhibition catalogue mentioned above by Montserrat, *Digging for Dreams*.

15 D. M. Howard, J. Schofield, J. Fletcher, K. Baxter, G. R. Iball and S. A. Buckley, 'Synthesis of a Vocal Sound from the 3,000 Year Old Mummy, Nesyamun "True of Voice"' *Scientific Reports*, 10.1 (2020).

16 Ibid., 2.

17 Giuliano J. de Leon, 'This Ancient Talking Mummy Is Now the New Internet Sensation! Find Out What He Said', *Tech Times*, 15 July 2020, https://www.techtimes.com/articles/251136/20200715/viral-this-ancient-talking-mummy-is-now-the-new-internet-sensation-find-out-what-he-said.htm (accessed July 2021).

18 Nicholas St. Fleur, 'This Mummy Speaks, but It Doesn't Say Much', *Arkansas Democrat Gazette*, 10 February 2020, https://www.arkansasonl ine.com/news/2020/feb/10/the-mummy-speaks-but-cryptically-so-far/ (accessed July 2021).

Notes

19 The body was unwrapped in 1824 and then examined by members of the Leeds Philosophical and Literary Society in 1828. For the report of 1828 see William Osburn, *An Account of an Egyptian Mummy, Presented to the Museum of the Leeds Philosophical and Literary Society, by the Late John Blayds, Esq.* (Leeds: Robinson & Hernaman, 1828).

20 For a comprehensive study of Nesyamun, the ethical problems of this study and how it fits into a wider problematic context of Egyptology see Uroš Matić, 'Talk like an Egyptian? Epistemological Problems with the Synthesis of a Vocal Sound from the Mummified Remains of Nesyamun and Racial Designations in Mummy Studies', *Archaeological Dialogues*, 28.1 (2021), 37–49; for a comprehensive overview of the responses to this study, see Michael Press, 'Attempts to Reconstruct a Mummy's Voice Are Cursed', *Hyperallergic*, 27 January 2020, https://hyperallergic.com/539573/attempts-to-reconstruct-a-mummys-voice-are-cursed/ (accessed July 2021).

21 'Mummy Returns: Voice of 3,000-Year-Old Egyptian Priest Brought to Life', *BBC News*, 24 January 2020, https://www.bbc.com/news/world-middle-east-51223828 (accessed July 2021).

22 An online search for 'mummy's voice' returns 'mummy's voice meme' as the most searched content, with thousands of comments on social media platforms including 'The "mummy voice" meme is great, but the original is honestly hilarious on its own. Poor guy sounds like the inhale on those screaming duck toys.' Numerous memes and videos reusing the sounds to make light of it have circulated on social media and video platforms.

23 On the differences between autopsies and minimally invasive methods of analysis see Dario Piombino-Mascali and Heather Gill-Frerking, 'The Mummy Autopsy: Some Ethical Considerations', in Kirsty Squires, David Errickson and Nicholas Marquez-Grant (eds), *Ethical Approaches to Human Remains: A Global Challenge in Bioarchaeology and Forensic Anthropology* (Cham: Springer, 2020), 605–625.

24 Alexandra Fletcher, Daniel Antoine and J. D. Hill, *Regarding the Dead: Human Remains in the British Museum* (London: British Museum, 2014).

25 John H. Taylor, *Mummy: The Inside Story* (London: British Museum Press, 2011).

26 You will remember here Budge's involvement in displacing ancient Egyptian mummies to the British Museum from Chapter 3 on the so-called 'Unlucky Mummy'.

Notes

27 John H. Taylor and Daniel Antoine, *Ancient Lives, New Discoveries: Eight Mummies, Eight Stories* (London: British Museum Press, 2014).

28 See Chapter 3 on the British Museum rotating mummy/coffin.

29 On the viewing of human remains see Charlotte Parent, 'Other Peoples' Secrets and the All-Seeing Eye of the Conservator', *IIC*, 2021, https://www.iiconservation.org/content/other-peoples'-secrets-and-all-seeing-eye-conservator (accessed July 2021).

30 On the social media platform Instagram, for example, accounts are entirely dedicated to sharing images of ancient human remains, for educational or entertainment purposes.

31 The same social media platform, Instagram, has been accused of fuelling the online sale of human remains, including ancient Egyptian mummified body parts. See, for example, Andrea Donetti, 'Instagram's Grisly Human Skulls Trade Is Booming', *Wired*, 18 July 2019, https://www.wired.co.uk/article/instagram-skull-trade (accessed July 2021).

32 A great overview is Michael Press, 'Who's Responsible for Bad Reporting on Mummies?', *Hyperallergic*, 27 February 2020, https://hyperallergic.com/544992/mummies/ (accessed July 2021). The issue of sensationalisation in research is highlighted in Anne Marie E. Snoddy, Julia Beaumont, Hallie R. Buckley *et al.*, 'Sensationalism and Speaking to the Public: Scientific Rigour and Interdisciplinary Collaborations in Palaeopathology', *International Journal of Palaeopathology*, 28 (2020), 88–91.

33 Dimitri V. Logunov and Nick Merriman, *The Manchester Museum: Window to the World* (London: Third Millennium, 2012), 34–45.

34 Campbell Price, *Golden Mummies of Egypt* (Manchester: Manchester Museum Press, 2021), 18–20.

35 Karen Exell, 'Covering the Mummies', 6 May 2008, *Egypt at the Manchester Museum* blog, https://egyptmanchester.wordpress.com/2008/05/06/covering-the-mummies/ (accessed October 2021). A more recent blog entry on Asru is Campbell Price, 'New Light under Old Wrappings (I): Reinvestigating Asru', *Egypt at the Manchester Museum* blog, https://egyptmanchester.wordpress.com/tag/asru (accessed July 2021).

36 Though not always representative, as people who don't like things tend to be more vocal. For responses in the press see 'Fury as Museum Bosses Cover Up Naked Egyptian Mummies to Protect "Sensitivities" of Visitors', *Daily Mail*, 21 May 2008, https://www.dailymail.co.uk/news/article-1020891/Fury-museum-bosses-cover-naked-Egyptian-mummies-protect-sensitivities-visitors.html (accessed October 2021);

Notes

'Mummies Cover-Up Reversed', *Manchester Evening News*, 18 April 2010, https://www.manchestereveningnews.co.uk/news/greater-manchester-news/mummies-cover-up-reversed-961977 (accessed July 2021); and 'Egyptian Mummies Are Covered Up', *BBC News*, 21 May 2008, http://news.bbc.co.uk/2/hi/uk_news/england/manchester/7413654.stm (accessed July 2021).

37 'Mummies Cover-Up Reversed'. It is interesting to see the play on the word 'cover-up', which fits with the newspaper's dissemination of the idea that museums are engaged in cover-ups and are working against visitors' wishes when it comes to human remains. Projects such as *Mummy Stories* have demonstrated that many more people are against the display of human remains but did not feel that they could share their views. See *Mummy Stories*, https://www.mummystories.com/ (accessed July 2021).

38 Rosalie David (ed.), *Mysteries of the Mummies: The Story of the Manchester University Investigation* (London: Book Club Associates, 1978); Patricia I. Lambert-Zazulak, Patricia Rutherford and A. Rosalie David, 'The International Ancient Egyptian Mummy Tissue Bank at the Manchester Museum as a Resource for the Palaeoepidemiological study of Schistosomiasis', *World Archaeology*, 35.2 (2003), 223–240.

39 For the talk see 'Your Mummies, Their Ancestors? Caring for and about Ancient Egyptian Human Remains', *Everyday Orientalism*, https://www.youtube.com/watch?v=CLGUhS2qUi8 (accessed July 2021).

40 To learn more about the inclusion projects at the Museo Egizio, from Refugee Day to work in prisons, see https://museoegizio.it/en/discover/special-projects/ (accessed July 2021). On the new display of human remains, titled 'In Search of Life', see https://museoegizio.it/en/explore/news/museo-egizio-opens-in-search-of-life-a-new-permanent-exhibition-room-2/ (accessed July 2021); it is accompanied by an online survey, https://museoegizio.it/en/explore/news/survey-on-the-exhibition-of-human-remains-in-museums/ (accessed July 2021).

41 Louise Tythacott and Kostas Arvanitis (eds), *Museums and Restitution: New Practices, New Approaches* (London: Taylor & Francis, 2014); Dan Hicks, *The Brutish Museums: The Benin Bronzes, Colonial Violence and Cultural Restitution* (London: Pluto Press, 2020). Shelley Angelie Saggar, *The Decolonial Dictionary*, is a great resource to understand the difference between restitution, repatriation and return: https://decolonialdictionary.wordpress.com (accessed July 2021). The Collections Trust

resources on restitution and repatriation can be found at https://colle
ctionstrust.org.uk/cultural-property-advice/restitution-and-repatriat
ion (accessed July 2021).

42 For human remains at the Pitt Rivers Museum see https://www.prm.
ox.ac.uk/human-remains-pitt-rivers-museum (accessed July 2021). In
the press see David Batty, 'Off with the Heads: Pitt Rivers Museum
Removes Human Remains from Display', *Guardian*, 13 September
2020, https://www.theguardian.com/culture/2020/sep/13/off-with-
the-heads-pitt-rivers-museum-removes-human-remains-from-display
(accessed July 2021).

43 Quote from Geraldine Kendall Adams, 'Pitt Rivers Museum
Removed Shrunken Heads from Display after Ethical Review',
Museum Association, https://www.museumsassociation.org/museums-
journal/news/2020/09/pitt-rivers-museum-removes-shrunken-
heads-from-display-after-ethical-review/# (accessed July 2021).

44 See the exhibition website at https://www.angelaspalmer.com/eyg
ptology (accessed July 2021).

45 Sydney H. Aufrère, *La momie et la tempête* (Paris: Alain Barthélemy,
1990), 166, my translation.

46 Hugh Miller, *First Impressions of England and Its People*
(London: J. Johnstone, 1847), 364. On Miller, see Simon J. Knell,
'Hugh Miller: Fossils, Landscape and Literary Geology', *Proceedings of
the Geologists' Association*, 117 (2006), 85–98.

Epilogue

1 Alice Procter, *The Whole Picture* (London: Cassell, 2020), 262.

2 Angy Essam and Mustafa Marie, 'Egypt's Pharaohs' Golden
Parade: A Majestic Journey that History Will Forever Record', *Egypt
Today Online*, 4 April 2021, https://www.egypttoday.com/Article/4/
100469/Egypt's-Pharaohs-Golden-Parade-A-majestic-journey-that-
history-will (accessed July 2021).

3 One of many headlines included was Mustafa Marie, 'Egypt's Soprano
Amira Selim Dazzles the World with Exceptional Performance in
Pharaohs' Golden Parade', *Egypt Today Online*, https://www.egyptto
day.com/Article/4/100490/Egypt's-Soprano-Amira-Selim-dazzles-
the-world-with-exceptional-performance (accessed July 2021); Rana

Notes

Atef, 'All You Need to Know about "Pharaohs' Golden Parade" Breathtaking Symphony', *See Egy*, 3 April 2021, https://see.news/pharaohs-golden-parade-symphony (accessed July 2021); Salma Ahmed, 'Egyptian Celebrities Steal Mummies Show in Cairo', *Arab News*, 5 April 2021, with Ahmed noting that 'the hashtag #Egypt_Impressed_The_World started trending on Twitter shortly after the event was over, with people expressing their views in more than 19,000 tweets', https://www.arabnews.com/node/1837606/lifestyle (accessed July 2021).

4 On this topic, I highly recommend Heba Abd el Gawad's podcast for *The Wonder House*, https://thewonderhouse.co.uk/heba-abd-el-gawad (accessed July 2021). And while you're there, *The Wonder House* is a wonderful podcast to learn more about current and best practice in museums. See also Monica Hanna, 'Egypt's Heritage Is More than an Indiana Jones Movie', *The Hill*, 28 April 2019, https://thehill.com/opinion/international/440035-egypts-heritage-is-more-than-an-indiana-jones-movie (accessed October 2021).

5 The life and career of Christiane Desroches-Noblecourt is better understood through her biography, which takes the form of a long interview: Christiane Desroches-Noblecourt, *Sous le regard des dieux* (Paris: Albin Michel, 2003). *Ramses Le Grand* was organised by the Egyptian and French governments and took place at the Galeries Nationales du Grand Palais in Paris in 1976.

6 Christiane Desroches-Noblecourt, *Ramses II: La véritable histoire* (Paris: Pygmalion, 1996); Christiane Desroches-Noblecourt, *Ramses II* (Paris: Flammarion, 2007).

7 On 1 June 1896, at 9 a.m., the unrolling of the mummy of Ramses II by Gaston Maspero started, with seventeen Egyptian officials present.

8 Ramses II was not on public view for a long time. After his unrolling, he was stored on the first floor of the Boulaq museum in Cairo; then, in 1935, he was stored in a separate part of the museum, towards the entrance, and then transported to the future mausoleum of Saad Zaghloul, before being brought back to the museum, where only a few people could see him. This changed, however, when the museum put him on public display. The humidity that came from people breathing, together with the heat inside the museum and in the cases, led to his slow decomposition. Christiane Desroches-Noblecourt, *Ramses II*, 244.

9 Christiane Desroches-Noblecourt was involved in restoring the obelisk to its original appearance. When the Place de la Concorde was

refurbished in 1974–1975, the mayor asked Desroches-Noblecourt for her opinion on the obelisk, and she suggested that a gold pyramidion (the top of the obelisk, which is in the shape of a small pyramid) should be added to bring the monument closer to its original appearance. An Egyptologist at the time called this project 'another fantasy by Christiane Desroches-Noblecourt!' and the idea was abandoned. In 1998, a year of events was planned for what was called 'the Franco-Egyptian year', including a visit from Egyptian president Hosni Mubarak. While the French wanted to commemorate the French expedition to Egypt, Desroches-Noblecourt reminded everyone that an attempted invasion was not the most festive event to focus on. She suggested doing something else and the idea of the obelisk resurfaced. The pyramidion was created in bronze covered with gold leaf. It is being regilded in 2022 to mark the bicentenary of Champollion's deciphering of the hieroglyphs. On the journey of the obelisk from Luxor to Paris, see Robert Solé, *Le grand voyage de l'obélisque* (Paris: Éditions du Seuil, 2004), and the exhibition catalogue for *Le voyage de l'obélisque: Luxor/Paris (1829/1838)* (Paris: Musée de la Marine, 2014).

10 From 26 September 1976 to 10 May 1977, 110 individuals, including 63 scientists, worked on the conservation of Ramses II's body. The parasite that was damaging Ramses II was identified by an Egyptian man, M. J. Mouchacca, who was interning at the Muséum national d'Histoire naturelle in Paris at the time. He identified it as *Daedalea biennis*, a type of fungus. The fungus was treated by irradiation before Ramses was returned to Egypt.

11 Extraordinary can also mean violent and authoritarian, let us not forget, as he was all those things.

12 A head of state, although of course the State is a concept that did not exist back in ancient Egypt the way we think about it today.

13 Not everyone was pleased by the expenses incurred from the move of Ramses II. The *New York Times* of 28 September 1976 reported 'The ceremonies were shown on French television. Not all those who were watching felt that what the Government was apparently seeking to present as a significant diplomatic victory was worth the expense. "It is ridiculous to spend our money on someone 3,000 years dead when we who are still breathing do not have enough, especially under Government austerity", said an irate Paris resident.' *New York Times*, https://www.nytimes.com/1976/09/28/archives/paris-mounts-honor-guard-for-a-mummy.html (accessed July 2021).

Suggested further reading

Alberti, Samuel J. M. M., *Morbid Curiosities: Medical Museums in Nineteenth-Century Britain* (Oxford University Press, 2011).

Black, Sue, *All That Remains: A Life in Death* (Black Swan, 2019).

Challis, Debbie, *The Archaeology of Race: The Eugenic Ideas of Francis Galton and Flinders Petrie* (Bloomsbury Academic, 2014).

Colla, Elliott, *Conflicted Antiquities: Egyptology, Egyptomania, Egyptian Modernity* (Duke University Press, 2007).

Conklin, Alice L., *In the Museum of Man: Race, Anthropology, and Empire in France, 1850–1950* (Cornell University Press, 2013).

Guichard, Sylvie, (ed.), *Notice Descriptive des Monuments Égyptiens du Musée Charles X* (Éditions Khéops, 2013).

Hicks, Dan, *The Brutish Museums: The Benin Bronzes, Colonial Violence and Cultural Restitution* (Pluto Press, 2020).

Johnston, John J. and Jared Shurin (eds), *Unearthed* (Jurassic London, 2013).

Mitchell, Robin, *Vénus Noire: Black Women and Colonial Fantasies in Nineteenth-Century France* (University of Georgia Press, 2020).

Moser, Stephanie, *Wondrous Curiosities: Ancient Egypt at the British Museum* (University of Chicago Press, 2006).

Noual, Pierre, *Restitutions: Une histoire culturelle et politique* (Belopolie, 2021).

Otele, Olivette, *African Europeans: An Untold History* (Hurst, 2020).

Pollès, Renan, *La momie de Khéops à Hollywood: Généalogie d'un mythe* (Éditions de l'Amateur, 2001).

Price, Campbell, *Golden Mummies of Egypt: Interpreting Identities from the Graeco-Roman Period* (Manchester Museum and Nomad Exhibitions, 2020).

Price, Sally, *Paris Primitive: Jacques Chirac's Museum on the Quai Branly* (University of Chicago Press, 2008).

Suggested further reading

Procter, Alice, *The Whole Picture: The Colonial Story of The Art in Our Museums and Why We Need to Talk About It* (Cassell, 2020).

Quirke, Stephen, *Hidden Hands: Egyptian Workforces in Petrie Excavation Archives, 1880–1924* (Duckworth, 2010).

Riggs, Christina, *Unwrapping Ancient Egypt* (Bloomsbury Academic, 2014).

Saini, Angela, *Superior: The Return of Race Science* (Fourth Estate, 2019).

Sarr, Felwine and Bénédicte Savoy, *Restituer le patrimoine africain* (Philippe Rey, 2018).

Squires, Kirsty, David Errickson and Nicolas Marquez-Grant (eds), *Ethical Approaches to Human Remains: A Global Challenge in Bioarcheology and Forensic Anthropology* (Springer, 2020).

Stevenson, Alice, *Scattered Finds: Archaeology, Egyptology and Museums* (UCL Press, 2019).

Wengrow, David, *What Makes Civilisation? The Ancient Near East and the Future of the West* (Oxford University Press, 2018).

Index

Index

Flinders Petrie *see* Petrie, William
 Matthew Flinders

Galton, Francis 108, 166, 167–168
Gautier, Théophile 100, 101,
 115–116, 242
Geoffroy Saint-Hilaire
 see Saint-Hilaire, Étienne
 Geoffroy
Goncourt, Edmond and Jules de
 115–116, 136, 187
Granville, Augustus Bozzi 138,
 153–155, 156, 172, 179–180

Hadley, John 36, 110–112, 151
Hunter, John 36, 110, 111–112,
 117–118, 230–231
Hunter, William 36, 110
Hunterian Museum, London 109,
 111, 112

Jardin d'Acclimatation, Paris
 176, 177
Jardin des Plantes, Paris 38, 62, 139

Leicester 4, 47–50, 91, 234
Leicester Museum & Art Gallery
 (formerly New Walk
 Museum) 46, 47, 48–51, 52,
 68, 90–91, 108
Lethieullier, William 70–72
London 19, 21–23, 25, 27, 43, 45, 49,
 69, 71, 92, 110, 112, 117–118,
 121, 122, 124, 127, 132, 138,
 140–141, 148–149, 150, 151,
 153, 157, 167, 170, 182–183,
 226, 255

see also British Museum,
 London; Egyptian Hall
 (formerly London Museum);
 Hunterian Museum, London;
 Petrie Museum of Egyptian
 Archaeology, London;
 Science Museum, London;
 University College London
 (UCL); Wellcome Collection,
 London; Wellcome Historical
 Medical Museum, London
London Museum *see* Egyptian Hall
 (formerly London Museum)
Louvre *see* Musée du Louvre, Paris

Manchester xi, 44, 193–194
Manchester Museum 44, 137,
 193–194, 248, 262–263
Mariette, Auguste 114–115
Mummy Stories 8, 220, 223, 263
Musée Charles X, Louvre, Paris
 77–81, 82, 83, 210
Musée de l'Homme, Paris 143,
 159–160, 173–179, 210, 256
Musée du Louvre, Paris 1–4, 23,
 39, 56, 60, 67–68, 75–84, 88,
 92, 93–95, 103, 104–105, 107,
 109, 120, 179, 186–187, 197,
 203–205, 208, 210, 221, 238,
 240–241, 242, 243
Musée du Quai Branly, Paris
 174–175, 178–179, 256, 257
Muséum national d'Histoire
 naturelle (MNHN), Paris 40,
 62, 142–143, 157, 159, 174–175,
 177, 178, 248–249, 256,
 257, 266

Index